$3

matisse

A PORTRAIT

Other books by Hayden Herrera:

Frida: A Biography of Frida Kahlo

Frida Kahlo: The Paintings

Mary Frank

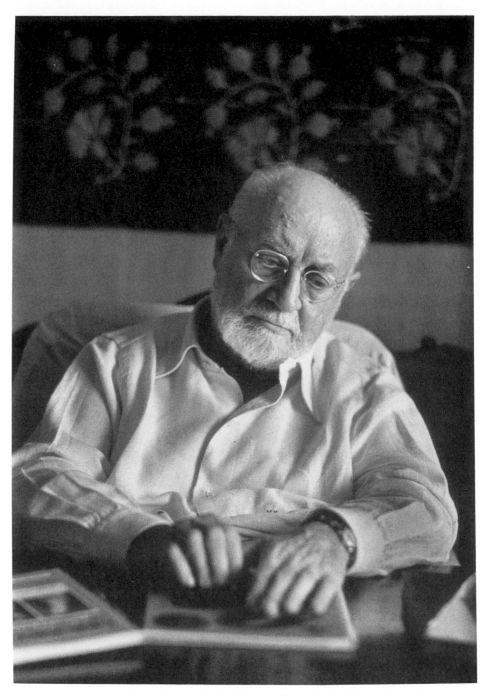

HENRI MATISSE, 1950. Photograph by Robert Capa.

Hayden Herrera

matisse

A PORTRAIT

HARCOURT BRACE & COMPANY

NEW YORK SAN DIEGO LONDON

Requests for permission to make
copies of any part of the work should be mailed to:
Permissions Department,
Harcourt Brace & Company, 8th Floor,
Orlando, Florida 32887.

©1993 Succession H. Matisse,
Paris / Artists Rights Society (ARS), N.Y.

Excerpts from *Matisse: From the Life* by Raymond Escholier,
translated by Geraldine and H. M. Colvile, © 1960 reprinted by permission of
Librairie Arthème Fayard.

Excerpts from *Matisse on Art* by Jack Flam copyright © 1973
reprinted by permission of Phaidon Press, Limited.

Excerpts from *Matisse: The Man and His Art, 1869–1918* by Jack Flam
copyright © 1986 by Jack Flam. Used by permission of the publisher,
Cornell University Press.

Excerpts from *Matisse* by Pierre Schneider, translated by Michael Taylor and
Bridget Strevens Romer, copyright © 1984 reprinted by permission of
Librairie E. Flammarion.

Library of Congress Cataloging-in-Publication Data
Herrera, Hayden.
Matisse: a portrait / Hayden Herrera.—1st ed.
p. cm.
ISBN 0-15-158183-5
1. Matisse, Henri, 1869–1954. 2. Painters—France—Biography.
I. Title.
ND553.M37H45 1993
759.4—dc20 92-31313

Photo research by Laurie Platt Winfrey / Robin Sand / Carousel Research, Inc.
Designed by Trina Stahl
Printed in the United States of America
First edition
A B C D E

TO MY FATHER

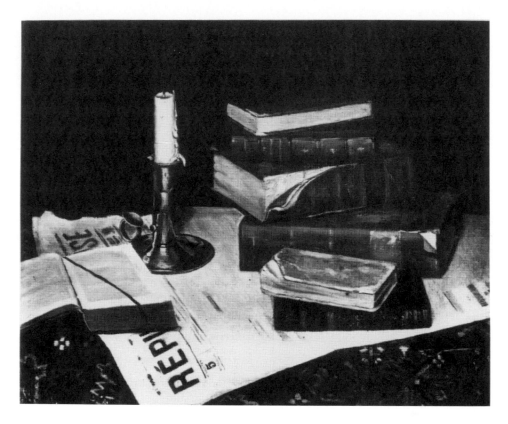

STILL LIFE, BOOKS AND CANDLE
(Bohain-en-Vermandois, 1890). Oil on canvas, 15″ × 17¾″.

CHILDHOOD IN PICARDY

enri Matisse is best known for paintings radiant with Mediterranean sunlight, but he was born in the north of France, in Picardy, a dreary landscape of beetroot, flax, and hemp fields lying flat beneath a damp gray sky. His wish was to express serenity and joy, yet he spoke often of being driven by "inner conflict," and the part of France he came from has a history of strife going back to Roman times. In 1870, the year after Matisse's birth, German troops invaded during the Franco-Prussian War. During each of the two world wars, Germans occupied Picardy again. Picardy's people have a reputation for stubborn strength; Matisse, like his father, was endowed with a powerful will; he needed all the strength he had to channel the warring forces within him into "an art of balance, of purity and serenity."

His mother, Anna Héloïse Gérard, came from a well-established family whose members, since the sixteenth century, had been tanners and glove makers. Late in 1869 she traveled for her lying-in to her parents' home in the small town of Le Cateau-Cambrésis, not far from the Belgian

1

border. At eight o'clock on New Year's Eve, she gave birth to the first of her three sons. Before going home to the nearby village of Bohain-en-Vermandois, she had her baby baptized Henri-Émile-Benoît Matisse.

Little is known about Matisse's childhood. His father, Émile-Hippolyte-Henri Matisse, was a hard-working grain merchant who in his youth had left Le Catcau to take a job as a sales assistant in a textile shop in Paris. There he met Matisse's mother, who was working as a milliner. In addition to making hats Anna Héloïse Gérard had a talent for painting china, and later, when her husband ran first a hardware shop and then a grain store in Picardy, she specialized in selling house paints and became so good at recommending colors that her customers, who frequently repainted their brick houses, came to rely on her taste.

Matisse was a well-behaved but sickly child. He suffered from what was thought to be chronic appendicitis, for which there was then no cure. (It is possible that he in fact had ulcerative colitis, an intestinal ailment that is often associated with nervous stress.) A brother, Émile-Auguste, born two years after Matisse, died before turning two. A second brother, Auguste-Émile, born in June 1874, was more robust than Matisse and, unlike his older sibling, would willingly follow in his father's footsteps to become a businessman.

Matisse's mother was especially attentive to her frail elder son. "My mother loved everything I did," he once said. Although he had great respect for his father and learned from him a sharp business sense and the value of hard work, Henri Matisse was attached to his mother and identified himself with her more sensitive and artistic nature.

His love for her is apparent in his account of what he called the "revelation at the post office," which occurred when he was an art student and, he said, taught him to follow his feelings rather than the rules of picture making.

> The revelation of the interest to be had in the study of portraits came to me when I was thinking of my mother. In a post office in Picardy, I was waiting for a telephone call. To pass the time I picked up a

telegram form lying on a table, and used the pen to draw on it a woman's head. I drew without thinking of what I was doing, my pen going by itself, and I was surprised to recognize my mother's face with all its subtleties. My mother had a face with generous features, the highly distinctive traits of French Flanders. . . . I was struck by the revelations of my pen, and I saw that the mind which is composing should keep a sort of virginity for certain elements, and reject what is offered by reasoning.

It is from his mother that Matisse is presumed to have learned an appreciation of shapes, textures, and colors. Perhaps the attraction to rich and decorative textiles revealed in Matisse's paintings is connected to his parents' knowledge of quality in fabrics and to the fact that weaving was Picardy's major industry. Many field workers of Bohain-en-Vermandois spent the winter months weaving on looms kept in their cellars. According to Matisse, he and his family participated; perhaps they helped a neighbor. "We used to make Indian shawls," Matisse remembered, ". . . decorated with palmettes and fringed at the edges." Patterned textiles play a dominant role in his still lifes and interiors; his female models are carefully clothed in—or unclothed but surrounded by—colorful fabrics. Matisse seems also to have inherited his mother's taste for millinery: in several of his portraits women wear extravagant hats. On one occasion he concocted an enormous hat with plumes and set it on the head of a young model named Antoinette Arnoux; he drew and painted her wearing it many times.

Like his parents, Matisse was eminently respectable. His life, he said, consisted of "extremely regular work, every day, from morning until evening." Although he recognized that his commitment to art separated him from the bourgeoisie, there was, he said, nothing revolutionary in his nature. He never abandoned the attitude of reserve and the bourgeois propriety that came with his upbringing. As he put it, "Everything I have done stems from my parents, humble, hard-working folk."

Up to the age of thirteen Matisse attended the local school in Bohain. After that he was sent to study in the larger town of Saint-Quentin, about twenty kilometers to the south. At the lycée he received a classical education, which included Greek and Latin as well as French literature. Years

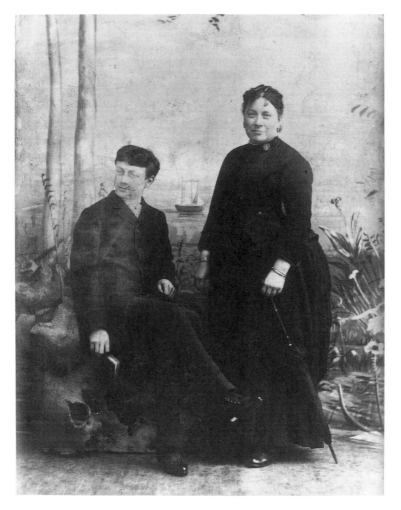

HENRI MATISSE AT AGE NINETEEN WITH HIS MOTHER,
ANNA HÉLOÏSE GÉRARD MATISSE, 1889.

later friends would remark that the precision and logic of French education were evident in Matisse's insistence that each term of a discussion—especially one about art—be carefully defined, and in his conscientious, sometimes laborious, evaluation of A and B before proceeding to C.

A good student with no special aptitudes, Matisse had no ambition to

become an artist. "I was very submissive," he later recalled. "I wanted to do what others wanted me to do." Yet the tall, plump redhead also had a rebellious streak and a dislike of authority. Once, for example, when the drawing teacher was late and hurrying up the stairs for class, Matisse spat on him and sent the students gathered on the landing into an uproar. Years later Matisse remembered with amusement how the drawing teacher, puffing to catch his breath, exclaimed to his assistant, "Look, look, they have—they have dared to spit on my top hat!"

Matisse had, it would seem, an acute case of Picardian resistance, a French attitude of irony and skepticism—what one observer called a *méfiance* of everything outside of himself. His stubborn reliance on his own vision is revealed in a story he used to tell about a hypnotist whose demonstration in Bohain's village hall had a group of schoolchildren so convinced that they were standing beside a stream that they stooped to pick flowers and to drink the stream's water. Matisse, too, felt the power of suggestion. But in the midst of a vision of grass and water, he suddenly saw the rug on the floor. "No," he cried, "I can see the carpet!" Even when he became a painter and his imagination invented the streams and flowers of an earthly paradise, Matisse would never lose touch with the concrete substance of things.

After Matisse graduated from school, his father arranged a job for him as a clerk in a lawyer's office. Finding the work tedious, Matisse was pleased when a Parisian lawyer suggested that young Henri should study law in Paris and his father agreed. In October 1887 Matisse registered at law school, where he was soon plagued again with the boredom and restlessness to which he would always be prone. To divert himself, he went to concerts. He had studied the violin and he loved music, something he shared with his father, who, with Matisse's uncle, used to take the train from Bohain to Paris to attend the opera. But as a law student Matisse took no interest in art and never even bothered to visit the Louvre. As in the lycée, he was drawn to mischief. One of his capers again involved an insult to a top hat—that emblem of male prestige and authority. Matisse liked to throw balls of glue out of his sixth-floor window and watch his target's

bafflement when a ball hit his top hat. This game came to an end when a glue ball landed on the bosom of a local seamstress, who complained to Matisse's landlord.

In spite of his indifference to his studies, Matisse passed his law examination in August 1888, with honorable mention, whereupon he returned to Picardy and took a job his father found for him as a clerk for Maître Derieu, whose law office was on Saint-Quentin's market square. Copying and filing transcripts was dull work. Soon Matisse took to filling page after page of legal paper by transcribing the fables of La Fontaine. No one ever read these papers anyway, he said, "and they served no purpose other than to use stamped paper in a quantity proportionate to the importance of the lawsuit."

Illness saved Matisse from this tedium. In 1890, when he was twenty, he had an attack of acute appendicitis, which may have been accompanied by some kind of psychological breakdown, perhaps depression. During his long convalescence at his parents' home in Bohain, he became friendly with a neighbor who ran a textile firm and painted in his spare time. The neighbor was copying a Swiss mountain landscape from a chromo, a type of color reproduction sold in albums and used as models by beginning painters. Hoping to cheer up her son, Anna Matisse bought him a set of brushes and a paint box that came with two such reproductions, one showing a water mill, the other a farm. Matisse copied both pictures and signed his canvases by writing his name in reverse—essitaM. H.—perhaps to emphasize that these replicas were not original to him.

His mother's gift of a paint box was a turning point in his life. For once he was not bored. To learn how to paint, he bought a popular handbook on oil painting, which told him how to make an academic picture, how to learn from the old masters, and how to be loyal to the appearance of nature. In June 1890, Matisse produced his first two original paintings, both highly conventional still lifes of piles of books. In *Still Life, Books and Candle* the candle that would enable him to read what might be his lawbooks is blown out, and the page-marking ribbon of one of the books is placed across the text, as if to say that Matisse's interest in law was extin-

THE ARTIST'S PARENTS,
ÉMILE-HIPPOLYTE-HENRI MATISSE
AND ANNA HÉLOÏSE GÉRARD
MATISSE, BEFORE OCTOBER 1910.

guished (illustration facing p. 1). "Other people's quarrels interested me much less than painting," Matisse recalled.

Years later he remembered how he felt when he started to paint:

> I was filled with indifference to everything that people wanted me to do. But the moment I had this box of colors in my hands, I had the feeling that my life was there. Like an animal that rushes to what he loves, I plunged straight into it, to the understandable despair of my father, who had made me study other things. It was a great allurement, a kind of paradise, in which I was completely free, alone, tranquil, whereas I had always been anxious and bored by the various things I had been made to do. . . . Before, nothing interested me; after that, I had nothing on my mind but painting.

7

Like most provincial middle-class Frenchmen of that epoch, Matisse's father thought painting was a frivolous pursuit, and when Matisse's health was restored, he did what was expected of him and returned to the law office. In secret, because he knew his father would disapprove, he kept on painting, enrolling in the elementary course at the École Quentin de La Tour, a design school to train tapestry and textile designers. Under the tutelage of Professor Croise, he drew plaster casts for an hour each day before going to work. The classes were held in the attics of the Palace of Fervaques, between seven and eight in the morning. After putting in a morning's work at the law office, Matisse would escape at noon, have a quick lunch and paint for an hour, before returning to the office at two. The adult Matisse recalled, "After office hours, I would rush back to my room (at six in the evening) and paint until nightfall—a good hour's worth of painting. But this was only possible in summer."

Now instead of filling sheets of legal paper with fables, Matisse filled them with drawings. "I'd be grateful," said the exceedingly patient Maître Derieu, "if you could draw a little less during working hours, and be more accurate when you copy my drafts." Although Matisse, like his father, was an orderly and practical person, his legal filing system was in disarray. Seeing that his clerk was unable to locate transcripts, Maître Derieu took to looking for them himself. Nevertheless, when Matisse's father stopped by to inquire how his son was doing, the older lawyer always reported—perhaps out of affection for his employee or loyalty to the father—that the young man's progress was fine.

Matisse was longing to give up his job and devote himself to art, and when his drawing teacher told him he had talent, he gathered his courage and announced his artistic aspirations to his father. Émile–Hippolyte Matisse was furious. A self-made man, he was ambitious for his son. He wanted him to pursue a respectable career as a lawyer or a businessman. But, driven by his will to paint, Matisse was no longer an obedient child. "Once bitten by the demon of painting," he remembered, "I never wanted to give up." He and his father fought. Finally Matisse's mother persuaded her husband to let their son study art in Paris. Matisse's father was some-

what appeased when one of young Henri's teachers gave the aspiring art student a letter of introduction to Adolphe-William Bouguereau, a well-known art teacher who was one of the world's most successful academic painters. If his son could follow in Bouguereau's footsteps, Émile-Hippolyte Matisse may have surmised, he could enjoy a prosperous middle-class life and win an honorable position in society. Nonetheless, legend has it that when Matisse left home to study in Paris in the fall of 1891, his father shook his fist at the departing train and shouted, "You'll die of hunger!"

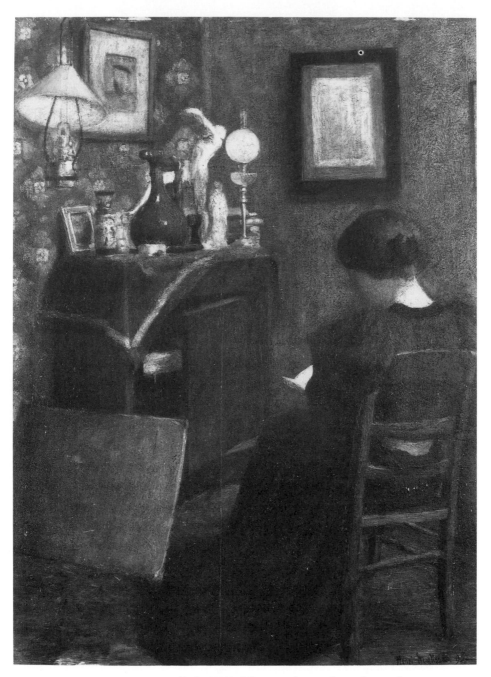

WOMAN READING (Paris, 1895). Oil on wooden panel, 24 ¼″ × 18 ⅞″.

ART STUDENT IN PARIS

hen he left Picardy and headed south to pursue an artist's career in his nation's capital, Matisse knew that his decision to become a painter held great risks:

> It was with the constant knowledge of my decision, although I knew I had found my true path, where I felt at home and not up against a stone wall as in my previous way of life, that I took fright, realizing that I could not turn back. So I charged, headlong, into my work, following the principle drummed into me all through my youth, which was "Don't waste time!" Like my parents, I wasted no time in my work, driven by I know not what, a force which I see today is quite alien to my normal life as a man.

From the beginning, work was the center of Matisse's life. It was what made him feel both alive and calm. But for many years painting earned him little money. His small monthly allowance from his father paid for essentials like his rent. He moved several times before taking a studio at 19 quai

Saint-Michel, a building overlooking the Seine where he would live off and on for many years. In the early days there Matisse could not see the building's splendid view of bridges, quays, and the Cathedral of Notre-Dame, because his first apartment was on the top floor and had no windows, only a skylight. In 1895 he moved to the fifth floor where he would stay until 1908. After paying thirty francs for rent, Matisse, who was always careful and precise in money matters, had to be extremely parsimonious with the hundred francs he had left. Trying to make one year's allowance last for two, in case his father refused to renew his support, he would order half-portions in cheap restaurants and drink water instead of wine. His friend and fellow art student Émile Jean teased him about this. "You'll never last," he would say as he poured a little of his own wine into Matisse's water glass.

Matisse hoped to enter the government-supported École des Beaux-Arts, the most powerful and prestigious art school in France. To prepare for the entrance exam, he registered at the Académie Julian, a private art school where Bouguereau was a professor. Matisse recalled that the preparatory course consisted of twenty lessons in drawing from plaster casts and that neither the professors nor their approach to art met with his approval. He found Bouguereau's paintings of idealized but nearly photographic half-naked nymphs to be treacle-sweet, and he was disgusted by the conceit with which Bouguereau painted reproductions of his own most salable pictures. Years later Matisse remembered his first encounter with the master: "I showed some of my first pictures to Bouguereau who told me that I didn't know perspective. He was in his studio, re-doing for the third time his successful Salon picture *The Wasp's Nest* (it was a young woman pursued by lovers). The original Salon picture was nearby; next to it was a finished copy, and on the easel was a bare canvas on which he was drawing a copy of the copy."

During Matisse's first lesson at the Académie Julian, Bouguereau criticized him for not centering his drawing of a figure on his sheet of paper. He also disapproved of the way Matisse used his finger instead of a rag to smudge a charcoal sketch. "That denotes a careless man," Bouguereau said.

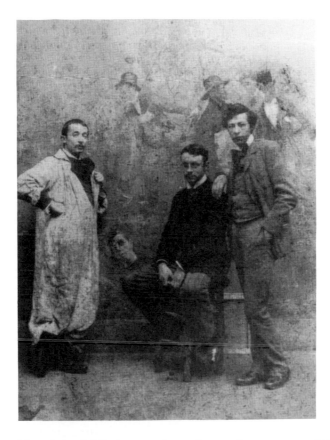

MATISSE (CENTER) WITH
ÉMILE JEAN (LEFT)
AND JEAN PETIT (RIGHT)
AT THE ATELIER OF
ADOLPHE-WILLIAM
BOUGUEREAU, ACADÉMIE
JULIAN, C. 1892.

He advised Matisse to draw from plaster casts: "First you must learn how to hold a pencil. You'll never know how to draw."

The following week another teacher, Gabriel Ferrier, admired Matisse's drawing of a plaster cast of Louis XV. "Now here's an artist," Ferrier exclaimed, and he recommended that Matisse work from a live model, something that in academic teaching was the privilege of advanced students.

Matisse's response was typically cautious: "I wouldn't dare. I'm only just beginning." Ferrier insisted: "Do figure studies then. You'll soon leave the rest of them behind." But the next time Ferrier came to give criticism, Matisse had just wiped out the head of a model he was drawing because he

felt it was so ugly that he didn't want his teacher to see it. "That is very bad; I can't tell you how bad it is," Ferrier pronounced when he saw Matisse working on a hand when he hadn't even completed the head.

Discouraged by the Académie Julian's response to his efforts, Matisse avoided class on the days when the professors came to give corrections. Although his work continued in the realist tradition, his teachers' academic goal of verisimilitude began to seem meaningless to him. The eye, he later said, "is nothing but a window behind which stands a man." Although nature was always the source, what came to matter to Matisse was the artist's response to what he saw; he thought nature should be transformed by feeling, not copied. He wanted his painting to be "a meditation on nature, on the expression of a dream which is always inspired by reality." The conflict between nature and imagination, or the subjective and the objective, was always alive for Matisse. It was one of the various conflicts that gave tension both to his paintings and to his artistic development.

Even though he avoided Bouguereau's and Ferrier's criticisms, it was under their sponsorship that he enrolled in February 1892 in the *concours de places*, the entrance examination for the École des Beaux-Arts, which tested candidates in anatomy, perspective, modeling, architecture, and history. To his father's fury, Matisse failed. One night Matisse's fear that his father would stop his allowance and force him to return to Picardy brought on a nightmare about being back on the job as a law clerk in Saint-Quentin. Awakening in terror, he relaxed only after he saw stars shining through his skylight and realized it was only a dream. Recognizing that he could "get nothing," as he put it, from these high priests of official art, he turned his back on the Académie Julian. Yet, dogged in his desire for artistic mastery, for years he did not give up studying. In the spring of 1892, still hoping to gain admission to the École des Beaux-Arts, he began to draw from casts of Greek and Roman sculptures in the École's "Cours Yvon," a large glass-roofed courtyard through which the professors passed on their way to their classrooms.

Starting in October 1892 and continuing until 1894, he also took courses in perspective, drawing, and geometry at the École des Arts Déco-

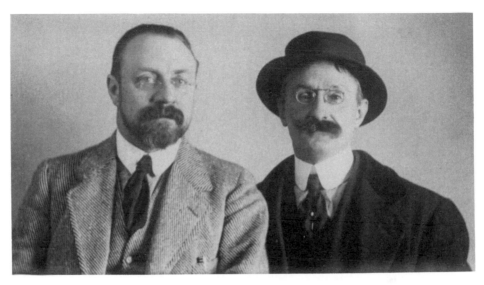

MATISSE AND ALBERT MARQUET, MARSEILLES, 1916.

ratifs. This maintained his academic standing, without which his father would have discontinued his allowance. Possibly it was also a means to gain qualification as a drawing teacher. Here he met Albert Marquet, who was to be one of his closest friends for the rest of his life. Marquet never forgot his first encounter with Matisse. When the teacher arrived and the class monitor said, "Hats off, Gentlemen!", Matisse refused to doff his hat. "Not in this draft," he cried, once again challenging authority but perhaps also protecting his health, since he was prone to illness. For this third piece of hat mischief, he was suspended for two weeks.

Six years younger than Matisse, Marquet was as short and thin as Matisse was tall and heavy. Both men wore thick spectacles. Matisse seemed to hide behind his, keeping a mask of reserve and rarely showing emotion. Marquet was even more restrained; his slightly deformed leg may have contributed to his shyness. The younger man rarely talked about art, whereas Matisse liked to exercise his well-trained mind by holding forth about painting—especially his own—for hours. He talked slowly and with great authority, intent on making himself understood. This, together with

his serious expression and his dignified bearing, made people liken Matisse to a German professor.

Discouraged by his lack of success at school, there were moments when Matisse felt like giving up painting. Yet the summer after he left the Académie Julian, his faith in himself and in art was restored when he visited the museum at Lille with his father and saw paintings by Goya and Chardin. Standing in front of Goya's *The Letter* and *Time,* also known as *Youth* and *Age,* he felt certain that this was the kind of painting he wanted to do. "It was an open door," he recalled. "The Académie Julian was a closed door." Another time Matisse remembered Goya's lesson this way: "In my beginnings, when I was a student at the École des Beaux-Arts, I believed that I would never be able to paint, because I did not paint like other people. One day I saw the Goyas at Lille. Then I understood that painting could be a language; I thought that I could be a painter."

Most of the professors at the Cours Yvon strode past the students working in the courtyard without paying them the slightest attention, for these students were not officially enrolled in the École des Beaux-Arts. There was, however, a new teacher who took an interest. His name was Gustave Moreau. Matisse had heard that if he wanted to work with Moreau he should stand behind his stool when Moreau entered the courtyard; this would signal that he wanted Moreau's criticism. If Moreau sat on a student's stool to correct the student's drawing, this meant the student would be accepted to work under him in his atelier. Moreau stopped by Matisse's easel, admired his drawings, and invited him to work in his studio on an informal basis, since Matisse had not passed the entrance exam. "But I haven't been admitted to the school," Matisse told Moreau. "That doesn't matter," Moreau said. Thus, probably in the summer of 1893, a wonderful period of apprenticeship began in which the generous-hearted Moreau became a kind of father figure to Matisse.

Although Moreau's jewel-like but mannered mythological scenes were not the kind of work Matisse wanted to do, Moreau's dedication to art was exemplary, and his emphasis on feeling and imagination helped Matisse find his own way. The master's precept that "In art, the simpler the

16

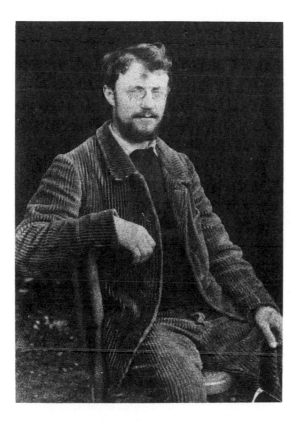

MATISSE AS A STUDENT, C. 1893.

means, the more apparent the sensibility" would be echoed again and again in Matisse's statements on art. In addition, Moreau had a passion for art history, which he shared with his pupils, accompanying them to the Louvre and pointing out paintings he thought might help them in their own development. "On one day he affirmed his admiration for Raphael," Matisse recalled, "on another, for Veronese. One morning he proclaimed that there was none greater than Chardin."

Moreau encouraged his students to learn technique and composition by copying old-master paintings in the Louvre. Among Matisse's models were Chardin, Fragonard, François Boucher, José de Ribera, Raphael, Annibale Carraci, Nicolas Poussin, and Dutch artists Salomon van Ruysdael and Jan Davidsz de Heem. Some of his copies were made for his mother's family; perhaps they helped convince his father of his diligence.

17

Others were sold to the French government to be hung in town halls and provincial museums. "I owe my art to all painters," Matisse once said. "When I was young, I worked in the Louvre copying the old masters, learning their thought, their technique." Throughout his life Matisse saw himself as carrying the tradition of painting a step further: "For my part," he told an interviewer in 1925, "I have never avoided the influence of others, I would have considered it cowardice and lack of sincerity toward myself. . . . I have accepted influences but I think I have always known how to dominate them."

Modern art such as Impressionism and Postimpressionism did not interest Moreau, and he did not send his students to see exhibitions of paintings by Gauguin, Cézanne, or van Gogh. But Moreau was open-minded: one morning he arrived at the school exclaiming about the "rude vigor" of a Toulouse-Lautrec poster that he had just seen pasted to a newspaper kiosk on the rue Lafitte. "It might have been painted in absinthe!" he said. Moreau wanted his students to learn from life as well as from tradition. "Do not be satisfied with going to the museum, go down into the street!" he said.

In the fall or winter of 1894, Matisse failed the entrance examination for the École des Beaux-Arts a second time; again his father was displeased. When the elder Matisse came to Paris to see how his son's career was progressing, Moreau told him that Matisse was one of his best students. A letter from Moreau to Matisse's father, probably written in 1894, also helped to allay paternal doubts. Moreau said that Matisse was "a fine student, a diligent worker, very gifted." He added that Matisse had "recently been making great progress. . . . His failure in the exams, where the competition is extremely high, and which are, for many reasons, a somewhat chancy business, proves absolutely nothing against him. I no longer have any doubts as to his obtaining a good result next time round." Reassured, Matisse's father decided to continue his son's allowance, and Matisse did pass the exam the following year, receiving 17 points in anatomy, 3 in perspective, 4 in modeling, none in architecture, and 13 in

history out of a possible total of 100 points, 20 for each subject. Out of the eighty-six candidates accepted, Matisse ranked forty-second. Even after he was officially enrolled in the École des Beaux-Arts, he continued working with Moreau. As Matisse's skills improved, Moreau was more and more convinced that Matisse could become a real artist. "You were born to simplify painting," he said.

Meanwhile, Matisse more than ever needed the added income that came from selling his copies to the French government (which was easier now that he was registered at the École des Beaux-Arts). He had a new financial burden. On September 3, 1894, the woman with whom he was living, Caroline Joblaud, gave birth to a daughter. The couple named her Marguerite Émilienne. That winter Matisse did a painting of his infant daughter in her crib, the first of many portraits that documented both his daughter's growing up and his enormous love for her. Matisse's conservative and practical-minded father was perturbed to learn that his son had sired an illegitimate child, especially when Matisse's financial situation was so precarious that he could not survive without his father's monthly allowance.

During his years in Moreau's studio Matisse met many lively young artists—painters like Charles Camoin, Henri Manguin, and Georges Rouault. These artists, together with Albert Marquet, who joined Moreau's studio in 1894, remained Matisse's friends and later took part in the radical movement called Fauvism, of which Matisse was the leader. In Moreau's studio Matisse continued to carry on passionate discussions about art, and well before he became a somewhat imperious "master," he had authority and stood out. He was also a good mimic, a frequent tease, and a great storyteller. The gestures he made with his beautifully manicured, well-shaped hands were full of character, and his blue eyes penetrated like a hunter's.

But his egotism could be colossal, and his seriousness could be ponderous. Some people took umbrage at the reverence with which Matisse spoke of his own work. His good friend and fellow student Simon Bussy maintained an attitude of teasing indulgence. When, for example, Matisse boasted

that one of his still lifes lit up the room, Bussy countered by saying he him-self preferred the dimmer light of a paraffin lamp. At a later time, when Matisse proclaimed that he no longer needed to learn from the old masters at the Louvre, Bussy said, "Yes, but you go to the rue Lafitte" (meaning, to see works by Manet, Monet, Cézanne, and Pissarro at the Durand-Ruel and Vollard galleries). This quip almost ended their friendship, but Matisse val-ued Bussy's company too much to remain hostile for long.

Matisse and Marquet, who around this time moved into Matisse's building, were inseparable. Together they went on painting excursions either to the banks of the Seine or to cafés, cabarets, and music halls where they learned to simplify drawing to a few swift, characteristic lines. At places like the Moulin de la Galette in Montmartre or the Petit Casino near the Opéra, they would sketch dancers and singers, including Mistinguette, a singer immortalized by Toulouse-Lautrec's caricatural portrait. Since they didn't have to pay for a model, they would spend fifty centimes on brandy or beer.

Unlike Toulouse-Lautrec, Matisse was not interested in capturing either atmosphere or a performer's individual character. In his art he was never completely a participant: even when he was immersed in his motif, part of him remained a detached observer. He later recalled that he and Marquet did not speak to anyone during these sketching trips, and they never tried to fathom their subjects' thoughts and feelings. They looked at people, Matisse said, "a bit the way one considers the inhabitants of an aquarium; one doesn't bother about what's going through the mind of a fish that's moving gracefully or that has a horrible face, like an octopus."

In his incisive and often humorous drawings of *café-concert* perform-ers, Matisse was trying to achieve something like the economy of Japanese brush drawing. He and Marquet liked to cite the romantic painter Eugène Delacroix's statement that an artist should be able to draw a man falling from the fifth floor before he hit the ground. "We were trying to draw the silhouettes of passers-by, to discipline our line. We were forcing ourselves to discover quickly what was characteristic in a gesture, in an attitude,"

Matisse later explained. For Matisse, who was by nature cautious, drawing quickly was difficult. To be able to work he needed silence and calm. Marquet had an easier time, and for Kees van Dongen, another future Fauve, it was easier still. At the Moulin de la Galette, Matisse recalled, "Van Dongen was prodigious. He ran around after the dancers and drew them at the same time. . . . All I managed was to learn the tune of the farandole that everyone shouted with the band."

In the summer of 1895, Matisse went to Brittany with Caroline Joblaud, his daughter Marguerite, and Émile Wéry, a young painter who lived across the landing from him at 19 quai Saint-Michel and who painted in a restrained Impressionist manner. Although he must have been aware of Impressionism, which had been around for over twenty years, Matisse resisted its influence. He continued to paint landscapes done in subtle shades of gray, as well as conventional still lifes and interiors based on Northern tradition, and inspired especially by his compatriot Chardin and the Dutch seventeenth-century masters.

Matisse, the great distiller and transformer of nature, looked back on the more literal realism of his early efforts and described them as "artlessly composed, or more precisely, composed without composition." He said, "It seemed to me that nature was so beautiful that I only had to reproduce it as simply as possible. I placed myself in front of objects that attracted me, identifying myself with them and seeking to create their double on my canvas." As the years went by, the idea of personal identification became more important, and the notion of creating a "double" gave way to the goal of creating an "equivalence."

One of the canvases that Matisse began that summer and finished the following winter is *Woman Reading* (page 10), which depicts Caroline Joblaud seated with her back to the viewer, and which reveals his love for intimate domestic interiors by Chardin and by Jan Vermeer, whose *Lacemaker* he had admired in the Louvre. In addition, the influence of Corot, whose large centennial exhibition at the Palais Galliera he had seen before leaving for Brittany, is reflected in the painting's gentle mood of

21

reverie, in its soft light, and in the reader's turned-away pose. The room's warm browns make the bright light that falls on the back of Joblaud's neck, on her book, and on a white sculpture seem all the more alive. Because the light comes from behind her, we can imagine that it enters through a doorway that we have just opened and in which we stand. The reader appears to be unaware of our presence—or of the presence of the painter, for we, of course, see her from his point of view. But Matisse makes his own presence felt in this painting (and in many later interiors) by placing his self-portrait on the wall. A drawing portfolio leaning against a cabinet also reminds us of the artist, and he is present as well in the almost palpable feeling of tenderness for the subject. Even in this early work, Matisse's emotional immersion in his motif gives his paintings an extraordinary immediacy. He later said that the feeling a model prompted in him "forces me to include myself in the [pictorial] space." The combination of his emotional presence in his painting and his rigorous detachment makes his art both cool and warm at the same time.

Woman Reading was one of four paintings that Matisse sent in the spring of 1896 to the Salon de la Société Nationale des Beaux-Arts, a yearly exhibition founded in 1890 as a somewhat more liberal alternative to the well-established Salon des Artistes Français, headed by academics like Bouguereau. Matisse was delighted with the success of his first public exposure; he sold *Woman Reading* to the French government, and it was hung in President Félix Faure's summer residence, the Château de Rambouillet. Matisse wrote to a cousin, "On the opening day I sold a still life of 20 by 30 centimeters for 400 francs, and last week the state bought from me the interior with a woman reading seen from behind (which you saw me draw last summer and finish this winter), for 800 francs. I also have an order from the Louvre (also by the state) for a copy of a picture by Chardin which will be at least 1,000 francs. . . . You see, my dear friend, there is some painting that brings returns." In recognition of his achievement, Matisse was honored with an associate membership in the Société Nationale, having been nominated by its president, Pierre Puvis de

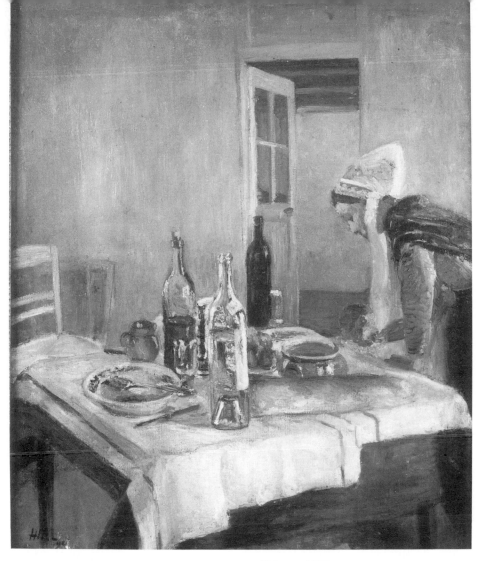

Chavannes. This meant that in future years he could exhibit at the Salon de la Société Nationale without submitting his paintings to the jury. His father's approval of this official success must have relieved Matisse's continuing anxiety that his financial support might be withdrawn.

The next two summers Matisse, Joblaud, Marguerite, and Émile Wéry returned to Brittany, staying on a small island called Belle-Île, where years

before Monet had painted Impressionist views of the rocky coast. Through Wéry, Matisse met the Australian Impressionist John Russell, who owned works by Monet and by van Gogh, one of whose drawings he gave to Matisse. Matisse recalled being affected by Impressionism in Brittany: "I then [upon arrival] had only bistres and earth colors on my palette, whereas Wéry had an Impressionist palette. Like him, I began to work from nature [meaning out of doors]. And soon I was seduced by the brilliance of pure color. I returned from my trip with a passion for rainbow colors whereas Wéry returned to Paris with a love for bitumen!" Yet Matisse did not turn to Impressionism at this time. Instead he simplified the landscape into broad areas of light and dark; or, as in *Breton Serving Girl* (1896), he joined the silvery tones of Chardin (whose *The Buffet* he was to copy that fall) with his love for Vermeer. *Breton Serving Girl*, which depicts Joblaud clearing the table, introduces a theme Matisse was to repeat in his *The Dinner Table* the following year. Apparently he had originally depicted his common-law wife feeding or wiping the face of their two-year-old daughter, for a broadly painted child's head and shoulders appear just above the table. Perhaps to make the scene less autobiographical, Matisse either painted out his daughter's features or left them unfinished.

His *Interior with Top Hat,* painted after his return to Paris in the autumn of 1896, may be an "homage to Manet," as Matisse scholar Pierre Schneider has suggested, arguing that at that time top hats were "invariably associated with Manet," who painted men wearing them and wore one himself. (Or, given Matisse's youthful mischief making with top hats, the hat could be a vestige of propriety set precariously amid the helter-skelter of Matisse's tiny studio, which fellow Moreau student Henri Evenepoel described as "filled with bits of tapestries and knickknacks gray with dust.") With its broad handling, its lively blacks, and its planar emphasis, *Interior with a Top Hat* does seem Manet-inspired. Details like the pairing of the upside-down black hat with a white vase, and the way the green lampshade seems to be on the same plane as the rectangular white picture on the wall just behind it, point forward to Matisse's later work. Together, these details suggest that the real subject of the interior is art making. If so, the

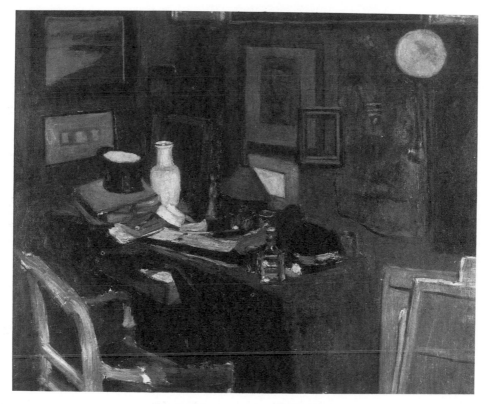

INTERIOR WITH TOP HAT (Paris, 1896).
Oil on canvas, 31½″ × 37½″.

painting anticipates Matisse's *The Red Studio*; indeed, *Interior with a Top Hat* includes many of the same motifs that will appear in that 1911 masterpiece. It depicts Matisse's paintings hanging on the studio wall, other canvases stacked against the wall, and several empty frames. The black/white opposition set up by the top hat and vase is reiterated in the contrast between dark bronze and the white plaster sculpture in *The Red Studio*'s upper right corner.

In the spring of 1897, Simon Bussy introduced Matisse to the elder Impressionist Camille Pissarro, and with Pissarro Matisse saw the Impressionist and Postimpressionist works in the Caillebotte bequest to the

state, which had recently been installed in the Luxembourg Museum. Inspired especially by Monet, Matisse now lightened his palette and began to work outdoors in an Impressionist manner. This plein air procedure did not last long: Matisse was a painter who needed to be enclosed in the protection of his studio, and his methods were always more laborious and less direct than those of the Impressionists. He worked toward spontaneity rather than being propelled by it at the outset.

His *The Dinner Table* (1897), in which Caroline Joblaud plays the role of a servant preparing a table for lunch, reveals the influence of Impressionism in its fascination with the play of light on objects and in its areas built up out of many small strokes of bright pure color (plate 1). The maid leans over an opulently set table to give the flower arrangement a final touch, just as Matisse might have given a reflection on a wine glass a final dab of white paint. With an aesthetic sense and a belief in the importance of meals that is typically French, the maid (and Matisse, because he is the one who really set this table) attends to all the comforts of bourgeois life. A delicious suspense that rides the still moment before the diners enter is enhanced by the sparkle of silver, crystal, porcelain, and fruit.

When *The Dinner Table* was exhibited at the Salon de la Société Nationale, Matisse's fellow members were upset. The painting was deemed to be in the Impressionist style and, to conservative tastes, Impressionism was still radical. Moreau—who had been the painting's instigator when, in the fall of 1896, he suggested to Matisse that after five years under his tutelage it was time to demonstrate his mastery with a large and ambitious composition—now defended his student's canvas, saying that the "decanters are solidly on the table and I could hang my hat on their stoppers."

Unhappy with the adverse criticism, Matisse was more anxious than ever to find his own direction: "I decided to allow myself a year's respite. I wanted to reject all restraint and paint as seemed best to me. Before long there came to me, like a revelation, a love of the materials of painting for their own sake." He realized that Impressionism was not his path. He wanted to follow Moreau's advice to pursue his inner vision. As he saw it,

"Nature is simply an opportunity for the artist to express himself." He felt he could no longer turn to the Louvre for inspiration: "I wanted to create something out of my own experience. . . . I wanted to see beyond their [the Impressionists'] subtle gradations of tone. . . . In short, I wanted to understand myself."

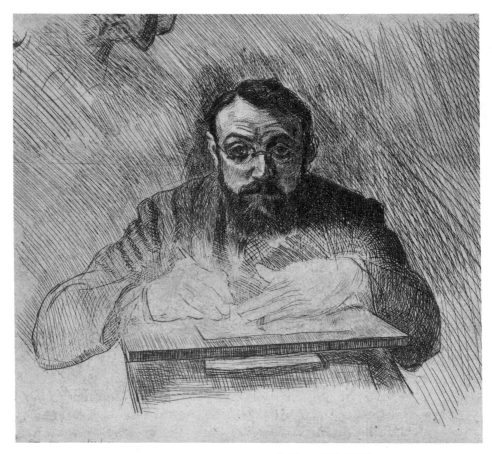

SELF-PORTRAIT AS AN ETCHER (Paris, c. 1900–1903).
Drypoint printed in black, 5 ⁵⁄₁₆″ × 7 ⅞″.

MATISSE, THE MADLY ANXIOUS

y the autumn of 1897, Matisse's relationship with Caroline Joblaud was over. Earlier that year, perhaps realizing that his life with the woman whom his friends called *sa femme* would soon end, he had legally recognized his daughter. Why they separated and what happened to Joblaud, who lived until the mid-1950s, is not recorded. Unlike Picasso, whose personal life is revealed in biographies, Matisse remains opaque. Like Matisse himself, his family and intimate friends have set great store on propriety and discretion, and have emphasized the reality expressed in his art over the details of his romantic life.

We do know that in late November or early December of 1897 at a friend's wedding, Matisse met Amélie Nóemie Alexandrine Parayre, a tall, slender, and nearly beautiful woman from the south of France. Matisse was twenty-nine; born on February 16, 1872, Amélie was two years younger. In the following years, her wide-set, almond-shaped brown eyes beneath high-arched eyebrows, her long nose, firm mouth, and mass of brunette hair swept up in a bun would inspire many of his paintings. Their courtship

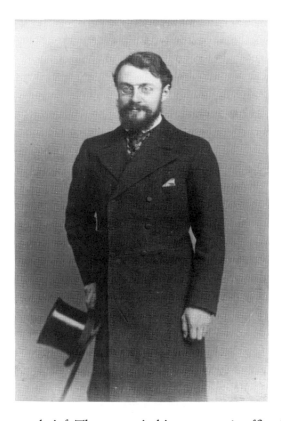

MATISSE AT THE TIME
OF HIS MARRIAGE TO
AMÉLIE PARAYRE, 1898.

was brief. They married in a mayor's office in Paris on January 8, 1898. The civil marriage was followed on the same day by a religious ceremony.

Madame Matisse was charming, vivacious, intelligent, and totally devoted to Matisse and to his art. In 1935 Matisse described her this way: "Madame Matisse was a very lovely Toulousaine, erect, with a good carriage and possessor of beautiful hair that grew charmingly, especially at the nape of the neck. She had a pretty throat and very handsome shoulders. She gave the impression, despite the fact that she was timid and reserved, of a person of great kindness, force and gentleness." She might have been gentle, but when standing up for something she believed in, she could be fierce. She was proud of being the granddaughter of a Spanish pirate; no doubt she identified with his boldness, and recognized her own core of persevering strength.

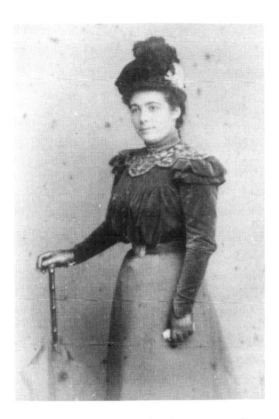

AMÉLIE PARAYRE (MADAME MATISSE)
IN AJACCIO, CORSICA, 1898.

In Matisse's continuing years of penury Amélie Matisse worked as a milliner to help him financially. Her spiritual support was essential as well; she took it upon herself to calm him during his attacks of anxiety. A life-long insomniac, he would wake her up in the middle of the night, and she would talk with him or read out loud until he fell asleep. If, seeing his eyes close, she put the book down, he would often order, "Keep reading." Sometimes when he could not sleep they would walk to nearby Saint-Germain-en-Laye, take the train to Paris, and spend the night in a hotel near the train station. Amélie Matisse seems never to have complained that the center of Matisse's life was his art and everything, even family life, was subordinated to it.

After a brief honeymoon in London, where Matisse had been advised by his friend and mentor Pissarro to study the landscapes of William

Turner, the couple spent a year in the South, first in Corsica and then in and near Toulouse, where Amélie's parents lived. Matisse was relieved to have escaped the pressures of the Paris art world. Also, though he was a northerner, he was almost allergic to Paris's damp, gray, dark winters: indeed, his writings show that sunshine was crucial to his happiness and to his art. It is even possible that Matisse suffered from what is now called seasonal affective disorder and was one of those people whose mood can be lifted out of depression by exposure to sunlight.

His first experience of Mediterranean light was liberating. "I went to Corsica one year," he recalled, "and it was by going to that marvelous country that I learned to know the Mediterranean. I was quite dazed by it all; everything shines, everything is color and light." A new energy and emotional intensity propelled his art out of the conservative Impressionism of *The Dinner Table* and into an expressionist mode that was at the forefront of modernism and is sometimes called proto-Fauve. The paintings he made in Corsica are ablaze with light and colors that record his feelings, not just his observations. Brush strokes are more spontaneous and, instead of simply describing objects or light in space, are independent shapes in themselves. Matisse recalled his exhilaration with his paintings' emotional directness: "I worked only for myself. I was saved."

For his vigorously brushed sunsets and sunflowers, Matisse drew inspiration from van Gogh, whose paintings he had studied in an 1897 exhibition at Ambroise Vollard's gallery; the new freedom in his art was prompted also by Pissarro, who advised him, "Paint the essential character of things. . . . Don't be timid in front of nature: one must be bold at the risk of being deceived and making mistakes." No doubt Matisse's headlong, luscious paint strokes also express the tumultuous and heightened perceptions of someone in love.

After half a year in Corsica, the Matisses stayed with Amélie's parents near Toulouse, where in January 1899 their first son, Jean, was born.

When the family returned to Paris with their newborn baby in February 1899, they moved back into Matisse's apartment at 19 quai Saint-Michel. Although Matisse had now been studying art for almost a decade, he felt he

had more to learn, so he went back to the École des Beaux-Arts. While Matisse had been away, Moreau had died. Under Fernand Cormon, the academic painter who had replaced Moreau, the atelier was no longer the lively place it had been. Matisse's friends Marquet and Camoin soon recognized the change. "Let's get out of here," Marquet said to Camoin. "It's much more fun to paint omnibuses!" Matisse, the diligent one, did not leave school with his friends, even though Cormon disliked his work, which in 1899 was moving from the high-key proto-Fauve style to cooler, more planar compositions influenced by Cézanne, whose work he had been studying at Vollard's gallery since 1897. At the end of 1899, Cormon ordered Matisse to leave the school on the grounds that he was over thirty.

To the end of his life Matisse was vociferous in his antipathy to the École des Beaux-Arts: "Attendance at the École should be replaced by a long free stay at the zoological gardens," he pronounced, and he recalled that his Beaux-Arts teachers had taught "the dead part of tradition, in which all that was not actually observed in nature, all that derived from feeling or memory was scorned and condemned as bogus."

Matisse found various studios where he could work from live models with or without instruction. For one month in 1900 he returned to the Académie Julian, where he was humiliated when he found one of his drawings covered with scribbles, a typical prank perpetrated by old students on a new student. His serious approach to his work and his work's modernity alienated people, making him feel, he said, like a "typhoid carrier." Beginning in September, he worked briefly at the Académie Camillo, where Eugène Carrière—that painter of murky gray and brown figure compositions—would come to give correction. Here Matisse was soon recognized among students as a leader. His message to his colleagues was to revere Cézanne, whom he called "the father of us all." Matisse's figure paintings from 1900 reveal the constructive brushwork, faceted modeling, and blue tonality of Cézanne. In 1949, remembering his apprentice years, Matisse said, "In modern art, it is indubitably to Cézanne that I owe the most."

Carrière respected and liked Matisse (he later said to him, "When you were in my studio I sensed that you had your own idea and I didn't want to

go against you") but he didn't understand Matisse's work, and his comment that it was "a bit like dyework" upset the vulnerable Matisse, who took his revenge. Recalling Jean-Louis Forain's remark that one of Carrière's shadowy paintings of children looked as if someone in the room were smoking, Matisse cried out in the middle of class, "The stove is smoking. Open the windows!" Later he said that he had not meant to be "really nasty."

Some time in 1900 before his atelier closed because of lack of enrollment, Carrière recommended that Matisse show his drawings to the well-known sculptor Auguste Rodin. Matisse later recalled the visit: "Rodin, who received me kindly, was only moderately interested. He told me I had facility of hand, which wasn't true." Rodin said Matisse should make his drawings more detailed: "Fuss over it, fuss over it. When you have fussed over it two weeks more, come back and show it to me again." Feeling misunderstood and not finding this advice helpful, Matisse never went back. "My work discipline was already the reverse of Rodin's," he said. Rodin, he explained, would detach the hand of a sculpted figure from the arm in order to work on the hand's details. By contrast, Matisse saw things in wholes, not parts: "Already for myself I could only envisage the general architecture, replacing explanatory details by a living and suggestive synthesis."

At this time Matisse began to study sculpture in the evenings at the studio of La Grande-Chaumière under Antoine Bourdelle. From now on, sculpture would provide Matisse not only with an alternative to painting but also with a way of solving certain problems in painting. Matisse's sculptures, mostly small nudes cast in bronze from clay originals, have a wonderful interplay between the vitality of the model, the artist's acute and energetic observation, and the evidence of the artist's fingers modeling the clay. "I took up sculpture," Matisse said, "because what interested me in painting was a clarification of my ideas. . . . That is to say it was done for the purpose of organization, to put order into my feelings, and to find a style to suit me. When I found it in sculpture, it helped me in painting." The physicality of modeling in clay, where his fingers seemed to find the volume rather than his imagination searching out the image, was a steadying influence.

The Serf (1900–1904), which depicts Rodin's Italian model Bevilaqua, is in part Matisse's answer to Rodin's *Walking Man* (for whose legs Bevilaqua served as model). And, with its firmly planted stance, the figure bears a resemblance to Rodin's stout and energetic *Balzac* as well. But unlike Rodin, who used a more naturalistic, anatomical approach, Matisse saw the surface of the model's body in terms of patches of light and color, as if he were forming the figure out of Cézannesque brush strokes and areas of *passage* (those elisions between colored planes that allow the viewer's eye to slide laterally between shapes that are differently situated in

THE SERF (Paris, 1900–1904). Bronze, 37⅜″ × 13⅝″ × 13″.

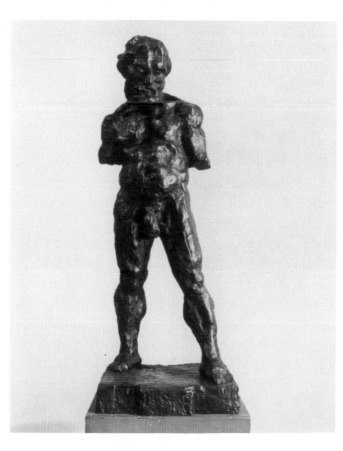

terms of depth). Indeed, *The Serf* parallels Matisse's contemporaneous and Cézanne-inspired painting of Bevilaqua, *Male Model*, in which flesh is faceted into colored planes that interact with planes forming the background so that the eye integrates surface and depth.

For all its vigorous sensuality, *The Serf* is depicted as if lighted upon by the eye, not touched by the hand. Like Matisse's later sculpture, it is a sculptural realization of a painter's perception of volume. In any medium, giving substance to his vision was for Matisse a ferocious struggle, and *The Serf* took over five hundred sittings. Speaking of his sculpture in general, Matisse said, "It was always in view of a complete possession of my mind, a sort of hierarchy of my sensations that I kept on working in the hope of finding an ultimate solution."

Meanwhile, in these years after his return to Paris, Matisse was having terrible financial problems. By June 1900, when his second son, Pierre, was born in Bohain, he had a wife and three children to support, for his six-year-old daughter Marguerite had come to live with him. (She was adopted by Madame Matisse, who soon loved her as if she were her own child.) Matisse's paintings were not selling—to conservative tastes they seemed wild. Even Matisse's friend Henri Evenepoel, who had been a fellow student at Moreau's studio, said that the Corsican paintings looked as if they were painted by "a mad and epileptic impressionist." Matisse sent four still lifes to the Salon de la Société Nationale, but his work was badly received, and this was his last participation in that Salon.

To help support the family, Amélie Matisse opened a millinery shop in October 1899. Like Matisse's mother she had a good sense of materials and patterns; her efficiency, patience, neatness, and thrift suited her for the job. However, although she kept her shop until the spring of 1903, childbearing and illness often made her unable to work. She also looked after the children and the house, and served as Matisse's principal model.

Posing for Matisse was not an easy task. He was often in agonies of doubt when he painted. He would talk to himself about the work in progress, as if his words provided encouragement. Frequently he experienced panic: he perspired, trembled, cursed, and wept. Beginning a work

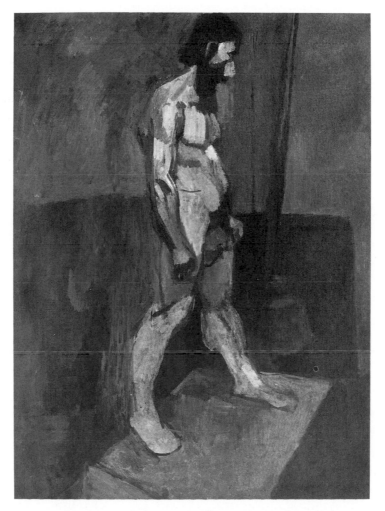

MALE MODEL (Paris, c. 1900). Oil on canvas, 39⅛″ × 28⅝″.

was especially tense. Later a friend recalled that sometimes he would stand in front of a blank paper or canvas for ten minutes, then get up and say, "I'm going to smoke a cigarette to calm myself." Other times he would say, "Quick, give me a pencil! The bubbles are popping!" Or he would contemplate his model, trace his conception of her in the air with his finger, then say "Zut! If I had been holding a brush, it would already be done!"

Matisse called painting a "prisoner's job" or "this lousy métier." To concentrate, he demanded no distractions. Madame Matisse had to be a strict disciplinarian. The children were told to keep quiet at meals so as not to agitate their father. As his daughter recalled, "The whole family revolved around the labors of the father." And Matisse was totally focused on his art: "He could think of nothing else." Perhaps to be close to him, Marguerite served frequently as his model, and when she grew up she often played the role of secretary as well. Matisse's powerful effect on his children is revealed in the fact that all three of them thought of becoming artists. Jean actually did become a sculptor, and Pierre became a prominent art dealer.

Matisse's demanding nature is revealed in an incident that took place in 1903 while Madame Matisse was posing for *The Guitarist*, a small picture in which she wears a toreador's costume and plays a guitar—an image possibly inspired by Manet's *Victorine as an Espada,* in which the model Victorine Meurent is dressed like a bullfighter. Amélie's legs began to cramp from holding the same position for so long. Matisse was aware of her impatience:

> I, on the other hand, was absorbed in my work, quite silent and often intense as a result of the effort I was making. Suddenly my wife gave a quick pluck at the strings: ding, ding. I let this pass without comment. After it had happened several times, I realized that it was getting on my nerves. I told her so with all the gentleness of a person who is holding on to himself. Finally, when my wife repeated the same sign of exasperation as a sort of unconscious form of relaxation, I gave a vigorous kick against the bar of my easel which was oblique and very lightweight. The bar broke in two with a loud noise, the easel fell down as did also the canvas and the oil cup which splattered everything. At this moment my wife threw the guitar on top of the other things with a gesture that was as quick as what had gone before. The guitar did not break, but we burst out laughing. This relaxed our nerves and united us in our gaiety as we had been united in our tension.

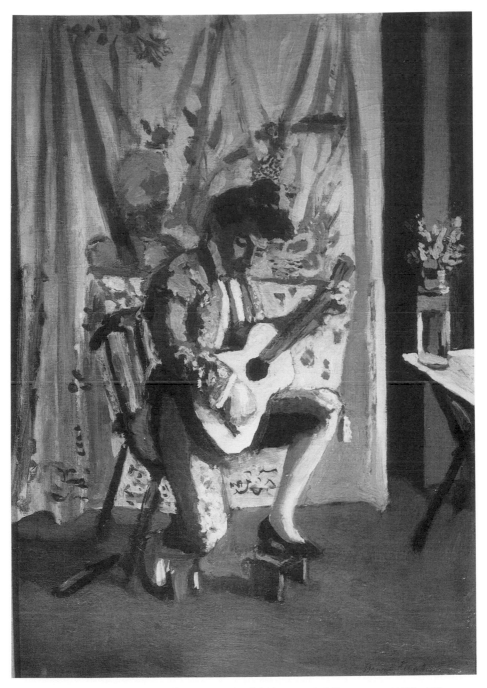

THE GUITARIST (Paris or Bohain-en-Vermandois, c. 1902–3). Oil on canvas, 21½″ × 15″.

Although Matisse was desperate about providing for his family, in the summer of 1899 he bought a small painting of three bathers by Cézanne from Ambroise Vollard, who owned numerous Cézannes and who had given Cézanne his first show in 1895. From Vollard he also bought a van Gogh drawing and a plaster bust by Rodin. In addition, he acquired a Tahitian painting by Gauguin by exchanging one of his own paintings for it with Vollard. Then in May 1900, Matisse purchased two Odilon Redon pastels from Durand-Ruel's Redon exhibiton. Gertrude Stein, who met Matisse a few years later (and who was ever alert to his selfishness and inventive in her anecdotes about him), said that the Cézanne was paid for by the sale of his wife's large sapphire engagement ring. Matisse denied this.

Family legend has it that Amélie Matisse did not at first understand Cézanne's *Three Bathers*. After living with it for a long time, she suddenly saw it afresh when it was temporarily removed from the wall and rehung. She then told Matisse that this painting had taught her to appreciate modern art, implying that her husband's paintings had failed to do the same.

Observing his drastic economic situation, friends advised Matisse to sell the Cézanne, and there were moments when he was tempted. But to Matisse, Cézanne was "a sort of god of painting," and the small canvas was necessary as a talisman to him. Respecting this need, when Vollard offered to buy *Three Bathers* back for half of what Matisse asked, Amélie Matisse advised her husband to keep the painting, which he did. "In moments of doubt, when I was still searching for myself, frightened sometimes by my discoveries, I thought: 'If Cézanne is right, I am right'; because I knew that Cézanne had made no mistake." Thirty-seven years later, when Matisse gave his Cézanne to the Musée du Petit Palais in Paris, he said of the canvas, "It has sustained me morally in the critical moments of my venture as an artist; I have drawn from it my faith and my perseverance."

In 1900, however, Matisse's distress over his economic situation was made worse by his fear that his father's disapproval of his experiments with modernism would cause him to cut off his allowance. At one point he and the equally penurious Marquet formed a plan to paint agreeable paintings to sell to tourists on the rue de Rivoli. A painting of swans that

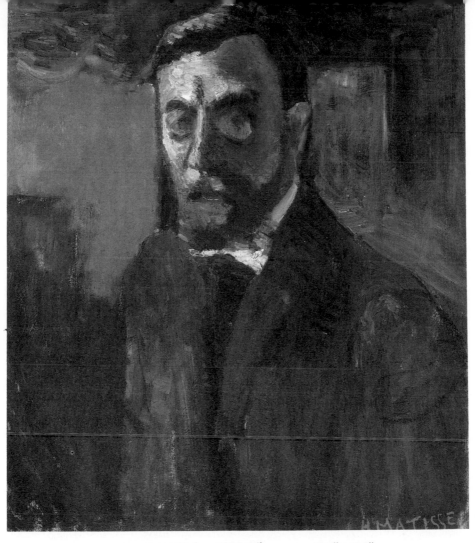

SELF-PORTRAIT (Paris, c. 1900). Oil on canvas, 21⅝″ × 18⅛″.

Matisse produced so disgusted him that he destroyed it. In the winter of 1900, the two friends went looking for work, and finally they took jobs painting garlands to decorate the recently built Grand Palais, which was being made ready for the 1900 Universal Exposition. It was tedious work, and it had to be done in a squatting position in a cold workshop for nine hours a day under the supervision of a boss whose nickname was Jambon (which means *ham*), and who was ready to fire anyone whose productivity flagged. The other workers on the job teased Matisse, calling him "the doctor" because he was so dignified and serious. One day when Matisse

was particularly gloomy, Marquet looked at his watch and said, "Courage, old boy, only seventeen quarters of an hour to go. Nine hours a day at a franc an hour. What more could we ask?" Matisse growled back, "Shut up Albert or I'll murder you." Another time, Matisse was in a better mood, and his whistling prompted Jambon to call out, "Hey, Doctor, I see you're enjoying yourself." According to Matisse he answered, "A fat chance of enjoyment here!" and was fired on the spot. The truth is, however, that he came down with a cold that turned into bronchitis and quit the job after a week.

Matisse's misery is reflected in a *Self-Portrait* (c. 1900) that combines a planar treatment inspired by Cézanne with a fin de siècle gloom that recalls Edvard Munch. The artist's overlarge, insomniac eyes (possibly covered with rimless lenses, though no frame is indicated on the bridge of his nose) look at us but do not connect with us: they are the lonely, shadowy eyes of one who is depressed. They seem to stare backward into his head rather than engaging the world.

Matisse's bronchitis persisted, and in the winter of 1901 his father took him to convalesce in the Swiss mountains west of Lake Geneva. During their weeks there, Émile-Hippolyte tried to persuade his son to find a better way to make a living. When Matisse refused to give up or to change his painting, he and his father fought. Even the boldly painted turbulent oil sketches of blue mountains that Matisse made in Switzerland triggered his father's anger.

After Matisse returned to Paris, he made no effort to tone down his paintings in order to make them more acceptable to buyers. Instead, encouraged by his new friendships with André Derain (whom he had met at the Académie Camillo in 1899) and Maurice Vlaminck (whom Derain introduced to Matisse at a 1901 van Gogh retrospective at the Berheim-Jeune Gallery), he became even more radical. These younger artists' energetic brushwork and bright color attracted him and made him feel that he had at last found companions who thought along lines similar to his own.

In the spring of 1901, Matisse sent ten loosely painted works to the Salon des Indépendants, which since its inception in 1900 served as an

arena for the avant-garde, and which was presided over by the Neo-Impressionist Paul Signac, whose book *From Eugène Delacroix to Neo-Impressionism* Matisse had read with great interest two years earlier. At this point Matisse was so poor that he and Marquet had their canvases transported to the Salon in a wheelbarrow pushed by Bevilaqua, and when they picked them up at the Salon's closing they considered staging an accident that would destroy their paintings so that they could collect insurance money. During the Salon exhibition, critics lambasted Matisse's work, calling his sketches "absurdities" and "blemishes." Nothing sold, and Matisse's father, seeing that his son was not moving in a reasonable direction, canceled his allowance.

In 1901 Marguerite became ill with diphtheria and had to have a tracheotomy to save her life. Amélie Matisse was worn out and anemic. Frayed with tension, Matisse wrote to Manguin: "I have been rather ill (3 weeks without sleep)." He went on to express his hopes of "slipping off to the South for a bit of rest." Instead, that winter Matisse took his family north to live with his parents in Bohain for several months. The rest of the time, the family subsisted mostly on rice brought back from his father's store after family visits. Matisse found it difficult to pay for and then not eat the fruit he used for still-life paintings. He kept the fruit in a cold room in his apartment so that it would last longer. Still, he held on to his Cézanne. The situation was so desperate that for a period of some months (and for frequent visits in the ensuing years) he sent his two-year-old son, Jean, to live with his parents in Bohain and his baby, Pierre, to stay with Amélie's family in Toulouse and then with her sister, a schoolteacher who lived in Corsica. This saved money on food bills and allowed Amélie time to pose for Matisse and to take care of her shop. Marguerite, whose health was fragile, continued to live at home.

In the spring of 1902, Matisse exhibited again at the Salon des Indépendants, and this time he actually sold a still life for 400 francs. In February of that year, he and a few friends from Moreau's studio, including Marquet, exhibited at the tiny gallery of Berthe Weill, a courageous but far from prosperous dealer who had given Picasso his first exhibition in 1900 and

who in the next few years would bring together and exhibit the core of the group that would come to be called the Fauves. (When Berthe Weill showed the Moreau group again in 1904, Camoin and Manguin were included as well, and in 1905 she added Derain, Vlaminck, and Dufy to the roster.) Two months after the February 1902 show, Weill sold a Matisse—his first canvas sold by a dealer—for 130 francs. These occasional sales gave encouragement, but they did little to solve the Matisse family's worsening financial problems.

During the winter of 1902–1903, Matisse was so poor that he, Amélie, and the three children again went to live with his family. "I am immobilized in the country on a strict restorative diet, and hardly working at all," he wrote to Manguin on February 3, 1903. Living with his parents was miserable: although Matisse adored his mother, he and his father were still not getting along. The tension, Matisse wrote to Bussy five months later, "has a bad effect on me, or on my work, for which I need the greatest calm and evenness of temper in the people I live with, which I am far from finding here . . ." During this period, Matisse's landscapes became darker, more restrained, and less experimental. In his July letter to Bussy, he wrote that he had returned "to the soft harmonies and close values that will certainly be better received by collectors, and even by the salon officials." Around this time, in the hope that his work would sell, he made an even more drastic compromise: he produced several paintings with anecdotal subjects, such as a meditating monk, or the popular actor Lucien Guitry playing the role of Cyrano de Bergerac. Admitting that he was "thinking like a shopkeeper," he explained, "I have a wife and three children to think about."

Another of Matisse's money-making schemes in 1903 was to establish a syndicate of twelve art collectors who would guarantee him an income in return for paintings. Only a cousin was interested, and the plan collapsed. At one point in that same year, Matisse applied for an administrative job at the Department of the Seine. One of a hundred applicants for three government office jobs, he was not hired. There came moments of total despondency when he thought about giving up painting. "If I could I'd throw painting to the dogs," he wrote to Manguin early in July 1903. A few weeks later he recovered his spirits and wrote, "Fortunately, perhaps, I

have again got a grip on myself, once again confident of my profession as an artist: its delectations have often made it possible for me to bear life and whatever bitterness it has already had in store for me." But his confidence was gone by the end of July when he wrote to Simon Bussy of the hardship of a painter's life. Quoting another friend, he said, "In order to be a painter, one must be unable to do anything else." Perhaps his father's arguments against an artistic career were sinking in, for his letter went on to say that he felt he could do something else and that he had done enough for painting. Made morose by the Northern winter, he also expressed his longing for the South: "You speak of going to the Midi. It is, alas, my fondest dream but, my dear friend, what can you do without money? I think that in the South I could do twice as much as in the North where the winter light is so bad. Perhaps that will come later."

Studio under the Eaves (c. 1902), which Matisse painted in a small attic studio in his parents' Bohain home, reveals his gloom and his yearning for light (plate 2). The low-ceilinged, claustrophobic room is almost all dark brown. Two narrow windows in the eaves and a window in the end wall let in patches of light. Light falls on a container that holds his paintbrushes— Matisse's principal source of strength—but the flowers set on his work-table are shadowy and have no color. In 1903 he wrote to Manguin of this "prison they call the artistic life," and he said, "All my labor only leads me to cry out my impotence more and more loudly." Yet Matisse was stubborn; he kept on struggling.

The bright sunny view of trees outside the open window in *Studio under the Eaves* expresses his will to escape from the dark interior. This need to rejoin the world through looking out must have been intense in Matisse, for open windows would become a favorite subject in his art. Since windows are rectangular, like the canvas on which they are depicted, and since they frame real space just as a canvas frames an illusion of space, open windows have been interpreted as metaphors for painting: it was through painting that Matisse looked out and joined the world. In *Studio under the Eaves,* the canvas on the easel is positioned in such a way that it actually touches (by overlapping) the window's landscape view, thus

linking the idea of the painted image with the image seen out of the window. Although we see only the back side of the canvas, we can imagine that the bright light falling on the foliage outside is reflected on its hidden surface. In his later paintings of open windows, Matisse seems to bring the outside inside so that nature penetrates a room's interior. By contrast, in *Studio under the Eaves* there is still a clear division between inside and outside, and the light and air outside hardly enter the dark room.

Both his anguish during these so-called dark years and his refusal to give up appear in his *Self-Portrait as an Etcher* (c. 1900–1903), in which Matisse's furrowed brow and pinched mouth look worried and determined (page 28). His hands, shown working on the etching plate, are huge and bright, as though the creative process gave him superhuman powers. With fearful concentration he leans forward, almost clinging to his worktable as if it were a life raft. Matisse wrote to Simon Bussy of his loneliness in 1903: "I have no contacts," he said. "I always live rather apart from everyone." Yet solitary artistic endeavor was what saved Matisse. To the same friend he said, "When my back is to the wall nothing can stop me."

For about half a year starting in July 1903, Matisse lived in Lesquielles-Saint-Germain, a small village near Bohain where he was free of the tensions that came with living under his father's roof and where he could support his family more easily than in Paris. Early in 1904 the Matisse family returned to their 19 quai Saint-Michel apartment. Here Matisse became less isolated. He had his artist friends, he was gaining a reputation as a vanguard painter in the Paris art world, and his work was getting more regular public exposure. In 1904 he was made adjunct secretary to the Salon des Indépendants, where he had exhibited for the last three years. In June 1904 Matisse had his first one-man exhibition at Vollard's gallery, which presented forty-five paintings dating from 1887 to 1903. The show was neither a financial nor a critical success, and Vollard bought only one work, *The Dinner Table,* for 200 francs. (He sold it a short while later for 1,000 francs.)

In 1904 Matisse accepted Paul Signac's invitation to spend the summer in Saint-Tropez. The older man, whom he had come to know through the

Salon des Indépendents, lent him a house near his own large villa. For Matisse, experiencing the Mediterranean light again was like getting out of that dark studio under the eaves and into the sunshine outside the window. He stopped using brown underpainting and lightened his palette.

The most venturesome painting from that summer is *The Terrace, Saint-Tropez*. Although the painting's structure looks casual, Matisse carefully divided the canvas along a diagonal and placed on the left the natural world of vegetation, beach, and sea, and on the right Amélie Matisse

THE TERRACE, SAINT-TROPEZ (Saint-Tropez, 1904). Oil on canvas, 28¼″ × 22¼″.

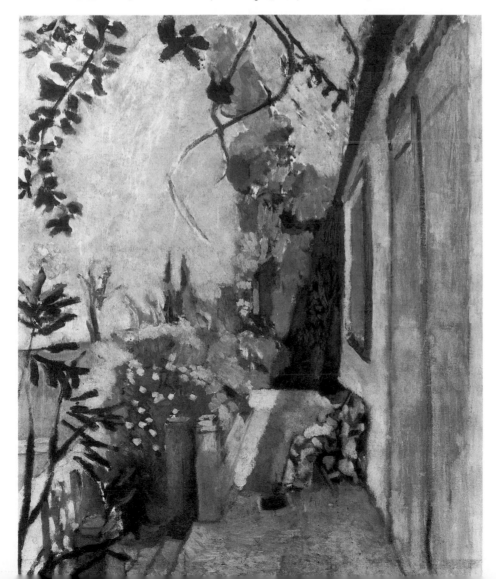

wearing a kimono and sitting with her sewing in the shade of Signac's boathouse. As always, Matisse links near and far, this time by making the lines that define trees in the distance continue in arabesques of foliage in the foreground. The scene captures a restful and private moment, with the golden beach and the calm blue sea available at a glimpse through a profusion of blossoms.

Yet Matisse did not feel as peaceful as this painting suggests. Noting his artistic struggles, the Neo-Impressionist painter Edmond Cross, who lived nearby and was a close friend of Signac's, called him "Matisse the anxious, the madly anxious." Indeed, despite his initial joy, Matisse was overwhelmed by the Côte d'Azur's dazzling sunlight. In the Midi, which he had called his "fondest dream" in his letter to Bussy, he suffered from the heat. He painted little, and the only painting that pleased him, he said, was a small number fifteen canvas "painted at sunset." In August he wrote to Manguin, "I think painting will drive me crazy. So I'm going to try to drop it as soon as I can."

Even though Matisse had been busy absorbing the influence of Cézanne, he was affected by his conversations with Signac and Cross, whom he later called "theoreticians of Divisionism." Yet Matisse did not become a Neo-Impressionist, and, seeing this, Signac took umbrage. Signac found *The Terrace, Saint-Tropez* to be so boldly painted, so different from the Neo-Impressionist method of carefully dividing the perceived world into thousands of dots of pure color, that he realized Matisse was not really a disciple. The two quarreled, and Madame Matisse had to take her husband for a walk on the beach to calm him down. Since for Matisse the best way to cope with inner turmoil was to work, he took along his paints, and right there on the beach he began *The Gulf of Saint-Tropez*, a small landscape with the figures of his wife and his son Pierre sitting on a beach that glows red from the setting sun. Composed of myriad colored marks, the painting does seem a nod to Neo-Impressionism, but as always, Matisse's strokes vary in size and change direction according to the object they depict and his feeling about that object. Surely *The Gulf of Saint-Tropez* is the sunset landscape Matisse professed to like and said took over ten sit-

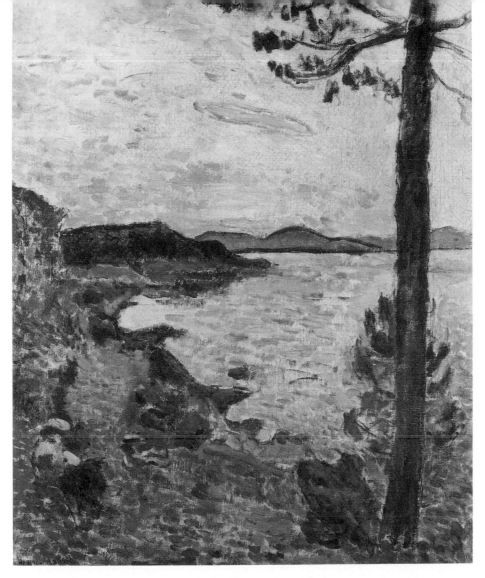

THE GULF OF SAINT-TROPEZ (Saint-Tropez, 1904). Oil on canvas, 25 ½″ × 19 ⅞″.

tings: "I still can't believe I did it. . . . It seems to me it was by accident that I hit on the result."

That autumn, this landscape became the basis for *Luxe, calme et volupté*, a large-figure composition in which Matisse did come close to Neo-Impressionist Divisionism (plate 3). Here, except where red arabesques define a figure's curves, the strokes are much more regular than those in *The Gulf of Saint-Tropez*. When *Luxe, calme et volupté* was

49

shown at the Salon des Indépendants in 1905, Signac liked it so much that he bought it and hung it in his Saint-Tropez villa.

The painting's title comes from "Invitation to the Voyage," a poem by the French Symbolist Charles Baudelaire in which the poet invites his love to come on an imaginary journey to an ideal, carefree land where "everything is order and beauty, / luxury, calm and voluptuous delight." *Luxe, calme et volupté* is the first major painting in which Matisse worked from his imagination rather than from the observation of nature. In it, he invented an idyllic world, an earthly paradise where naked women enjoy leisure on the seashore and where the sun, so important to Matisse, constantly shines. No doubt he was influenced in his choice of subject by his treasured painting of female bathers by Cézanne. But Matisse's image is warmer and more emphatically joyous.

The nudes luxuriating in the sun are made to seem all the more timeless and ideal by the presence of a clothed figure, who is in fact taken from the representation of Amélie Matisse in *The Gulf of Saint-Tropez*. Madame Matisse presides over a tablecloth spread on the sand and set with teacups, but this is not a tea party: the nudes do not really share her company. The only connection between her and them is that one recumbent nude holds a teacup—astonishingly mundane behavior for a nymph from the Golden Age! The odd juxtaposition of clothed and unclothed women captures a conflict that was to give tension to all of Matisse's art, the conflict between the seen and the imagined, the real and the ideal. "I cannot copy nature in a servile way," he said in 1908. "I am forced to interpret nature and submit it to the spirit of the picture." Years later in his *The Music Lesson* (1916), Matisse again juxtaposed the clothed Madame Matisse with a voluptuous nude: this, no doubt, was another tension in Matisse, the conflict between the bourgeois propriety that came with his strict Northern upbringing and his urge toward the *volupté* of the Mediterranean south.

Matisse imposed an ideal harmony on *Luxe, calme et volupté* by organizing the composition according to the classical proportion called the golden section (in which the short side of a rectangle is to the long side as the long side is to both sides added together). But the painting is far from

calm. Although the image is built up out of an accumulation of little spots of color, Matisse's touch is less methodical than that of the Neo-Impressionists. And his colors are brighter. For him the Divisionist technique of laying down small, equal-sized strokes of a dominant color (for example, green) and then adding similarly shaped strokes of its complementary (red) was just too confining. "I couldn't get into the swing of it," he said. "Once I had laid in my dominant, I couldn't help putting on its reactive color equally intense." In *Luxe, calme et volupté*, a mass of red spots makes the beach red: like Gauguin, who painted a beach pink, Matisse felt no need to record nature's color accurately. His spots do not meld into the grayish white light typical of Neo-Impressionism. Instead they create an overall scintillation that is agitated, not soothing. *Luxe, calme et volupté* vibrates and sings like cicadas in summer. You can almost feel the pulse of light and the heat rising off the sand.

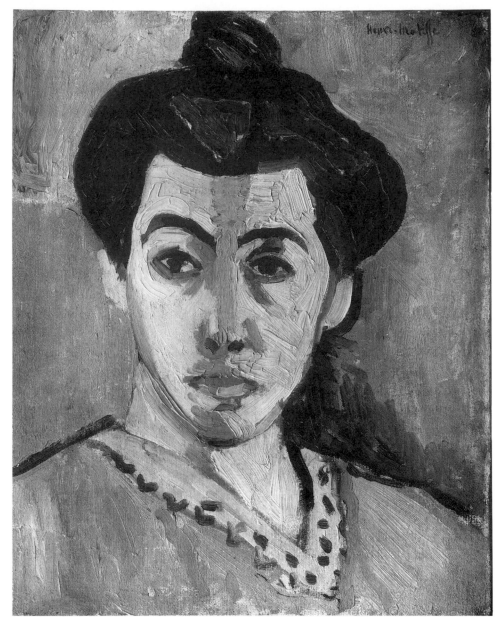

PORTRAIT OF MADAME MATISSE/THE GREEN LINE (Paris, 1905). Oil on canvas, 16″ × 12⅞″.

KING OF THE FAUVES

ith its boat-filled harbor, long curved beaches, and warm sunlight falling on red, blue, and yellow houses, Collioure, a Mediterranean fishing village near the Spanish border, was the perfect setting for a painter who wished to liberate painting through color. When Matisse spent the summer here in 1905, he found the landscape soul-stirring. "All I thought of," he said, "was making my colors sing, without paying any heed to rules and regulations." Together with Derain, who joined him that summer and worked by his side, Matisse invented what would soon come to be called Fauvism, the first avant-garde art style of the twentieth century.

Matisse described the new style as "construction by colored surfaces." It was, he said, "a brief time when we thought it was necessary to exalt all the colors together, sacrificing none of them. Later we went back to nuances, which gave us more supple elements than the flat, even tones." With its tumult of strokes whose sizes and shapes corresponded to the painter's impulse, and with its freely expressive color, Fauvism, as Matisse later said, "overthrew the tyranny of Divisionism." Yet the cautious,

rational side of Matisse's nature never disappeared. Indeed, every stroke in his Fauvist paintings plays a role in the overall interaction of form and color. Every aspect of painting—light, space, color, texture, and shape—joins to create a single effervescence in which figures and landscape merge.

The almost visceral pleasure of paintings like *The Open Window* (1905) comes from their energetic and varied brushwork and from odd yet perfect color choices (plate 4). The wall that surrounds the open window, for example, is blue-green on the left, dark green and blue above, and violet-pink on the right. Such color choices might seem arbitrary, but they answer to pictorial and emotional needs. Matisse described the method by which he freed colors and strokes from the task of accurately recording nature:

> I had a sensation of the coloring of an object: this enabled me to set down my first color, the first color on my canvas. I would then add a second color, and then, instead of painting it out, when that second color did not seem to go well with the first, I would add a third one, intending to harmonize them. And I had to go on like that until I got the feeling that I had created a complete harmony on my canvas and had acquitted myself of the emotion that had made me undertake it.

Like Cézanne, Matisse felt no need to cover every inch of the canvas or to make every mark and every centimeter of surface refer to some precise object in space: in his Fauvist paintings the white of the canvas shines through the intervals between strokes, unifying the picture surface and giving colors room to breathe.

The Open Window looks simple and direct, as though Matisse had glimpsed the sea from his window and painted it in the rush of excitement. Yet its structure, with one rectangle set within and framing the next, is as intricate as a Chinese box. The painting's real subject is the pleasure of being inside and looking out. This liminality had great appeal for Matisse: he could have all the safety, privacy, and control of being in his studio without feeling cut off from the outer world.

If the open-window motif is a reflection on art making, the rectangular view of boats in the harbor, like the spring landscape outside the win-

dow in *Studio under the Eaves,* can be seen as a painting within a painting. But now the view does not seem distant. From this time on, Matisse created spaces that suggest he felt connected to his surroundings. He perceived the world, he said, as a single flux "from the horizon to myself, myself included." Now Matisse's windows open onto views that are available and abundantly present. We do not have to move out to the view. It comes in the window to us.

This is so because the colors do not gray toward the horizon, and they have more or less the same light/dark value both inside and out. As a result, the colors resound from the picture surface; they move out toward the viewer rather than pulling the viewer into depth. Also, we respond to the colors—for example the red-orange masts, the red geraniums, or the red that outlines the window—not just as representing objects in space but as patches of pigment on canvas surface. Thus, we read them as echoing each other across the canvas rather than as receding into deep space. This union of inside and outside, near and far, eliminates longing and creates a feeling of contentment.

In a certain state of happiness everything seems close and connected; the entire expanse of the sky seems to belong to the person gazing at its blue. This sensation of oneness in Matisse's paintings of open windows is achieved by his focus on rendering his emotion. As he said, "This state of soul is created by the objects which surround me and which react in me. . . . For very often I put myself in the picture." Asked by the poet Louis Aragon, who became his friend during World War II, why his paintings of windows had such charm, Matisse said, "Probably from the fact that for me the space is one unity from the horizon right to the interior of my work room, and that the boat which is going past exists in the same space as the familiar objects around me; and the wall with the window does not create two different worlds." What changed between his early window painting *Studio under the Eaves* and *The Open Window* was Matisse's "state of soul." Art was no longer a prison but a supreme form of freedom. He no longer felt so cut off from the world. The open window expressed his feeling of connection between his inner world and the world outside himself:

"Windows," he said, "have always interested me because they are a passageway between the exterior and the interior."

Matisse not only brings the outside in but also moves imaginatively out into nature and brings it into himself. "An artist must possess Nature," he said. "He must identify himself with her rhythm." Another time he put it this way: "My work consists in steeping myself in things. It is by entering the object that one enters one's own skin." Thus, when Matisse painted a harbor view, he would discover himself in the image, and his presence in it makes the image more intimate for the viewer.

Most of Matisse's Fauvist paintings done at Collioure are small landscapes. After he returned to Paris in the fall of 1905, he painted *The Woman with the Hat*, a large portrait of his wife holding an open fan in her gloved right hand and wearing an extravagant hat (said to be of her own design) that looks like fruit and flowers piled in a still life (plate 5). Dwarfed by the hat and the fan, Madame Matisse's face looks diminutive, but her gaze is as alert and direct as that of a fox. The background is composed of abstract patches of color that heighten the intensity of the colors forming the figure. By placing the complementaries red/green and blue/yellow near each other, Matisse sets our eyes rocking. His brusque strokes have an animal energy, as if he were driven by his passionate response to the model—as if, for all Madame Matisse's demure pose, she possessed an electric charge that shocked Matisse into action. "The essential thing," Matisse said, "is to spring forth, to express the bolt of lightning one senses upon contact with a thing. The function of the artist is not to translate an observation but to express the shock of the object on his nature; the shock, with the original reaction."

Looking at this portrait, it is easy to imagine Madame Matisse's commanding presence, her fierce strength, and her pride in being the grandchild of a Spanish pirate. However, this vitality and confidence seem to have drained out of her in portraits made later in her marriage. By 1913, when Matisse made his last portrait of his wife, Amélie Matisse's sensuous proportions have been pared away and her carnal face, bright with color in the 1905 portrait, has become a gray mask (page 102).

Matisse's portraits are far from being exact replicas of what he saw. As

he said in 1909, "The photograph is there to render the multitude of details a hundred times better and more quickly." In spite of the abstractness of the colors (Madame Matisse was in fact dressed in black, and her hair was dark brown, not red) *The Woman with the Hat* captures Amélie's personality. Her character is conveyed less by her primitively rendered features than by relationships of shapes and colors. "Expression," Matisse said, ". . . does not reside in passions glowing in a human face or manifested by violent movement. The entire arrangement of my picture is expressive."

In October 1905, Matisse sent *The Woman with the Hat* and *The Open Window,* along with eight less important recent works, to the liberal Salon d'Automne, founded in 1903. His work was hung in Room VII along with paintings by his friends Derain, Vlaminck, Marquet, Camoin, Manguin, and Rouault. A critic named Louis Vauxcelles, noting in this room a conventional sculpture that reminded him of the Florentine sculptor Donatello, exclaimed with amusement, "Aha, Donatello among the fauves!" The epithet was picked up by other reviewers, and Fauve, meaning "wild beast," became the accepted name for the new avant-garde. Room VII was now called the "central cage," and Matisse (by all appearances the most sober of men) was the undisputed king of the wild beasts.

The public was scandalized by the Fauvist paintings, especially by Matisse's portrait of his wife. Matisse's bright color, his seeming lack of structure, and his impassioned brushwork looked brutal, incoherent, even crazy. One critic called his paintings "the barbaric and naive sport of a child who plays with a box of colors he just got as a Christmas present."

Although Matisse is thought of as a sensuous painter, he seems to avoid the kind of bravura brushwork (one thinks of Frans Hals, Velázquez, and Manet) that gives the viewer the delight of seeing brush strokes first as paint lovingly applied to canvas and then—presto!—as a feather in a hat, lace on a cuff, or a highlight on a lemon. To a viewer looking for luscious brushwork, Matisse's canvases are often disappointingly rough. The parts he left unfinished or scraped away; the *pentimenti* (lines and shapes visible through subsequent overpainting) left blatant for us to see; the extra contour lines that, as in Cézanne's drawings, give evidence of process, search, and doubt;

the patches of unexpected color that seem to land (oddly but quite necessarily) on a forehead, nose, or hand—all these continue to make Matisse's paintings shocking even today. Of course, like everything else with Matisse, this unfinish was deliberate. It allows the viewer to enter, to participate. It reminds us that a painting is an accumulation of marks on a flat surface, and it keeps us alert to pictorial means. About the response to his and his friends' Fauvist paintings, Matisse explained:

> The people who saw painting from the outside were made uneasy by the schematic state of certain details. Hands, for example, . . . We ourselves were preoccupied with the measure of the plastic ensemble, with its rhythm, with the unity of its movement. Thus we were accused of not knowing how to paint a hand or how to draw any other detail. Nothing could be more false. It was simply that the state of our pictorial problem did not permit us to go all the way to the perfection of details.

Salon visitors felt so insulted by *The Woman with the Hat*'s rejection of conventional modes of portraiture that they howled, jeered, and cried, "This is madness!" Some visitors wanted to stab the canvas or scratch off the paint. On the wall of a urinal in the Montparnasse section of Paris, someone scrawled "House painters, stay away from Matisse! Matisse has done more harm in a year than an epidemic! Matisse causes insanity!" On another wall someone wrote, "Matisse makes you crazy, Matisse is more dangerous than absinthe." A group of conservative artists expressed their dislike of such unconventional color choices as the green line that runs down Amélie Matisse's nose in *The Woman with the Hat* by sending to Matisse an ugly woman whose face they had painted with green stripes. Here, they said, was a perfect model for Matisse. The public outcry was so virulent that Matisse visited the Salon only once and forbade Amélie to come at all.

Matisse's portrait was seen as a desecration of women. Years later he defended himself: "Someone called me: 'This charmer who takes pleasure in charming monsters.' I never thought of my creations as charmed or charming monsters. I replied to someone who said I didn't see women as I represented them: 'If I met such women in the street, I should run away in terror.' Above all, I do not create a woman, *I make a picture.*"

He had been aware of the public's incomprehension since before the Salon opened, when its president advised him not to hang *The Woman with the Hat* because it was so "excessively modern." The negative reaction to his work hurt him (Matisse was highly sensitive to bad reviews and untouched by good ones), but he was not daunted. "This has saddened me a great deal," he wrote to Signac, "since it was the first time in my life that I was glad to exhibit, for my things may not be very important but they have the merit of expressing my feelings in a very pure way. Which is what I've been taking pains to do ever since I began painting."

Matisse's dejection over the negative reaction to his work was turned around when he learned that someone wanted to buy *The Woman with the Hat*. The painting was sold for the asking price of five hundred francs (about one hundred dollars) to an American family named Stein. When he visited the Salon, Leo Stein, an amateur painter and collector who had moved to Paris in 1903 and who lived with his sister, the writer Gertrude Stein, was totally taken aback by the portrait. It was, he said, "a thing brilliant and powerful, but the nastiest smear of paint I had ever seen." Leo and Gertrude Stein bought the painting together with their older brother, Michel, a retired businessman who had settled in Paris with his wife, Sarah. Starting with this purchase, the four Steins became ardent collectors of Matisse's work, giving him both encouragement and financial security.

The Matisses became frequent guests at both Stein homes, and through Leo and Gertrude they met many artists and writers of the Parisian avant-garde. Picasso, for example, was to become a lifelong friend and rival. He and Matisse exchanged paintings on several occasions, and well into their old age they continued to discuss art. Soon after the Steins introduced the two artists in 1906, Matisse told Picasso's friend the poet Max Jacob that if he were not painting the way he was, he would like to paint in the manner of Picasso. Jacob said, "Well, isn't that curious. Do you know that Picasso said the same thing about you?" Years later, Matisse told Picasso, "We must talk to each other as much as we can. When one of us dies, there will be some things the other will never be able to talk of with anyone else."

Matisse, reserved and intellectual but also polite and social, talked in a slow, measured way that might have been pedantic were it not for his immense clarity, his honesty, and his sense of humor. Picasso was quick, impulsive, mercurial, a man who spoke little and stood apart. As Picasso put it, they were as different as the North Pole and the South Pole.

Leo Stein noted the difference:

> Matisse—bearded, but with propriety; spectacled neatly; intelligent; freely spoken, but a little shy—in an immaculate room, a place for everything and everything in its place, both within his head and without. Picasso—with nothing to say except an occasional sparkle, his work developing with no plan, but with immediate outpourings of an intuition which kept on to exhaustion, after which there was nothing till another came.

Fernande Olivier, Picasso's mistress during his Cubist years, made a similar comparison: "He [Matisse] was already nearly forty-five and very much master of himself. Unlike Picasso, who was usually rather sullen and inhibited at occasions like the Steins' Saturday gatherings, Matisse shone and impressed people."

Matisse soon became dissatisfied with Fauvism's emphasis on capturing a fleeting response to nature. He wanted to create art that was more solid, permanent, and controlled. The "madly anxious" Matisse was looking for calm. Fauvism's impulsive brushwork, exuberant color, and vibrant light seemed to him agitated and limited. "You can ask of painting a deeper feeling which touches the mind as well as the senses," he said.

Portrait of Madame Matisse/The Green Line, painted late in 1905, shows the change toward a more abstract mode (page 52). Instead of creating an image out of an excited swirl of colored marks that vibrate against the white of the canvas, Matisse now simplified form into broad, flat areas of color that cover the canvas and are contained within firm contours. Light is now created by color alone, not by the canvas shining through. These changes may have been inspired by a visit to the retrospectives of Manet and Ingres at the Salon d'Automne. Manet's way of building a figure out of flat planes of unmodeled color gave Matisse the courage to divide his

GIRL READING (Paris, 1905–6). Oil on canvas, 25⅝″ × 23⅛″.

wife's face into two differently colored halves, with a green line drawn down the center referring to the shadow seen when light falls on the face from one side. The green line may also be Matisse's witty retort to the people who had objected to the green line running down Madame Matisse's nose in *The Woman with the Hat*.

In spite of his move toward a more synthetic "decorative" manner, Matisse continued to make Fauvist paintings: his artistic evolution shows no continuous linear development but rather a back and forth as he experimented with various modes, sometimes in the same month or even on the

same day. Contemporaneous with *The Green Line* is *Girl Reading*, which depicts his twelve-year-old daughter, Marguerite, and is a Fauvist version of the traditional subject he had chosen eleven years earlier for his painting of Marguerite's mother, *Woman Reading*. It is a wonderful motif—one that Matisse painted many times; it suggests that a man can possess a woman with his eyes and love her as an immobile, silent object while she keeps her separateness, her privacy.

In both pictures a female figure, completely absorbed in her book, is shown in an interior that contains still-life objects and paintings on the wall. The earlier canvas is dark and quiet. Color in the 1906 painting is so raucous one wonders how the girl can concentrate. Applied in dabs that sit on the canvas's surface, the colors deny atmosphere and depth. The space behind the reader is made up of patches of pure color—red, yellow, and green—that resemble the abstract color areas that surround Madame Matisse in *The Woman with the Hat*. The difference is that in *Girl Reading* the patches of color are not just part of an undefined portrait background, but rather are interspersed with recognizable objects, and we therefore expect them to create a legible interior space. The abstractness of the background looks forward to the invention of nonobjective art half a decade later by painters such as the Russian-born Wassily Kandinsky, who, inspired by Fauvism, painted abstractions in which colored shapes seem to float in space and are freed from recognizable subject matter.

Later in the same year Matisse painted Marguerite reading again, this time in a more densely painted style reminiscent of Cézanne. A few months later, he painted her portrait in his highly simplified post-Fauve manner, using a solid earth-color background and only a few other flat tones. Here, as in many portraits, Marguerite wears a black velvet ribbon around her neck to hide the scar left by the tracheotomy performed when she was four. The primitivism of *Marguerite* (1906 or 1907), which looks like a child's poster painting, reveals Matisse's admiration for the drawings and paintings made by his children, all of whom painted. The portrait's title scrawled in childlike capital letters across the top shows that primitivism was a deliberate choice. The marvelous combination of naïveté and bold

sophistication must have appealed to Picasso, who, probably late in 1907, chose to take *Marguerite* in his first exchange with Matisse (who chose Picasso's 1907 still life entitled *Pitcher, Bowl, and Lemon*).

Gossips mistakenly said that Picasso selected *Marguerite* to make his rival's work look crude. More likely, Picasso, who was influenced by primitive art himself at this time, admired Matisse's courage in adopting the radical simplification, freshness and vitality of children's art.

MARGUERITE (Paris or Collioure, 1906 or 1907). Oil on canvas, 25 ½″ × 21 ¼″.

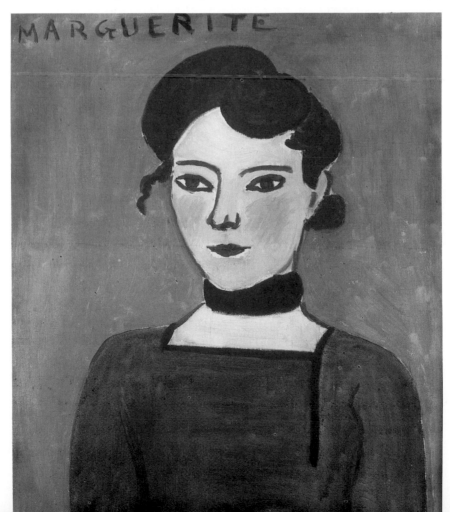

LE BONHEUR DE VIVRE (Paris, 1905–6). Oil on canvas, 68 ½″ × 7′ 9 ¾″.

JOY OF LIFE

or five months beginning in October 1905, Matisse worked on *Le bonheur de vivre* (Joy of Life), the largest painting he had yet made. To accommodate the nearly six by eight foot canvas he rented a studio in Couvent des Oiseaux at 56 rue de Sevres, a building that had once been a convent. *Le bonheur de vivre* began with a Fauvist landscape done during the previous summer at Collioure. After many studies, Matisse moved away from Fauvism and created a highly synthetic, imaginary scene with female nudes set in a clearing in the woods before a distant sea. Like *Luxe, calme, et volupté*, *Le bonheur de vivre* is a vision of the Golden Age, a traditional subject in European art from the bacchanals of Titian, Poussin, and Ingres, to the paintings of nudes by the shore by Matisse's friends Signac, Cross, and Derain. In the years to come, Matisse would continue to alternate between the ideal world of the imagination and the real world of observation. As he put it, "A distinction is made between painters who work directly from nature and those who work purely from imagination. Personally, I think neither of these methods must be preferred to the exclusion

of the other. Both may be used in turn by the same individual." Instead of recording what he called "fugitive sensations of the moment," he wanted "to reach that state of condensation of sensations which makes a painting." In order to do this, he simplified figures and landscape into broad, smooth areas of color: "I painted it [*Le bonheur de vivre*] in plain flat colors because I wanted to base the quality of the picture on a harmony of all the colors in their plainness. I tried to replace the vibrato with a more responsive, more direct harmony, simple and frank enough to provide me with a restful surface."

Matisse's paintings continued to tug at his emotions even after they were finished. "There was a time," he said, "when I never left my paintings hanging on the wall, because they reminded me of moments of over-excitement and I did not like to see them when I had again become calm." Matisse was convinced that his art could affect people's mood, even their health. One friend recalled that when he told Matisse he had the flu, Matisse took his pulse and nailed some of his own paintings to the wall. "I'll come back tonight," Matisse said. "My paintings will keep you company." Certainly for Matisse, making art was a way of balancing inner conflicts. In the 1930s, when the ideas of Sigmund Freud entered the popular mainstream, he would speak of his art as a form of sublimation. In 1908 he wrote, "What I dream of is an art of balance, of purity and serenity, devoid of troubling or depressing subject matter, an art which could be for every mental worker, . . . for example, a soothing, calming influence on the mind, something like a good armchair which provides relaxation from physical fatigue." Years later, when Matisse was eighty-two, he felt the same way: "I believe my role is to provide calm. Because I myself have need of peace."

Although Matisse wanted *Le bonheur de vivre* to give peace, the reaction when he sent it as his sole entry to the Salon des Indépendants in March 1906 was agitated. Usually he sent groups of paintings to Salon exhibitions in order to show the range of his work. Sending this single large canvas was clearly a kind of manifesto or position taking. The public was horrified by the painting's bright, flat color and its simplified, schematic figures. Indeed, to eyes unused to modern art, the figures looked

grotesquely distorted. In defense of the liberties he took with anatomy, Matisse liked to quote Delacroix's saying, "Exactitude is not truth."

The angriest of the critics was Matisse's former mentor Paul Signac. Even before *Le bonheur de vivre* was finished, Signac had written to a friend, "Matisse whose attempts I have liked up to now seems to me to have gone to the dogs. Upon a canvas of two and a half meters he has surrounded some strange characters with a line as thick as your thumb." Signac found Matisse's colors "disgusting," like "the multicolored shop fronts of merchants of paints, varnishes and household goods." At an artists' gathering in a café after the Salon's opening, he picked a fight with Matisse. Such a public altercation with his former mentor must have been profoundly upsetting to Matisse at this stage in his life, when he was struggling to invent his own vision.

At first Matisse's new patron, Leo Stein, shared the negative reaction to *Le bonheur de vivre*. But—remembering his initial dislike of *The Woman with the Hat* and realizing that radical new art requires putting aside preconceptions and looking long and patiently—Stein went back to study the painting again and again. After a few weeks he came to the conclusion that it was "the most important painting done in our time"; before long he was its owner.

On March 19, 1906, the eve of the Salon's opening, Matisse had inaugurated his second one-man show, this time at the Galerie Druet. His fifty-five paintings, three sculptures, and assorted works on paper ranged in date from 1897 onward. Unlike Matisse's smaller show at Vollard's two years before, the Druet exhibition was a financial success, perhaps because it included some of his earlier, more conventional works or perhaps because of the popular interest spurred by his notoriety. Soon after it opened and with the proceeds of various sales—for example, of the oil sketch for *Le bonheur de vivre* to Michel and Sarah Stein—Matisse and his wife traveled to Biskra in North Africa "to see the desert." During his two weeks in Algeria, where he also visited Algiers, Constantine, and Botna, he was impressed by the intense sunlight, and he bought textiles and pottery that would become motifs in still lifes and interiors in the following years.

Biskra, which he later called "a superb oasis, a lovely and fresh thing in the middle of the desert," stayed in his memory; a year later he evoked the pleasure it had given him in *Blue Nude: Memory of Biskra*, in which the robust curves of a nude that embodies the oasis's fertile earth are echoed in the palm leaves behind her. The rather sculptural nude (like the closely related sculpture *Reclining Nude I*, begun a little earlier) assumes the traditional posture of a love goddess, a posture that, as Matisse scholar Jack Flam notes, has since the Renaissance signified lust. Yet, for all her curves, the *Blue Nude* has none of the luxuriant ease of, say, a Titian or a Rubens Venus. She is tense and hyper-alert like certain African sculptures whose expressive anatomical distortions Matisse admired. Her arms are enormous and strong, not soft, relaxed, and helpless as in traditional images of the recumbent Venus. Huge in relationship to the painting's framing edge, the nude twists her body so that from the waist up she is seen from one viewpoint and from the waist down from another. As in *The Pink Nude*,

BLUE NUDE: MEMORY OF BISKRA (Collioure, early 1907). Oil on canvas, 36¼″ × 55¼″.

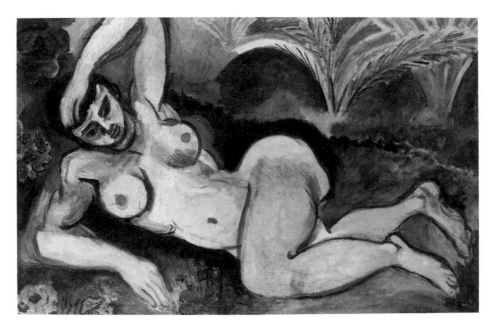

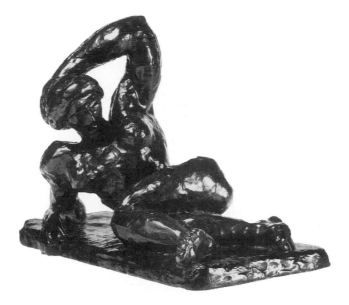

RECLINING NUDE I (Collioure, 1906–7). Bronze, 13⁹⁄₁₆″ × 19⅝″ × 11″.

another grand and startling nude painted nearly three decades later, the figure seems to plaster herself against the picture plane, offering her body to it.

Blue Nude was Matisse's sole entry to the 1907 Salon des Indépendents. Naturally it shocked the public. To Gertrude and Leo Stein, for whom it was to be their last Matisse purchase, the nude was a masterpiece. Gertrude Stein recalled, "We knew a Matisse when we saw it, knew at once and enjoyed it and knew that it was great art and beautiful." Gertrude Stein liked to tell the story of her concierge's five-year-old son, who upon seeing *Blue Nude* jumped into Gertrude's arms and "cried out in rapture, 'Oh là là, what a beautiful body of a woman.'"

From Biskra the Matisses went to Collioure. Here Matisse continued to alternate between Fauvism and his experiments with a more structural approach to composition. Several small Fauvist paintings of nudes in bucolic settings testify to his continued interest in the pastoral. The circumstances in which they were painted do not sound idyllic. Matisse and his wife would set out at five in the morning, pass through the Racou

tunnel after the Paris-Barcelona train went by, and, having walked for an hour in the mountains, they would settle into a spot where Amélie would pose. At eleven they would eat something and she would pack up their belongings. Once the twelve-thirty train had passed through the tunnel they would return to Collioure.

In Collioure, Matisse also painted a marvelously intense self-portrait in which he looks uncharacteristically bohemian in his striped fisherman's shirt. Though people said the bespectacled, neatly dressed Matisse looked like a businessman or a professor, in this self-portrait he looks like a *peintre maudit*, an artistic rebel. The intransigence of his expression recalls self-portraits by his idol Cézanne, and the ferocity of his gaze also brings to mind self-portraits by Gauguin and van Gogh. Nothing remains of the

SELF-PORTRAIT (Collioure, 1906). Oil on canvas, 21⅝″ × 18⅛″.

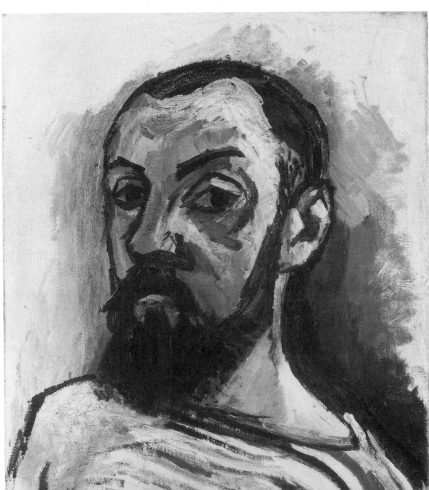

MATISSE, MADAME MATISSE, AND MARGUERITE IN MATISSE'S STUDIO AT COLLIOURE, SUMMER 1907. Behind Matisse: *Le Luxe* (1). Behind Marguerite: the sculpture *Two Women*.

plump, docile youth in this stubborn-lipped man. Fernande Olivier described a less fiery Matisse in her memoir of their meeting in 1906, the year he painted this self-portrait: "There was something very sympathetic about Matisse. With his regular features and his thick, golden beard, he really looked like a grand old man of art. He seemed to be hiding, though, behind his thick spectacles, and his expression was opaque, gave nothing away, though he always talked for ages as soon as the conversation moved on to painting."

When he painted the 1906 self-portrait, Matisse was in his late thirties and was just beginning to earn enough money to support his family. About this time, he was able to afford to send his boys to boarding school at Noyons, which they hated. This unusual choice for a French family was

prompted in part by the fact that the quai Saint-Michel apartment was too small for a family of five. With the improvement in his finances came a change in artistic stature. Even as he moved beyond Fauvism, he became well known in Paris as the king of the Fauves. And his reputation as the most important vanguard artist in France spread all over the world. Starting with seven of his works sent to a group exhibition in Brussels in 1906, he began to be included in important group exhibitions outside of France. Also in 1906, Michel and Sarah Stein introduced him to their houseguest, the Baltimore collector Etta Cone, who soon bought several paintings and who, with her sister Claribel, would become an important patron. By 1908 Matisse's paintings commanded respectable prices and were sought after by a group of loyal patrons, almost all of whom were not French.

Delighting in his new prosperity, Matisse developed a taste for luxury. In the spring of 1908, after the Couvent des Oiseaux, which had been his studio since 1905, was sold by the state, he moved to grander quarters in the Hôtel Biron, an eighteenth-century mansion on the corner of the boulevard des Invalides and the rue de Varenne. Formerly called the Couvent de Sacré-Coeur, it was, like his former studio, another expropriated convent. That October, Rodin took up residence in the Hôtel Biron as well, and part of the building is now the Rodin Museum. Matisse began to dress in expensive, well-tailored suits, and he made sure his wife and daughter went to one of the best dressmakers in Paris. Their style mattered enough to him that he even accompanied them to fittings at the salon of Germaine Bongard, a fashionable couturier who was one of the famous couturier Paul Poiret's sisters. Early in 1908, at a dinner to celebrate the completion of his portrait of his friend and student Greta Moll, a German painter, Matisse served champagne for the first time—he had to ask for instructions on how to open the bottle.

In 1908 he also had his first one-person show outside Paris, an exhibition of works on paper organized for Alfred Stieglitz's vanguard Little Galleries (known as 291) in New York by the photographer Edward Steichen, who came to know Matisse through the Steins. Steichen called Matisse "the most modern of moderns," but American critics were horrified by Matisse's

distortion of anatomy, what the press called his "sickening malevolent desire to present the nude (especially women) so vulgarized, so hideously at odds with nature." In the same year Matisse also participated in group shows in London and Moscow, and in December he had a one-man exhibition in Berlin's Cassirer Gallery. The latter did not fare any better than his New York debut. After a hostile response from critics and artists at the exhibition's preview, Cassirer almost canceled Matisse's show. Matisse's fury overwhelmed his sense of decorum; to shock the German public, he wore his sheepskin coat with its fleecy lining turned inside out so that he did indeed resemble a wild beast. Upon his return to Paris, he was upset when he received a large wreath from an American professor named Thomas Whittemore. The card attached to the wreath said, "To Henri Matisse, Triumphant on the battlefields of Berlin," alluding to the controversy triggered by his Cassirer show. Instead of enjoying the compliment, Matisse was morose. To him the wreath looked funereal. "But I am not dead yet," he protested. His wife, ever ready to cheer him up, plucked a leaf from the wreath, tasted it, and said, "It's real bay leaf, think how good it will be in soup." And, she pointed out, the red ribbon would be lovely in Marguerite's hair. Whittemore later bought *The Terrace, Saint-Tropez* for the Boston collector Isabella Gardner, the first Matisse to enter an American museum collection.

Early in 1908 Matisse opened the Académie Matisse. He had been giving informal painting lessons to his friends Sarah Stein and Hans Purrmann, and they persuaded him to open an official school, which they then helped to organize. Matisse recalled: "I refused any fee for my corrections, not wishing to be tied by such considerations when I might have reason to give it up." Beginning with about ten students, the school grew over the next three years to an enrollment of about 120 students who came from all over the world, especially from the United States, Central Europe, and Scandinavia. The students' economic situations were as various as their nationalities. One man was so poor that he ate the balls of bread that students left on their drawing boards to be used as erasers. This sign of poverty and lack of hygiene horrified the American women as did the offer of a male student to pose nude.

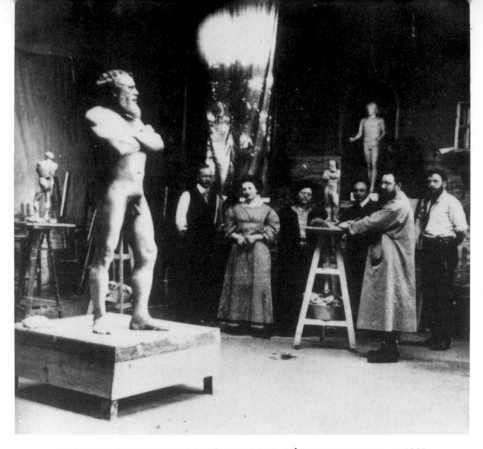

SCULPTURE CLASS AT THE ACADÉMIE MATISSE, HÔTEL BIRON, PARIS, C. 1909.
Left to right: Jean Heiberg, unidentified woman, Sarah Stein, Hans Purrmann,
Matisse, Patrick Henry Bruce.

Matisse came once or twice a week to give criticism. He was a demanding teacher. Although he emphasized imagination and wanted his students to express their personalities in their work, he also insisted upon a thorough academic training—the very training he had rebelled against only a few years before. Some students were surprised at the traditionalism of his teaching. On opening day the students decked the studio with paintings they had done in a Fauvist style. Matisse, who like Moreau did not want his students to imitate his art, entered the classroom and said, "What's all this rubbish? Take it down at once!" He went home, returned with a Greek head, placed it on a stand in the middle of the classroom, and told his students to start drawing from the antique. "Don't think you are committing suicide by adhering to nature and trying to portray it with exactness . . . ,"

he said. "In the beginning you must subject yourself totally to her influence. . . . You must be able to walk firmly on the ground before you start walking a tight-rope!"

He insisted, "No lines can go wild. Every line must have its function" and a clear relationship to a plumb line. Colors were to be carefully orchestrated to create an equivalence, not a copy, of nature. "Good color sings," he said. "It is melodious, aroma-like, never over-baked."

In the year he opened his school, Matisse set down his ideas about art in a magazine article entitled "Notes of a Painter." Published on December 25, 1908, in *La grande revue*, it is said to have been instigated by the journal's unofficial editor, Georges Desvallières, but its motivation came also from Matisse's desire to defend his art from detractors and to set forth his ideas for the general public. Perhaps his need to make a statement was further impelled by his uneasiness about the development of Cubism, which was beginning to attract attention as the new avant-garde movement. Late in 1907 or in the autumn of 1908, Matisse visited Picasso's studio and saw *Demoiselles d'Avignon* (1907); the huge painting's radical restructuring of space and form upset him. In the fall of 1908, as a member of the Salon d'Automne's jury, he is said to have referred to Georges Braque's L'Estaque landscapes done that summer as being composed of "little cubes," which helped to get Braque's paintings rejected.

Whatever prompted it, "Notes of a Painter" is one of the most lucid and influential statements on art ever made. It was soon published in Russian and German. In it, Matisse stressed both direct observation of nature and the transformation of observation through feeling—feeling that was to be communicated through color, line, and shape, not simply through the image represented: "What I am after, above all, is expression. . . . But the thought of a painter must not be considered as separate from his pictorial means. . . . I am unable to distinguish between the feeling I have about life and my way of translating it."

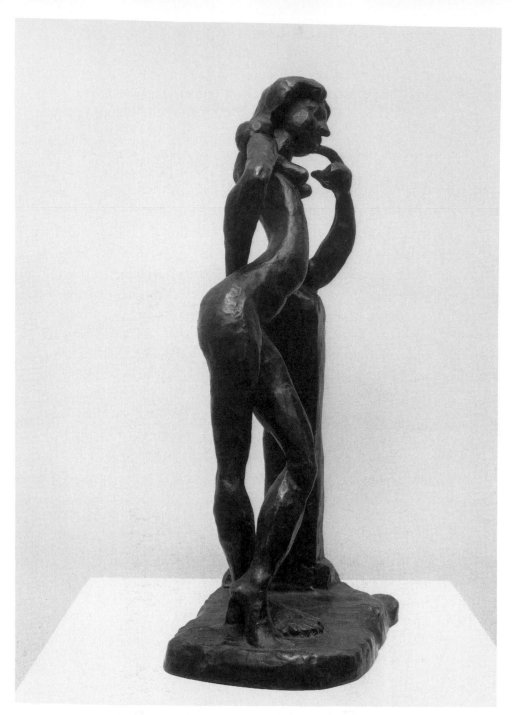

LA SERPENTINE (Issy-les-Moulineaux, 1909). Bronze, 22¼″ × 11″ × 7½″.

Cher Maître

In 1909 Matisse signed a contract with the Bernheim-Jeune Gallery, which guaranteed to buy all of his canvases up to a certain size. Thanks to his improved economic position he was able to move his family, including his sons (who now came home from boarding school and attended the Lycée Michelet at Vanves) to a house in the country near the suburban town of Issy-les-Moulineaux, fifteen minutes by train southwest of Paris. For a few years he rented the house and then bought it in 1913. Here he could work in greater peace than in Paris, where his home, studio, and school were all in the same building. He continued to visit his school on Fridays and Saturdays, but as his interest in teaching diminished he came less often and the Académie Matisse closed in 1911. "The effort I made to penetrate the thinking of each one [student] tired me out," Matisse said. "The saddest part was that they could not conceive that I was depressed to see them 'doing Matisse.' Then I understood that I had to choose between being a painter and a teacher. I soon closed my school."

Matisse's house at Issy-les-Moulineaux was a two-story eighteenth-century structure with shutters and oval oeil-de-boeuf windows in a mansard roof. It was surrounded by a large garden with a pond and a greenhouse. Matisse called his garden "our little Luxembourg" after the grand Luxembourg Garden in Paris. At the end of a path lined with flower beds and cypress trees, he built a prefabricated studio, following the recommendation of his friend Edward Steichen, who had organized Matisse's New York exhibition at Stieglitz's 291. At Issy, Matisse enjoyed long walks in the nearby woods: when he was nervous he insisted that Amélie accompany him on exhausting hikes, sometimes to villages several miles away. He and his children also took up horseback riding. (He once said that the other careers he had dreamed of pursuing were those of a jockey, a violinist, and an actor.) Occasionally he would ride with Picasso, who was an even less skilled equestrian than himself; Matisse liked to exceed the speed at which the Spaniard was comfortable so that Picasso would become stiff from the exercise. When a *New York Times* interviewer visited him at Issy in 1912, Matisse told her, "Oh, do tell the American people that I am a normal man; that I am a devoted husband and father, that I have three fine children, that I go to the theatre, ride horseback, have a comfortable home, a fine garden that I love, flowers, etc., just like any man." This solid-citizen side of Matisse was noted by another interviewer in 1944: "No one could be less bohemian than this artist who requires and studies his comforts like a *grand bourgeois.*"

Matisse had not starved as his father had predicted he would. Instead he was a man of means. But his father still refused to acknowledge Matisse's success. When Émile-Hippolyte Matisse came to see his son's new home at Issy-les-Moulineaux, he shook his head in disapproval and said, "Look at all this wasted land. Think of the potatoes you could grow here."

The large studio at Issy was necessary because Matisse had an important commission for mural-sized canvases from a new patron, Sergei Shchukin, a Russian textile importer who specialized in Eastern textiles. Shchukin's ornate eighteenth-century palace in Moscow was already decorated with numerous modern paintings by Gauguin, Cézanne, Renoir,

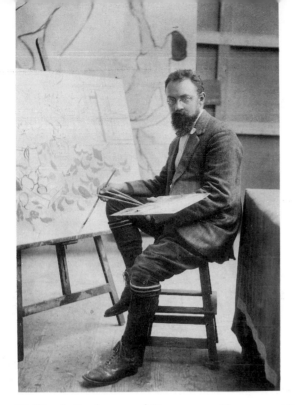

Vuillard, Redon, and Rousseau. Between 1905 and 1908, Shchukin's wife died, and two of his sons and his younger brother killed themselves. Apparently Shchukin shared Matisse's notion that art could assuage mental anguish.

Shchukin was a small, sober, middle-aged man with intense, somewhat slanted eyes set in a face that seemed to come right out of the Russian steppes. Though he was shy and had a terrible stammer, he was a shrewd and willful businessman. Most important, he had a great eye and love for art. "One day," Matisse said, "he dropped by at the quai Saint-Michel to see my pictures. He noticed a still life hanging on the wall and said: 'I buy it [*sic*], but I'll have to keep it at home for several days, and if I can bear it, and keep interested in it, I'll keep it.'"

In the early years of the century, Shchukin had bought a few Matisses, but starting in 1908, he replaced the Steins as Matisse's most avid collector. He also developed an appetite for works by Picasso, to whom Matisse generously introduced him in 1908. By the outbreak of World War I in 1914, when he was cut off from Paris and stopped collecting, Shchukin had acquired thirty-seven of the boldest and best Matisses and hung them in his

79

immense living room, where they were seen by many people during chamber music concerts and other social gatherings. He introduced his younger friend, the industrialist Ivan Morosov to Matisse's work, and Morosov, even though his taste was more conservative than Shchukin's, bought many canvases as well. Matisse recalled, "When Morosov went to Ambroise Vollard, he'd say: 'I want to see a very beautiful Cézanne.' Shchukin, on the other hand, would ask to see all the Cézannes available and make his choice among them." Like Leo Stein, Shchukin always seemed to choose Matisse's most adventurous, most simplified paintings. As Matisse later reflected, "It took sheer nerve to paint in this manner, and it took sheer nerve to buy."

Among the paintings that Shchukin bought in 1908 was *Harmony in Red* (plate 8). At the time of its purchase, the unfinished painting was called *Harmony in Blue*. A large interior, it began as a green composition; then it became blue; and finally it was repainted in a cherry red that suits the cheerful subject, a table being set for that all-important French event—the midday meal. Like *The Dinner Table* of 1897, *Harmony in Red* shows an aproned maid fussing over the table arrangement. In both paintings the table's centerpiece is a curious glass fruit bowl surmounted by a vase containing flowers, and in both paintings fruit is strewn around the table. In *Harmony in Red* the maid gathers the scattered fruit into a bowl with all the care of an artist composing colors and shapes. Both paintings reveal the pleasure Matisse took in delicious meals prepared by women in a well-run home, but there the similarities end.

By simplifying and abstracting according to feeling, Matisse achieves in *Harmony in Red* the "condensation of sensations" that makes a painting "representative of my state of mind." In the 1897 work, the excitement and pleasure of the subject were conveyed in the sparkle of light on objects. The joy of the 1908 interior comes from the enveloping red and from the wild dancing curves of the flower baskets and the blue garlands that seem to come off the tablecloth and grow up the wall (which was in fact white). The patterned tablecloth (which Matisse did own) is of a traditional type of French textile called toile de jouy; it appears in several other of Matisse's still lifes and interiors as well.

Color, Matisse maintained, speaks to the senses; drawing to the spirit. He stressed his need to make color changes "in a purely instinctive way" as his painting progressed: each new color changed the function of colors already on the canvas. "Suppose I have to paint an interior," he wrote in "Notes of a Painter." "I have before me a cupboard; it gives me a sensation of vivid red, and I put down a red which satisfies me. A relation is established between this red and the white of the canvas." He goes on to suppose that he adds green and yellow to his canvas and that the color scheme no longer works. "A new combination of colors will succeed the first. . . . I am forced to transpose until finally my picture may seem completely changed when, after successive modifications, the red has succeeded the green as the dominant color. . . . From the relationship I have found in all the tones there must result a living harmony of colors, a harmony analogous to that of a musical composition."

The analogy to music must have been the reason he titled his 1908 interior *Harmony in Red*. Indeed, the scattered fruits are like notes on a musical score—the servant, like a painter, gathers them lovingly into a chord. Like many artists paving the way for, or making, abstract art in the first decades of this century, Matisse defended his departures from realism by comparing painting with music, which is, of course, abstract.

Harmony in Red can be seen as a play on both reality and the language of art. Paradoxically, the flower basket and garland pattern on the toile de jouy seem more alive than the "actual" fruit and flowers on the table. And everything inside the room looks lifelike compared to the flat and schematized garden view: once again, the open window creates a picture within a picture.

Although the chair on the left is drawn in perspective, and therefore we know it occupies a certain portion of deep space, *Harmony in Red* is extraordinarily flat. There is no change in tone or scale between the pattern on the tablecloth and the pattern on the wall, and the division between the edge of the table and the wall is barely defined, with the result that the color red seems to spread from top to bottom and from left to right but does not move backward in space. This flatness is reinforced by the echoing of colors

and shapes in the foreground and in depth. Yellow crocuses in the garden, for example, echo the yellow flowers and fruits on the table, and we see these yellow shapes as related to each other across the surface. When a pattern of shapes on the canvas surface is perfectly joined with the meaning of those same shapes as conveyors of depth, or when surface and depth readings are so locked together that they reinforce and energize each other, the arrangement takes on a timeless quality as, for example, in Piero della Francesca's frescoes at Arezzo, which had thrilled Matisse when he traveled to Italy in July 1907. Matisse sought this fixity within flux for its sublimity and calm.

The Dinner Table was a triumph of observation; in it Matisse depicted a certain moment, a particular condition of light. *Harmony in Red* is a brilliant invention; by eliminating highlights, shadows, and perspective, Matisse created a lasting dream, an ideal state of being outside of time. The difference in intention between the 1897 and 1908 paintings is illuminated by a parable Matisse told later in life about a man with only one eye, which takes pictures like a camera. This man feels sure that he knows "the reality of things." But then another eye brings forth a different picture, and, as Matisse told it, "our man no longer sees clearly, a struggle begins between the first and the second eye, the fight is fierce, finally the second eye has the upper hand. . . . The second eye can then continue its work alone and elaborate its own picture according to the laws of interior vision. This very special eye is found here." Matisse pointed to his head.

Conversation (plate 9), begun in 1908 and finished several years later, has been seen as a pendant to *Harmony in Red*. Both canvases are almost the same size, both are domestic interiors, and both have windows on the back wall looking onto a garden that is depicted so reductively that the view can be mistaken for a picture on the wall. *Conversation*'s dominant color is blue, just as *Harmony in Red* was once *Harmony in Blue*. Shaped like a giant U, or a staple, the blue background color holds together the two figures in *Conversation*, but they look as though they would rather be apart. Blue freezes everything in place; it is the opposite of the warm red set in motion by joyous arabesques in *Harmony in Red*.

Harmony in Red is about pleasure, abundance, movement, interconnectedness. Every part of the picture flows with a single unifying energy. The surging forms and throbbing color suggest the urgency of love; indeed, the woman depicted is almost certainly a memory image of Matisse's companion Caroline Joblaud, who appeared as the servant in *The Dinner Table*. "He who loves," said Matisse, quoting Thomas à Kempis, "flies, runs, and rejoices; he is free and nothing holds him back." By contrast, *Conversation* is about emotional paralysis. It suggests the tension and noncommunication that can develop when intimacy is lost and respect replaces desire. The two figures, whom Matisse identified as himself and his wife, are divided by the window and by the implacably flat expanse of blue. If only there were a breakfast table set between the man and woman—anything to bridge the void and to make the silence in this "conversation" less uncomfortable.

Matisse stands stiffly in his blue pajamas, whose white stripes are as straight as prison bars. Because his head and his lower legs are cut off by the top and bottom edges of the canvas, he is locked in place like a stripe himself. Since the blue of the background was enlarged to cover the front of what was once a more substantial body, Matisse is pushed further from his wife and, since he is overlapped by the background color, he is even more tied to the picture plane. Hands in his pockets, he is aloof and cool. Though his seated wife tilts her head to look up at him, he does not bend his head to look down at her. Yet, across the great abyss of the garden view, we know their eyes surmounted by doubled eyebrows interlock.

Amélie Matisse appears to be the one who has spoken or who has something to say. She stares at her husband as if waiting for a response. But both spouses have flat ears with no indication of an opening to the auditory canal; so their "conversation" falls on deaf ears. Dressed in a black bathrobe that she actually owned, Madame Matisse looks as rigid as an Egyptian queen. *Pentimenti* show that like the figure of her husband, she has been much repainted. Her legs once extended out toward her husband but were pared back to conform with the right-angle turns of her figure. Her too-small blue chair almost disappears against the blue background.

Yet she doesn't need it: she is sustained by her own tension. Her immobility suggests controlled anger—a lonely, futile anger that will only make her husband more distant.

That rage is suggested by the curious gray blotch rimmed with black and punctuated with a dot of green that darkens Amélie's forehead like a storm cloud. Surely Matisse knew how strange this blotch would look. Here and in other paintings he broke into a figure's face with odd patches of color or with scraped areas (as in, for example, his *Portrait of Olga Merson*, 1911). In *Conversation* Madame Matisse's forehead and ear have been scraped out, leaving striations that seem to have been scratched, almost angrily, with the end of the brush. There is something peremptory, abrasive, and yet magnificent in Matisse's scratches and scrapings; it suggests the artist's absolute conviction that the force of his conception could not be weakened by vestiges of earlier doubts and changes of mind.

The painful stillness of *Conversation* is broken only by the curves of the black grillwork in the window. As Jack Flam has pointed out, the grillwork spells out in capital letters the word that both husband and wife seem to be saying: *NON*. (Although the third letter may look more like a mirror-image *N* or an *X*, once the word *no* has been pointed out, it plays a dominant role in the composition.)

For a long time Matisse left *Conversation* (which really should be called *Silence*) unfinished. Perhaps its autobiographical subject matter upset him; perhaps he thought it revealed too much. At this time he was in fact having a love affair with one of his students, a young Russian Jewish woman, Olga Merson, whose figure he sculpted and whose portrait he painted in 1911 (and whom some have seen as the inspiration for the red-haired nymph approached by the nude male in *Nymph and Satyr*, from the winter of 1908–1909, a painting whose dramatic eroticism was unusual for Matisse). In 1912 when Shchukin bought *Conversation*, he wrote to Matisse, "I often think of your blue painting (with two people). It reminds me of a Byzantine enamel, so rich and deep is its color. It is one of the most beautiful paintings in my memory."

In *Le luxe II* (1907) and *Bathers with a Turtle* (1908), two highly simplified compositions each containing three schematic figures set in a seascape (plates 6 and 7), Matisse returned to the arcadian world of *Le bonheur de vivre.* In both paintings two dark-haired nudes whose faces are visible are paired with a crouching blond nude whose face is turned away. In the 1908 painting, the seascape is abstracted into three horizontal bands of color that are proportioned according to the golden section. This ideal geometry places the scene outside of specific place and time. Space is so rudimentary that the nude on the right doesn't even have a chair or a rock to sit on; she is supported by a structure of form and color more solid than any furniture.

The monumental figures, placed in a spare setting and enclosed in concise contours that perfectly express the painting's emotional content, recall Matisse's admiration for Giotto's frescoes on his recent trip to Italy. But the nudes also look primeval. Their gestures are untutored. Their bodies, drawn like the awkward Eves in medieval mosaics or illuminated manuscripts, belong to the beginning of time. Like Picasso's early Cubist *Demoiselles d'Avignon*, which Matisse possibly saw for the first time when he took Shchukin to Picasso's studio in the fall of 1908, the heads of the two dark-haired nudes appear to have been influenced by primitive sculpture, and they seem to have been painted or repainted after the bodies were finished. Perhaps the primitivism of these creatures was a response to Picasso's challenge.

If this is so, Matisse was making his own use of a source he had shared with Picasso in the fall of 1906. Indeed, Matisse was probably the first modern artist to take a real interest in African sculpture. In 1906 he had bought an African carved wooden head he happened to see in a store window on his way to a gathering at Gertrude and Leo Stein's. "There I found Picasso, who was astonished by it," he recalled. "We discussed it at length, and that was the beginning of the interest we all have taken in Negro art." Having watched with anxiety as Picasso transformed this source in ways so different from his own gentler assimilation (seen especially in his sculptures of

1906–1907), Matisse may have wanted to unite the primitive with the arcadian in a more peaceful, less abrasive synthesis.

The bathers watch a reddish brown turtle, a creature as primeval as the serpent in the temptation of Eve. Here it is the turtle who is tempted, not the woman. The hands of the central figure (as Elderfield has noted) look as if she might originally have been depicted playing a flute; perhaps she was calling the turtle forth from his shell. In the final version, the turtle is lured out of his shell by a blond nude who offers food, but who keeps her body turned away and her face hidden. Her right arm reaches out in a stiff and somewhat unnatural gesture so that her fingers curl up toward the turtle. It is as though she were afraid of, and tentative about, her own act of giving.

A somewhat similar and even more awkward twist appears in the right arm of Matisse's *The Back (I)*, the first of four relief sculptures of nudes seen from the back done over a period of twenty-two years and begun, along with *Bathers with a Turtle*, early in 1908. Like the blond nude seen from the back in *Bathers with a Turtle*, the women in the back sculptures keep their faces averted from the viewer, and this turning away from the hand's reaching gesture gives them a shyness—possibly even a hint of Eve-like shame—similar to that of the blond figure in *Bathers with a Turtle*. But the most likely source for the blond woman's crouching and reaching position is the squatting nude with her arm extended on the left in Cézanne's monumental *The Bathers* (1898–1905). Cézanne's crouching bathers also informed the fierce squatting nude in Picasso's *Demoiselles d'Avignon*.

Bathers with a Turtle's mysterious drama is unusual for Matisse. There is an odd contrast between the shy, closed posture of the woman feeding the turtle and the openness of that normally shy creature, which advances boldly toward her. Could Matisse have had some special affinity with the reddish brown turtle being seduced out of its shell? Might his relationship to Olga Merson be hinted at here, albeit in a more covert way than in the slightly later *Nymph and Satyr*? Certainly the extreme length of the blond nude's torso from waist to hip is similar to the elongated buttocks of *Seated Nude (Olga)* from 1911—though, of course, the enlongated shape may have been prompted solely by formal concerns.

Bathers with a Turtle certainly has, as Elderfield has pointed out, "an element of primal sexuality." Indeed, the painting's sexual energy is not unlike that of Picasso's *Demoiselles*. Adding further layers to the painting's metaphoric resonance, *Bathers with a Turtle* might, as one observer suggests, depict the myth in which Apollo, disguised as a tortoise, became the plaything of Dryope and her wood nymph friends. Could not Matisse, who recognized the Apollonian rational side of his nature, have entered the private world of women in Apollo's disguise?

Or was the turtle just an excuse for painting three nudes all focused on the same object and fanning out from the center like petals from a flower? The scene, like its counterpart, *Game of Bowls* (1908), in which three nude boys look like Greek athletes, might simply be Matisse's idea of arcadia. Then, too, the slow, unchanging, ancient turtle could embody the idea of time itself slowed and condensed into a timeless present. Though in making such interpretations one might seem to wander out onto fragile limbs, Matisse did, after all, invite viewers to find their own meanings. "A painter," he said, "doesn't see everything that he has put in his paintings. It is other people who find these treasures in it, one by one."

In "Notes of a Painter," which he wrote the same year he painted *Bathers with a Turtle*, Matisse said he wanted to render a landscape's "essential character," not just "one moment of existence." This idea of duration, of condensing the endless succession of fleeting moments into something slower and more lasting, seems to be one possible meaning of *Bathers with a Turtle*. In his article, Matisse reveals his familiarity with the philosophy of Henri Bergson, whose *Creative Evolution* had been published in 1907 and had become a popular success. As several Matisse scholars have pointed out, the philosopher's ideas were widely discussed in intellectual circles, and Matisse was certainly aware of them. Matisse's stress on intuition and on emotional penetration into the motif echoed Bergson's idea that the artist tries to capture his intuition of life "by placing himself within the object by an act of sympathy." Bergson saw reality as constant flux, and he believed that there is some dynamism—he called it

the *élan vital,* or vital impulse—that pervades all reality. Duration is, said Bergson, "the continuous progress of the past which gnaws into the future and which swells as it advances. . . . The piling up of the past upon the past goes on without relaxation. . . . It follows us every instant." Human beings, Bergson believed, are always in a state of becoming, and they grasp their own reality in the midst of time's flux only through intuition, not through analysis: "It is our own person in its flowing through time, the self which endures." Similarly, in "Notes of a Painter," Matisse acknowledged this idea of a person becoming conscious of a self existing through endless flux, and, like other early modernists (Kandinsky and Mondrian, for example), he was taken with an almost mystical urge to find an essential order underlying change. He wrote, "Underlying this succession of moments which constitutes the superficial existence of beings and things, and which is continually modifying and transforming them, one can search for a truer, more essential character, which the artist will seize so that he may give to reality a more lasting interpretation." The "madly anxious" Matisse must have been unnerved by the idea that personality has no permanent, stable existence and that reality never stays still. No doubt the thought of the past "gnawing" into the future and every moment bringing human beings closer to death made him feel, like many artists, that he had no time to waste: to the absurd unreality of each passing instant he opposed his own enduring creation.

In one or two days in late February or early March 1909, Matisse painted *Dance I,* his largest canvas yet. Like *Bathers with a Turtle,* it depicts a Golden Age when people lived in harmony with each other and with nature. He said the painting was based on his memory of peasant dances— perhaps the sardana danced by fishermen on the beach at Collioure. He also said he painted it just after going to the Moulin de la Galette dance hall and watching the farandole, which he described as follows:

> Dancers hold each other by the hand, they run across the room, and they wind around the people who are standing around. . . . It is all extremely gay. And all that to a bouncing tune. . . . Back at home I composed my dance on a canvas of four meters, singing the same tune I had

heard at the Moulin de la Galette, so that the entire composition and all the dancers are in harmony and dance to the same rhythm. . . . This dance was in me, I did not need to warm myself up: I proceeded with elements that were already alive.

For his composition he took the ring of six ecstatic dancers in the center of the background of *Le bonheur de vivre,* enlarged them, eliminated one figure on the left, and brought the dancers so close to the picture surface that they touch or almost touch the framing edge and seem ready to burst out of the canvas.

It is likely that Matisse painted *Dance I* as a sketch for a potential commission from Sergei Shchukin. In any case, when Shchukin saw *Dance I* he liked it so much that he took Matisse to lunch at Restaurant Larue, one of the best restaurants in Paris, to discuss Matisse's making large paintings to decorate the landings on the stairwell of his Moscow home. Although Shchukin was dismayed by the high prices Matisse asked, and was also worried that paintings with nudes would offend conservative Muscovites, he made the commission anyway. The result was *Dance II*, which, along with Shchukin's other paintings, was appropriated by the state during the Russian Revolution (plate 10). Today it is the pride of the Hermitage Museum in Saint Petersburg.

At first Matisse thought Shchukin wanted three paintings. A dance panel would greet guests on the first floor, Matisse explained:

> One must summon up energy, give a feeling of lightness. My first panel represents the dance, that whirling round on top of the hill. On the second floor one is now within the house; in its silence I see a scene of music with engrossed participants; finally, the third floor is completely calm and I paint a scene of repose: some people reclining on the grass, chatting or daydreaming. I shall obtain this by the simplest and most reduced means; those which permit the painter pertinently to express all his interior vision.

As it turned out, Shchukin's house was only two stories high, and the final commission was for just two panels. Matisse began the third panel but

left it unfinished until 1916, when, totally transformed, it became *Bathers by a Stream.*

Although the arrangement of figures is the same as in *Dance I,* *Dance II* is more intense. The colors are denser and more vibrant. Matisse chose what he called "the bluest of blues" for the sky, a bright green for the earth, and red instead of pink for the flesh tone. *Dance II*'s colors are closer to each other in terms of light/dark value, so that none stands out or recedes, and they all compete for our attention, keeping our eyes leaping, just like the dancers themselves. With three simple colors, which he said were based on the Mediterranean landscape, he achieved an equilibrium that never settles; again like the dancers, the colors radiate continuous energy.

The women in the first version of the dance seem to float; they are softer and gentler than those in the second version. In contrast, the *Dance II* revelers are taut, muscular amazons. Their lines are simple and incisive, like the drawing on Greek vases or like medieval frescoes. Red with exertion, they strain to keep up with a dance that carries joy to the point of frenzy. The two upper figures thump so wildly that their feet pound holes in the hill.

As Matisse said, "This dance was in me." He maintained that he felt great kinesthetic empathy with the postures of his models, and in *Dance II,* the postures, like the bodies themselves, are distorted to show movement as it is felt, rather than movement as it is seen. Unlike gestures caught in snapshots, the movements are not specific to one moment in time. The gesture, Matisse felt, should subsume and condense movement's past and future, "so that equilibrium is re-established, thereby suggesting the idea of duration." Duration, a constant state of becoming, is the very essence of a round dance, since a circle goes on forever. The ring of dancers thus embodies Bergson's *élan vital,* the life force: the revelers are caught up in the dance of life.

Ironically, the idea of the ongoing dance of life is reinforced by a break in the ring where a lunging woman strains to reach the hand of the dancer to her left. Matisse has carefully placed the gap between the hands so that it overlaps the leg of a dancer in the back of the ring, thus avoiding a break in the ring of red. He was a canny and calculating overlapper—when *Dance I*

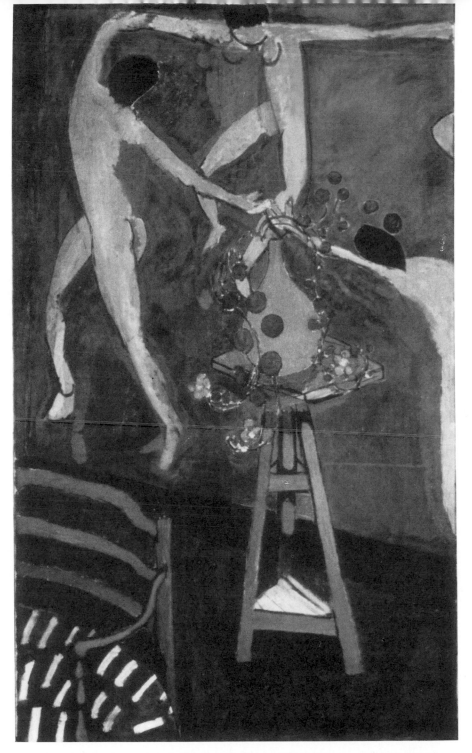

NASTURTIUMS WITH DANCE II (Issy-les-Moulineaux, 1912). Oil on canvas, 6′ 3″ × 44 ⅞″.

appears in *Nasturtiums with Dance II* (1912), the nasturtiums burst forth from the vase just in front of the almost-touching hands in his dance panel; as a result, the plant seems to join in the dance, and the dance appears to grow out of the vase. In *Dance II* this crucial juncture of hands and legs is made all the more tense by the convulsive movement of the woman in back, who appears to be electrified by the gap between the hands.

With this simple conjoining of hands and legs, Matisse gives an extraordinary tension to the linking of surface to depth. The dancers' not-quite-touching hands have been compared to the equally tense reaching hands of God and Adam in Michelangelo's *Creation of Adam* on the ceiling of the Sistine Chapel. It could be said that both paintings encapsulate creative energy and portray an endless state of becoming.

The green and blue shapes that the figures in *Dance II* cut out (the negative space) are as full of life as the figures themselves. Pieces of blue enclosed by the dancers' red limbs, for example, are too compelling as shapes to be mere background. The blue moves forward toward the viewer, so that the whole composition resounds on one flat surface. Of *Dance II*'s "luminous harmony," Matisse said, "The color was proportioned to the form. Form was modified, according to the reaction of the adjacent areas of color. For expression comes from the colored surface which the spectator perceives as a whole."

When Matisse transformed the six dancers in *Le bonheur de vivre* into the five dancers of his dance panels, he turned an ancient, mythic pastoral into something alive and physically present. You can almost hear the music in *Dance II*; its raucous rhythms set our own muscles twitching. This empathy with the dancers' movements makes us participants. As Matisse said, "The characteristic of modern art is to participate in our life." Indeed, as viewers we are invited to join hands and enter the round dance where there is an opening between the two reaching hands. We complete the circle.

The wild ecstasy of *Dance II* is the opposite of the depressed mood of Matisse's dark early paintings such as *Studio under the Eaves*. Indeed, *Dance II*'s energy could be called manic; its exuberance becomes a perilous

and almost painful spending of the self. The dance of life might also be a dance of death, for its exaggerated movements and precarious equilibrium are sustained only by the tugging and reaching of joined hands, suggesting the risk of chaos and dissolution. Indeed, the top central dancer (whose bent posture recalls the crucified Christ) seems to hold the top edge of the canvas upon her stooped shoulders. Should this caryatid balancing on one leg take a fall, the whole canvas, one feels, would collapse. Derain once said to Matisse, "For you doing a painting is like risking your life." Another time Matisse put it this way: "We have to live over a volcano." In *Dance II* telluric unrest merges with Matisse's search for calm through simplicity. This ambiguity recalls Bernini's mixture of rapture and agony in his *Ecstasy of Santa Theresa*. It is the perfect lucidity within ambivalence that gives Matisse's *Dance II* its undying fascination.

The painting's extreme dynamism worried Matisse. He asked Edward Steichen to come to Issy to witness the way *Dance II* seemed to vibrate and tremble as the light faded at sundown. Steichen reassured Matisse with a seemingly scientific explanation. But on another occasion Hans Purrmann was with Matisse when *Dance II* was on the studio floor waiting to be rolled up for transport. Matisse, having forgotten that it was there, suddenly caught sight of it out of the corner of his eye and jumped back, terrified. Purrmann recalled that Matisse was concerned that other people might be frightened by the painting as well.

MUSIC (Issy-les-Moulineaux, 1910). Oil on canvas, 8′ 5⅜″ × 12′ 9¼″.

Music, the second of the two mural-sized panels for Shchukin, would not have caused such anxiety. It was meant to be contemplative and still. In it, five self-contained, immobile male figures are separately absorbed in playing or listening to music. Set against the line of the hill like notes rising and falling in a melodic line, they embody the idea of harmony. Even the colors—again red, green, and blue—come together like notes in a musical chord. "Colors are forces as in music," Matisse said. His colors resound in our eye long after we no longer actually see them, just as music continues to resonate in our ear after the players have stopped.

Dance II and *Music* caused a furor when they were exhibited in October as Matisse's entire contribution to the 1910 Salon d'Automne. Disturbed by the negative reaction, Shchukin told Matisse that he could not accept the panels. His excuse was that he had just adopted two young nieces, and he therefore could not hang paintings of nudes. Matisse was so upset over this, and over the recent death of his father in Bohain on October 15, that on November 16 he left for Spain and did not return to Issy until January 1911. Fortunately Shchukin changed his mind, and the panels arrived in Moscow in December, whereupon Shchukin had the genitals of the flutist in *Music* covered with red paint.

Matisse's escape to Spain for two months alone made Amélie unhappy. Gertrude Stein, who had grown critical of Matisse in the last few years, calling him *"cher maître"* because he often played the role of the great master, wrote of what she called Matisse's "brutal egotism" and lack of a "feeling for life." Later she remembered his thoughtlessness in relation to his wife at this time in her "Storyette H.M.," in which she recorded or invented a dialogue that took place between Matisse and Amélie before his departure for Spain: "'I am content. You are not content?' asked Matisse. The devoted Amélie replied, 'I am content you are content.' Satisfied, Matisse pronounced, 'You are content? I am content.' His conscience cleared, he left."

Matisse did not deny what he called his "aristocratic egotism." Often he quoted a Picard proverb: *"Chacun son pain, chacun son hareng,"* which loosely translated equals "Every man for himself." Though he liked to carry on about his own art, as the years went on he paid less and less atten-

tion to that of his colleagues. Jane Simone Bussy, who with her father, Simon Bussy, saw a lot of Matisse in the 1920s and 1930s, noted that Matisse's self-absorption could be "intensely boring" and that the "prodigious egotism that lies behind the bland benignity of his manner ends by choking almost everyone off." Yet, she wrote, "With all his egotism he is without an atom of affectation and it is this complete naturalness that makes him endurable." To her he once admitted, "I only take an interest in myself," whereupon he blushed and buried his face in his hands. Another time he said to Marquet, "I am too involved in what I am doing. I can't tear myself away from it. For me nothing else exists."

Matisse was so anxious and depressed in Spain that he could not sleep. Later he described his state as a near nervous breakdown. Perhaps he was mourning his father. Even though Émile Matisse had played the role of the ogre in his son's life, his authoritative presence and his unattainable standards were no doubt necessary to Matisse even as he rebelled against them. Perhaps the father had energized Matisse's ambition by instilling in his son a wish to please him.

To calm himself Matisse took three hot baths a day, and he tried to work, producing two still lifes featuring Spanish shawls he had recently acquired and draped over hotel furniture. He did the still lifes "in a fever." He said, "I worked half an hour, at most three-quarters of an hour. I had nervous palpitations. I couldn't go on. I left. I came back the next day for a shorter time. All the rest of the time, I dragged around my fatigue and my disgust." When he returned to Paris he painted his wife looking tall and melancholy in one of the new fringed shawls. In this second portrait of his wife in Spanish costume, she is perhaps as proud, but no longer as fierce, as her Spanish pirate ancestor.

In Spain, Matisse visited Madrid, Cordoba, Seville, Granada, and Toledo. He was especially impressed by the Alhambra and other Moorish architecture he saw in the south. A few months earlier, on a trip to Munich, he had feasted his eyes at a large Islamic exhibition of rugs, bronzes, textiles, pottery, and Persian miniatures. He was impressed by Islamic art's intricate decorative patterns and flattened space. "The decorative is an extremely precious thing for a work of art," Matisse said. "It is an essential quality. It does

not detract to say that the paintings of an artist are decorative." In Persian miniatures, pockets of deep space inhabited by small figures are often interspersed with areas of abstract, flat pattern. This play of surface and depth, together with the miniatures' multiple and elaborate decorative patterns, was inspirational to him. "Persian miniatures," he said, "showed me all the possibilities of my sensation."

Islamic art inspired a series of sumptuous interiors that seem a reaction to the mural-like simplicity of the dance and music panels. For example, *The Painter's Family*, done at Issy-les-Moulineaux in the spring of 1911, is, like a Persian miniature, crammed with patterns while also containing figures and some indication of depth. In it, the Persian rug is tilted up so that we can enjoy its flat pattern, whereas the checkerboard upon which Matisse's sons play is drawn in perspective and creates a wedge of depth. Matisse is absent, but *The Serf*, which is the only sculpture he did of a male, presides over the bourgeois family scene and may be a substitute for the artist: as Jack Flam observed, Matisse so identified with this bronze that it can be seen as a "spiritual self-portrait."

In the background of *The Painter's Family,* Madame Matisse sits with her embroidery. Seventeen-year-old Marguerite stands in the foreground holding a book. As Matisse's relationship to Amélie became more distant,

THE PAINTER'S FAMILY (Issy-les-Moulineaux, 1911). Oil on canvas, 56¼″ × 6′ 4⅜″.

Marguerite became an increasingly important companion. His voice would soften when he spoke of her, and he called her "my little girl."

The figures in *The Painter's Family* are not individualized—as we have noted, Matisse insisted that "expression is carried by the whole picture.... If you put in eyes, nose, mouth, it doesn't serve for much; on the contrary, doing so paralyzes the imagination of the spectator and obliges him to see a specific person." For all that, the four figures do create a definite mood, and a strong interpersonal dynamic is conveyed by their postures and positions in space. Indeed, for all its cozy clutter of ornament and warm colors, *The Painter's Family* has a tension that is as affecting as the feeling of psychological isolation in Degas's *The Bellelli Family* (1859–1860). And it seems likely that Matisse was inspired by Edvard Munch's grim family scenes such as *Death and the Child* (1890), in Oslo's Munch Museet, or his lithograph *Death in the Sickroom* (1896). Matisse would certainly have seen the slightly older Norwegian painter's various Paris exhibitions in the early years of the century. Matisse's frontal and static Marguerite recalls Munch's figures of standing women who, like Marguerite, are often dressed in black and who separate themselves from the figures grouped in the background by confronting the viewer like an actor addressing the audience rather than speaking to his fellow players.

Another source for this family scene might be Cézanne's *Overture to Tannhäuser* (c. 1866), which Morosov bought from Vollard and which

IN MATISSE'S STUDIO AT COLLIOURE, SUMMER 1911.
Left to right: Madame Matisse, Matisse, a servant (standing), Olga Merson, Marguerite Matisse,
the painter Albert Huyot (standing), and Madame Matisse's father, Monsieur Parayre.
In the background: *Interior with Aubergines.*

depicts Cézanne's sister playing the piano and his mother seated in the background sewing. Like Matisse's family, Cézanne's figures are surrounded by rich patterns of wallpaper, textiles, and carpet. This Cézanne interior might also have served as a model for Matisse's 1924 reinterpretation of *The Painter's Family* entitled *The Music Lesson*, which shows a surrogate family—his model Henriette at the piano while her two younger brothers play checkers—in Matisse's ornate apartment in Nice.

When he was at work on *The Painter's Family*, Matisse wrote to Michel Stein that he was "uncertain of its success. This all or nothing is very exhausting." Even after he had achieved mastery and fame, Matisse was driven by self-doubt. In a later postcard he sounded more sure about his progress: "The color," he wrote, "is beautiful and generous."

The last and the boldest of the large decorative interiors of 1911 is *The Red Studio* (plate 11). Here Matisse brings all parts of the composition to the canvas surface not by covering every inch with a patchwork of patterns, as in *The Painter's Family*, but by using an all-encompassing red like the cherry color that pervades *Harmony in Red*. Delicate lines of light that divide the floor from the walls hint at spatial recession. Pictures and furniture arranged along the walls suggest deep space as well. But Matisse, who was often playful and paradoxical in his handling of pictorial means, created the room's orthogonals and the lines that define objects by bringing red pigment up to the edge of a contour and then leaving a narrow line of paler underpainting in reserve. On first glance it looks as if he had scratched into the painting's red background with the handle of his brush. Since the lines indicating depth are actually the underpainting or the canvas itself revealed, we must recognize them as flat. Because the volumes are drawn with light diagrammatic outlines and have no opaque planes, they are drained of substance, and the red of the background shines through. The pale outlines of the clock or the chair, for example, do not depict solid objects in the visible world; rather, they project an idea about these objects that exists in the painter's mind. Indeed, the whole studio interior could be a metaphor for what Matisse called his "interior vision."

In *The Red Studio,* as in many of his interiors and still lifes beginning

in the mid-1890s, Matisse included a number of his own artworks, as if he were happiest when surrounded by the products of his labor and imagination, taking his identity from them and finding peace in his own invented world. *Le luxe II*, for example, is in the upper right corner, and a ceramic plate that Matisse painted with a recumbent nude is in the lower left. Matisse depicted his paintings with their actual colors, while turning the walls of his Issy studio from white to red. The paintings float in that red like the bright spots of color we see when we close our eyes after looking at the sun.

In the painting's center, the round, handless face of the grandfather clock suggests the suspension of time in Matisse's art. Since like a pivot it keeps all the other objects circling, it also suggests the passage of time in his life as, distributed around the clock, Matisse's artworks replace the clock's illegible numbers as time's markers. Past and future are encompassed by finished pictures and an empty frame leaning against the wall. *The Red Studio* is thus a picture of the life Matisse would later describe as "extremely regular work every day, from morning until evening."

As in *Dance II,* we are invited to enter the picture, this time through an opening along the painting's lower edge, where no furniture blocks our passage. The only living thing we find in the red room is the green nasturtium, leaping like a genie out of a vase that resembles an Aladdin's lamp and looping around Matisse's 1906 sculpture of a nude with bent upraised arms. The neck of the nasturtium vase penetrates a 1911 painting of a recumbent nude surrounded by flowers (*Large Nude,* later destroyed). Matisse seems to suggest a duality between the painted nude and the nude sculpture surrounded by nasturtium leaves, between nature (the nasturtium) and art (the paintings and sculptures). Compared to nature, art is a pale reflection. We know that Matisse had such contrasts on his mind in 1911 from the comparison he made between the color of paintings and the color of flowers: "Sometimes I put flowers right alongside my paintings," he said, "and how poor and dull all my colors seem!"

That *The Red Studio* is about art making is suggested also by the prominent place on the table given to the box of pencils that point the way

into the picture and that might even be seen as playing the role of cutlery in a place setting consisting of the plate and the glass. Two pencils have been taken out of the box and are ready to use. Instead of *Harmony in Red*'s table set for a meal, *The Red Studio* offers a table set for art. Among other art ingredients set on this table are the elements of circle versus square (in the plate and the pencil box); closed versus transparent volume (in the vase and the glass); and drawing versus sculpture (in the nude sketched on the plate and the nude modeled in clay). In the studio's far corner this series of oppositions continues in the plaster and bronze sculptures placed on stools, which seem to carry on a dialogue about darkness and light. All of these art elements are sustained by the red that floods the studio's space.

As he had done with *Harmony in Red*, Matisse changed the color of *The Red Studio*: originally it was blue-green. "I find that all these things, flowers, furniture, the chest of drawers, only become what they are to me when I see them together with the color red. Why such is the case I do not know." Matisse clearly loved red and, as Jack Flam has noted, associated himself with this color. As another Matisse scholar, John Elderfield, has suggested, the red could come from a perceptual color substitution that occurred when Matisse moved from the green of his garden into his bright white studio. To an interviewer in 1920, Matisse offered still another explanation for his nonimitative colors. He called the flowers in his garden at Issy "the best lessons in color composition":

> The flowers often give me impressions of color that are indelibly burnt onto my retina. Then, one day when I stand, palette in hand, before a composition and know only approximately which color I should apply, a memory like that may appear in my mind's eye and come to my aid, give me a start. In that way, I, too, become a naturalist, if you can call it naturalist to listen to one's memories and to the selective instinct that is so closely related to all creative talent.

When in 1911 a visitor to his studio questioned him about the red in *The Red Studio*, he said, "You are looking for the red wall. That wall doesn't exist at all! As you can see here, I painted the same furniture against

a purely blue-gray studio wall. . . . As paintings they did not satisfy me. When I found the color red, I put these studies in the corner, and there they remain. . . . Where did I take this red color from? My goodness, I don't know."

Red clearly answered to many impulses, but it is, most important, the color of light seen through closed eyelids, the color of reverie: it is the medium for imaginings formed behind shut eyes. To help his students find the "essential character" of their subject rather than simply recording nature's appearances, Matisse once advised them, "Close your eyes and visualize the picture; then go to work."

Soon after finishing *The Red Studio*, Matisse, still plagued with insomnia and in need of change and rest, visited Shchukin in Moscow. Here he was full of enthusiasm for Russian icons. Although he was not religious in any formal sense, he had what he called a "religious awe toward life," and he once said, "All art worthy of the name is religious." The simplicity and abstractness with which icons expressed religious passion must have affected him deeply.

In Moscow he was distressed to see the way Shchukin had framed his paintings with glass and hung them tilted from the wall at a forty-five-degree angle to avoid reflections. He persuaded his patron to change the hanging, but he could not convince him to remove the spot of red paint that covered the sex of the flutist in *Music*. Another cause of unhappiness was a negative article about his art in the Russian press. It reminded him of something he had known for several years: that he was no longer the leader of the avant-garde. His work had not generated a movement, as had Picasso's. Gertrude Stein, feeling that Matisse had stopped venturing onto new terrain, now focused her friendship and patronage on Picasso, and even Picasso was not averse to suggesting that Matisse was lagging behind. The Russian article said, "Matisse is by no means the innovator he is usually thought to be. . . . Matisse is, as his Cubist counterpart Pablo Picasso calls him, a necktie: his beauty is all on the surface. He has not created a genuine school."

PORTRAIT OF MADAME MATISSE (Issy-les-Moulineaux, 1913). Oil on canvas, 57″ × 38⅛″.

Signs That Arise from Feeling

n January 1912, Matisse and Amélie, accompanied by Albert Marquet, visited Tangier in Morocco. Glad to get away from Paris, where Cubism had taken center stage, Matisse also wanted to renew his contact with nature and to experience again North Africa's brilliant light. He was intrigued as well by Morocco's Islamic culture and by Delacroix's fascination with Arab life in Morocco eighty years before. He and Marquet continued the tradition of the nineteenth-century Frenchman exploring the exoticism and "primitivism" of France's North African colonies. In Tangier, perhaps to allow free range to his appetite for local color, he painted in a less abstract manner, while at the same time continuing to flatten space.

During the first few weeks in Morocco, it rained and Matisse was distraught. Even in good weather, his creative process was full of miseries. On March 16 he wrote to Gertrude Stein, "Painting is always very hard for me—always this struggle—it is natural? Yes, but why have so much of it? It's so sweet when it comes of its own accord." When the sun came out, he painted his favorite theme, an open window, which showed the view from

103

his hilltop hotel room looking out over the city. In *Window at Tangier,* the walls of the Casbah can be seen beyond the green roof and tower of Saint Andrew's English Church (plate 12). The surrounding hills are a tawny yellow, what he called "the color of lionskin," and the shadowed areas are filled with a throbbing blue that floods and unites all of space, from the sky and distant bay to the windowsill to the interior. As in *The Open Window,* he brings the outside in, and we are caught up in an ecstatic blueness. It is as if, after weeks of rain, Matisse were overwhelmed by the cobalt sky. He wrote to Camoin: ". . . we are enjoying the good weather and the vegetation which is absolutely luxuriant . . . the light is so soft, it is completely different from the Mediterranean."

Moving his easel from his hotel room to the medina, or Arab quarter, Matisse painted *The Casbah Gate* (plate 14). The subject is, in fact, not the main gate to the Casbah but rather a lookout gate situated inside the medina. Like *Window at Tangier* the painting brims with blue light that dematerializes the walls, the ground, and the Arab seated at the gate's portal. Its brightness is set ringing by the oval of light (actually a depiction of a circular pattern in the cobblestones beneath the gate), which echoes both the rounded arch and the Arab's roundness. The blue is intensified also by the geometric patch of sunshine that turns the ground pink as it moves through the gate toward us. The pink shape's flatness and brilliance pull the distant buildings seen through the gate's opening into the foreground so that, as in Matisse's open-window paintings, what is far away seems near.

Like Delacroix before him, Matisse delighted in the beauty and color of Arab costumes—indeed, perhaps prompted by his memories of Biskra, he had already painted a costumed *Algerian Woman* in 1909. In Tangier he produced a series of portraits of sumptuously dressed Moroccan men and women. *Zorah Standing,* for example, is an iconic portrait of a young girl whom he discovered in the medina and who, because she was a prostitute, did not have to wear a veil. Matisse painted Zorah three times on his first trip to Morocco, but when he returned in October 1912, she had disappeared. After making many inquiries, he found her in a brothel. When Matisse and Camoin, his old friend from student years who had joined him

in Morocco, went on painting expeditions to brothels, Matisse would warn his companion, "Be careful, we have to go there like doctors making a house call."

Having persuaded Zorah to pose again, Matisse produced *Zorah on the Terrace*, in which space is divided into geometric planes of shimmering color (plate 13). "Morocco had excited all my senses," Matisse later recalled. ". . . The intoxicating sun long held me in its spell." Dazzled by light, Matisse invented colors so luminous that the material world seems to melt away. Years later, this kind of bold, nearly abstract composition would be inspirational for American abstractionists such as Robert Motherwell and Richard Diebenkorn. Mark Rothko, too, would infuse Matissean luminosity with his own Abstract Expressionist aspirations toward spiritual transcendence.

Kneeling on her enclosed terrace, Zorah is shaped like an Islamic enamel vase: her head could be the stopper. To the left of the rug upon which Zorah sits are her slippers, which, because no ground line divides the terrace floor from the wall, seem to float in space as freely as the goldfish suspended in their bowl. The yellow-and-blue lozenge pattern on Zorah's dress echoes the slippers and has all the shimmer of fish scales. Although he gave Zorah great charm, his model apparently irritated him. He wrote to Camoin: "I have begun to paint a Moorish woman on a terrrace, to make a pendant to the little Moroccan from last year, but lots of wind and an annoying model have thwarted me. . . . I took my canvas home and I did not dare turn it around afterward for fear of dissatisfaction. It is a decorative canvas that I ought to make and I think that it will be, but I would have wanted something more."

Goldfish bowls were common in Morocco. Matisse was intrigued with the way Arab men spent hours contemplating them. No doubt the Arabs' calm and leisure impressed the tense, hard-working Matisse. Henceforth, goldfish bowls appear frequently in his interiors and still lifes. Like his open-window motif (or like a painting), the fishbowl contains and frames a fragment of life. Like two red strokes, the fish hang in space, catching our eye with their beauty.

But could Matisse have had another reason for placing the goldfish bowl beside Zorah? Could these objects of pleasure and contemplation trapped in the bowl refer to Zorah's resplendent but unfree life? The girl's posture is certainly self-enclosed and static, and her slippers, which could offer her the possibility of escape, are set in a separate and unavailable space. Matisse probably would have laughed at such an interpretation; he always insisted his message was expressed in form and color, not in the subject depicted. Still, the fishbowl's presence on Zorah's walled-in terrace has an odd poignancy and suggests the combination of confinement and unrootedness in this child's situation.

In March, after the rains stopped and Morocco's foliage reached its full luxuriance, Matisse took his easel to a large private garden attached to the Villa Brooks and painted *Park at Tangier*, another predominantly blue-and-pink canvas and one of his most sensuously beautiful works. It depicts a kind of dreamland that is not far away and unavailable, but rather made utterly present by the formal device of bringing near and far together on a single plane. The picture surface is asserted by linking near and far arabesques and by imbedding strokes in, or making them transparent against, a richly painted ground. As in Cézanne's landscapes, the sky moves forward between the limbs of trees, and surface unity is achieved also by painting the sky pink on top of blue, while below a blue earth overlays a pink ground. The effect is a Rothko-like radiance of colored light that moves out to embrace the viewer.

Park at Tangier reveals Matisse's astonishment at Morocco's lush and varied vegetation. A passionate gardener who carefully observed and learned from plants, Matisse recalled, "I had never seen an acanthus before. I only knew the acanthus through the drawings of Corinthian capitals that I had done at the École des Beaux-Arts." He worked at the Villa Brooks for over a month and then reworked *Park at Tangier* in the studio. After his return to Paris in April, when friends responded to the painting with delight, Matisse insisted that it was unequal to nature's beauty: "That's not how it is, it's better than that," he said. "You'll see next year when I rework it." Fortunately, upon his return to Tangier in early October, he found the

PARK AT TANGIER (Tangier, 1912). Oil on canvas, 46½″ × 31½″.

Villa Brooks garden parched from the dry-season sun, so he left the canvas alone and instead produced two landscapes in browns and ochers.

Amélie Matisse had not accompanied her husband on this second trip to Morocco, and she was not pleased to have been left alone so long at Issy. Matisse's friends Marquet and Camoin went to Issy at Matisse's request and tried to persuade her to be patient. When good weather and good progress in his work prompted Matisse to prolong his stay, Madame Matisse and Camoin joined him in January 1913. Toward the end of January it began to rain, and, oppressed by the weather, the following month the Matisses sailed to France, where they saw Matisse's mother in Menton. From there they went to Corsica, their honeymoon place, before returning to Paris in the spring of 1913.

When Matisse exhibited his Moroccan paintings at Bernheim-Jeune in mid-April, *Zorah on the Terrace* became part of a triptych with *Window at Tangier* and *The Casbah Gate*, in which the gate's opening is shaped like Zorah upside-down. The three panels were bought by Ivan Morosov, Shchukin's friend, for his home in Moscow. A number of the Moroccan canvases went to Shchukin, and the rest were purchased by Germans and Scandinavians. Critical reception was good, but other "isms" such as Cubism, Orphism, and Futurism had replaced Fauvism as the focus of vanguard controversy, and a recently published book by the critic André Salmon spoke of Matisse's art as inconsistent, "incoherent," "nihilistic," and, unlike Picasso's, "without a logical effort toward style." Ignoring the moral force that drove Matisse toward a decorative synthesis, Salmon said, "[Matisse has the] taste of a milliner; his love of color is the same as a love for chiffon."

The United States was late to realize that Matisse was no longer on the cutting edge, and when a group of his paintings was included in the huge international exhibition of modern art named the Armory Show, which opened in New York in 1913 and traveled to Chicago and Boston, Matisse was singled out for especially virulent attack. His pictures were called "coarse," "perverse," "monstrous," "epileptic," and "revolting in their in-

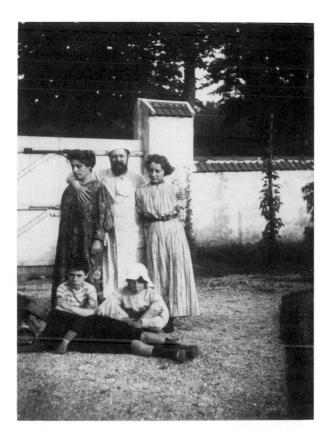

MATISSE WITH HIS FAMILY
AND A SON'S FRIEND IN
THE GARDEN AT ISSY-LES-
MOULINEAUX, C. 1911.

humanity." Students at the Art Institute of Chicago burned effigies of his *Blue Nude: Memory of Biskra* and his *Le luxe II*, both painted in 1907.

Around 1913, under the influence of Cubism, Matisse's paintings became less sensuous, more abstract, more rectilinear in structure, and more sober in color. Back in Issy in 1913, he painted *The Blue Window* (plate 15), which depicts the view from his bedroom and recalls *Window at Tangier* in its conflation of near and far into one palpitating blue field. Objects set on a mantelpiece in front of the window are difficult to decipher: from left to right they represent a vase, a shell, a vase of flowers placed on a dish, a reproduction of an antique sculpture of a head, a lamp with what may be a slate or a mirror in front of it, and in the foreground a

dish with a brooch and some other trinket. (Or is that small yellow stroke a mere reflection?)

The yellow object is the same shape and color as the gable end of Matisse's studio, which can be seen above the trees at the far end of the garden. *The Blue Window* is a perfect example of the way Matisse keeps things flat by rhyming shapes. The viewer's eye links these geometric shapes across the picture surface rather than perceiving them in depth. When shapes are rhymed in an Analytic Cubist picture, they are usually flat geometric planes that indicate one aspect or fragment of an object that has been "analyzed," or broken down into numerous facets. Matisse's rhyming shapes tend to be discrete objects. Thus, in *The Blue Window* the base of the sculpture and the blackboard/mirror are square like the window itself, and various circles, ovals, and arcs (plates, trees, flowers, and an oval cloud) keep the viewer's eye moving from one rounded shape to another.

Likewise, Matisse created a simpler and more naturalistic version of the Cubist grid by setting a series of vertical lines (window jambs, etc.) against the horizontal of the window ledge. He denied the window view's depth by painting the dark tree trunks so that they lead directly to the tops of the sculpted head and the lamp, seeming at first to be part of them. Since this goes against all classical rules of composition, which Matisse knew well, we can be sure it is a deliberate and purposeful pictorial witticism. Because the perspective lines of the mantelpiece are not defined, the green vase on the left floats against a seemingly flat vertical blue band, like Zorah's slippers in *Zorah on the Terrace*. The yellow, green, and red shapes suspended in a luminous expanse of blue create a serene, almost celestial harmony that recalls Matisse's statement "I go toward sentiment, toward ecstasy. . . . And there I find calm."

In the summer and early fall of 1913, Matisse struggled with one of the most beautiful and moving of his Cubist-inspired paintings. *Portrait of Madame Matisse* (page 102), which took over one hundred sittings, began as a quite realistic portrait that greatly pleased Amélie Matisse. As it progressed, however, this last portrait of Amélie became more and more abstract. Her

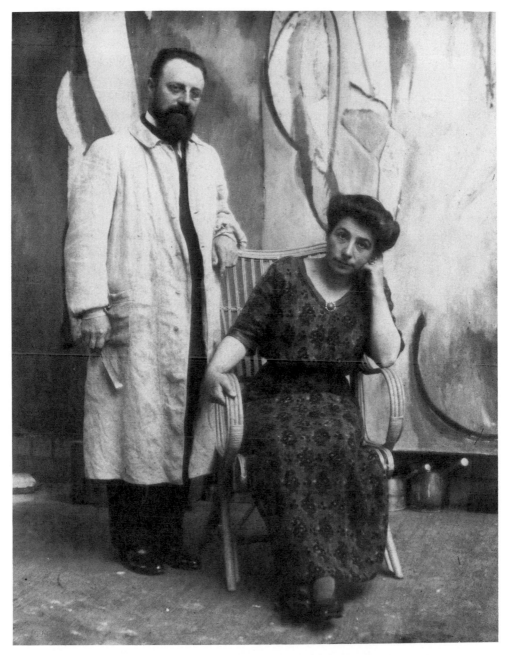

MATISSE AND MADAME MATISSE AT THE ISSY-LES-MOULINEAUX STUDIO, IN FRONT OF THE
UNFINISHED *Bathers by a River*, May 1913. Photograph by
Alvin Langdon Coburn.

face is turned into a pale oval, like a Japanese Noh mask. Her narrow lips and almond-shaped eyes inscribed in black are highly schematized, yet her gentle, resigned nature is vividly present. In making portraits, Matisse said, he tried to "penetrate amid the lines of the face those which suggest the deep gravity which persists in every human being." He has immortalized his wife, but has he, in this portrait, loved and enjoyed her? The lusty handling of his 1905 *The Woman with the Hat* is gone. The 1913 portrait is tender but not intimate. Amélie seems as remote and untouchable as the saints in Byzantine icons he had admired in Russia. As she watched her portrait change over the months, Madame Matisse wept for the loss of her recognizable image.

Her figure is an arrangement of simple, flat forms that do not carry flesh-and-blood substance. Her arms are stiff; her knees are primly crossed. Her oval head and her alert, upright posture bring to mind Cézanne's similarly distilled and distant portraits of his wife, one of which Matisse eventually owned. Madame Matisse has elegance and poise, not sensuousness. Indeed, her pillbox hat, with its plume and its pink flower, is the most tangible shape on the canvas.

The portrait's overall gray tonality relates to Analytic Cubism's reduction of color to browns and grays in order to emphasize structure. Its mood could not be more different from that of *The Red Studio* or the Moroccan paintings. Indeed, when he painted it, Matisse was depressed, irascible, and full of self-doubt. At first he had been unable to decide whether to send *Portrait of Madame Matisse* to the Salon d'Automne. In November, when it was hanging as his sole entry to the Salon and critics responded favorably, he wrote to Camoin, "By chance my painting (the portrait of my wife) has had a certain success among the vanguard. But it does not satisfy me at all, it is the beginning of a very painful effort."

In his November letter to Camoin, Matisse said that the weather had been so gray and heavy that it made him "disgusted with life." The "sadness of the Parisian winter," he said, was the equivalent of a "demi-suicide." He went on: "I hadn't worked for at least two weeks, and to keep from falling into blackness I set myself to it yesterday, Sunday. I hired a model and I am doing a nude. This morning, second sitting, the beginning

of anxiety." Matisse's paintings of this period reveal the uneasiness he felt as he struggled with Cubist ideas. Many parts of his canvases are scratched out and repainted. Nothing seemed to please him, neither his own work nor that of other artists he saw at the Salon. "The truth is," he said to Camoin, "that Painting is quite a disappointing thing."

The moment of Cubism was a period of conflict for Matisse. Although Cubism fascinated him, and he acknowledged that it "had a function in fighting the deliquescence of Impressionism," the new mode made him nervous, perhaps because its transformation of space and structure was so different from his reinvention of the world through color. He saw a lot of the Cubists, especially Picasso and the Spanish-born Juan Gris, and his intellectual exchange with them was important to him. Of Picasso, he said, "There is no question that we each benefited from the other. I think that ultimately, there was a reciprocal interpenetration between our different paths."

Fernande Olivier wrote, "[Matisse and Picasso] clashed over the birth of Cubism; a subject which managed to startle Matisse out of his normal calm. He lost his temper and talked of getting even with Picasso, of making him beg for mercy. None of this prevented him, some months later, when the new developments in the Spanish painter's work began to bear fruit, from attempting to see some similarity in their artistic ideas." No doubt his long-standing rivalry with Picasso was exacerbated by Cubism's hegemony, but he could make light of it. Once upon entering La Coupole, a favorite artists' restaurant in Montparnasse, and seeing the flurry of excitement he caused, Matisse said, "On me prend pour Picasso" (they take me for Picasso). Later, around 1952, Matisse was able to admit his unhappiness over Cubism's preeminence:

> A difficult watershed for me was the period of Cubism's triumph....
> I was virtually alone in not participating in the others' experiment—
> Cubism—in not joining the direction that was acquiring more and more
> followers and whose prestige was becoming increasingly widespread....
> I was entrenched in my pursuits: experimentation, liberalization, color,
> problems of color-as-energy, of color-as-light. Of course, Cubism

interested me, but it did not speak to my deeply sensory nature, to the great lover that I am of line, of the arabesque, those bearers of life. . . . For me to turn toward Cubism would have been to go counter to my artistic ideas.

Matisse was too in love with the sensuous appearance of things to adopt a language as intellectually distanced as Cubism. As John Elderfield has noted, Cubism involves an opposition between reality and its representation, whereas in Matisse's view, the two are intimately intertwined. "Rapport," said Matisse, "is the affinity between things. . . . rapport is love, yes, love."

Matisse's depressed state of mind in the fall and winter of 1913–1914 is revealed in the dark gray tonality of several of his paintings. One visitor to his studio at this time recalled seeing a reproduction of Andrea Mantegna's *Dead Christ* hanging in Matisse's bedroom. As always, Paris's dank, gray winter pained him. He planned to escape the northern winter's bleakness and return to the intense sunlight of Tangier. But when he went to say good-bye to Marquet, who still lived at 19 quai Saint-Michel, he discovered that the studio on the floor below had just become available. He went home to Issy and told Amélie, "We're not going any more, I've rented a studio below Marquet's." Her response is not recorded. When Matisse made up his mind to do something or go someplace for the sake of his art, other people's needs and feelings were secondary. He explained his decision to stay in Paris in his November letter to Camoin: "I have to involve myself in highly concentrated work." He was delighted to be back in his old building with its view of the Seine and the Cathedral of Notre-Dame and to participate in the art world of Paris. To another friend he wrote, "It's a great pleasure to have new sensations in a familiar place."

In the spring of 1914, Matisse returned to a subject he had explored at the beginning of the century while living with his wife and young children at 19 quai Saint-Michel. He painted two views of Notre-Dame with the bridge called the Petit Pont below it and the barges lined up along quays that provided walkways at the river's edge. The first version is a thinly painted and rather conventional view. The more abstract second version

transforms the cathedral into a simple cubic mass (plate 16). The trees that lined the quay in the first version are here clumped together to form a bright green oval, and the bridge is just two black horizontal lines above an arc. Two diagonals indicate the barges and the quay; since the longer diagonal both recedes into depth and lies across the canvas surface, it seems ready to snap forward like a spring and to propel the cathedral toward us.

Two blue bands, a horizontal one that defines the bridge and a vertical one that defines the edge of Matisse's studio window, give the second version of *View of Notre-Dame* its scaffold. These axes reaffirm the edges of the canvas which to Matisse were part of his design. The blue that covers almost the entire canvas is brushed in the same brusque, exacerbated way regardless of what is represented. Matisse was not afraid of mistakes and, as the *pentimenti* in this canvas show, he did not bother to hide them. The boldness with which he revealed his painterly process is part of what he called his "sincerity."

Notre-Dame seems to hang in the painting's blue space like a hallucinatory vision. Part of it is left white. Part is a transparent blue through which, in a nod to Cubist transparency and simultaneity (seeing more than one aspect of an object at once), we can see lines that define the structure of the church, which should be hidden behind the facade. Above and behind the cathedral's towers, a black cloud gathers. Black shadows on the towers have been partially scratched away, augmenting the tension. The painting's ominous mood suggests the imminence of war. Hanging in the sky, Notre-Dame is like a fortress of hope in a threatened world.

That summer, German troops occupied Luxembourg and crossed the French border, and on August 3, 1914, World War I was declared. The forty-four-year-old Matisse reported for military service but was rejected. In mid-August the Allies retreated from Picardy, and Le Cateau (where Matisse's mother, who had heart trouble, lived) was taken by the Germans. Matisse had no news of his mother or of his brother, who had in fact become a German hostage. As the Germans advanced toward Paris, the Matisses sent their three children to Amélie's parents in Toulouse. In the beginning of September, Matisse and Amélie headed south as well. After a brief stay in Toulouse, they moved into a villa at Collioure. Here they saw

a great deal of Marquet and of Gris, whom Matisse tried to help financially, since Gris's dealer, D. H. Kahnweiler, was a German and had to leave France. Matisse's conversations with the highly articulate Gris were important to his artistic development, fueling his love-hate relationship with Cubism. Gris wrote to Kahnweiler, "We argue so heatedly about painting that Marquet can hardly sit still for boredom."

Matisse was deeply upset by the war. His sons would soon be of draft age. Many of his younger friends—Camoin, Derain, Braque, and Vlaminck—were in the army, and he had heard that Derain had been wounded. Wishing to be able to play a more active role, he asked his friend and patron Marcel Sembat, who was now minister of public works, what he could do to help the war effort. "Go on painting good pictures," Sembat advised, but Matisse was too anxious to produce much work.

However, he did produce one great painting during his weeks at Collioure before returning with his family to Paris and Issy in late October. *Open Window, Collioure* expresses his despair in bold, nearly abstract terms (plate 17). The center of the picture is a broad band of dense black, an opening that neither invites us to enter nor keeps us out. None of Matisse's usual flower vases sit on the narrow brown sill to mediate between inside and outside space. The black, which began to dominate Matisse's palette during the war years, does not recede as black usually does, but rather it holds to the canvas surface like the other colors: we can read it either as a flat plane or as deep space.

To the eye used to American abstract art of the 1950s and 1960s, especially the paintings composed of stripes of color by Barnett Newman and Kenneth Noland (both of whom were inspired by Matisse), *Open Window, Collioure* might look purely abstract. But Matisse was too French, too fascinated by the materiality of his surroundings, to let go of the object. The blue vertical band with horizontal lines represents a closed shutter. The gray band to the right must be an open shutter, and the green vertical is part of a wall. What is left ambiguous is whether we are on the outside looking in or on the inside looking out. This uncertainty vividly conveys Matisse's own unease, heightened by the uncertainties of war.

116

Back in his Paris studio, Matisse was still too agitated to concentrate on painting. He couldn't sleep and his exhaustion sometimes led to migraines. He worked on drawings and small portrait etchings, and he hired a violin teacher to help him relearn the instrument of his youth. Perhaps as an escape—for Matisse could find calm only by keeping busy— he practiced works by Bach, Vivaldi, and Corelli with such obsessive zeal that he wore himself out.

One painting he did produce at this time was *Artist and Goldfish*, a powerful Cubist-inspired interior containing a still life on a table placed in front of a window and, to the right, the artist—so abstracted as to be almost unrecognizable as a figure. In October he sent a postcard of Albrecht Dürer's engraving *St. Jerome in His Study* to Camoin, who was in the army. No doubt he identified with the saint's solitary and intense concentration on work. On the back he sketched himself with a palette sitting before a goldfish bowl and wrote: "I'm doing a picture, it's my picture of the *Goldfish* that I'm redoing with a person who has a palette in his hand and who observes." In a later letter to Camoin, he wrote, "I've already done quite a few things to my picture. It's quite a bit firmer than when you saw it. . . . I'm pleased with my picture, which comes back to me in the midst of all this mental activity. Is it weakness or blindness on my part? Possibly." Some of Matisse's "mental activity" concerned the conflict he felt between the rational, intellectual approach to art that he saw in Cubism and a more emotional approach. In his letter to Camoin he spoke of art as intellectual ("scientific") invention versus "signs that arise from feeling." It was diffi- cult for Matisse to go against his natural inclination toward the expression of feeling through color in order to absorb and transform Cubist ideas. In the letter to Camoin he noted that he was "a Romantic," but he went on to say, "a good half of me is a scientist, a rationalist, and that's what causes the struggle from which I sometimes emerge the victor, but exhausted."

This struggle is evident in *Artist and Goldfish*. In this odd self-portrait all we can see of Matisse are his bent legs, which project into the canvas from the right edge, and his left arm, which is drawn with three diagonal black lines. This arm holds a rectangular palette through whose hole his

ARTIST AND GOLDFISH (Paris, 1914). Oil on canvas, 57¾" × 44¼".

thumb protrudes. His painting arm is missing; so are his easel and his canvas. Perhaps Matisse did not represent his canvas on the easel in this studio interior because he conflated it with the motif he was depicting—the still life with the goldfish bowl. If this is so, we can imagine that the still life of fish, plant, and orange suspended against the broad black band stands

WHITE AND PINK HEAD (Paris, 1914–15). Oil on canvas, 29½″ × 18½″.

for the missing canvas. In that case, the open window in *Artist and Goldfish* does not suggest a painting within a painting; rather, it *is* the painting: two moments and two realities are joined.

In *Artist and Goldfish*'s upper right corner, the web of black lines— some of which are filled in with flesh-color, white, and black—has been seen as a Cubistic rendering of the upper part of the artist's figure. That interpretation is not entirely convincing; the arrangement of lines seems to depart even further from reality than Matisse was wont to do even in con- temporaneous works like *White and Pink Head*, a portrait in which Marguerite is schematized into a Cubist structure of lines and planes. Perhaps another interpretation will seem still more farfetched: the black

119

lines do not stand for the artist's head or upper body but rather for his observing mind. The diagonal lines, which converge on a black triangle and project down toward the palette and up toward the open window motif, seem to convey the drama and tension of artistic focus; indeed, they could be trajectories of vision, the artist's gaze looking out and in at the same time.

The black cross made by two of these lines offers another iconographic conundrum. It is too obviously a Christian cross for Matisse not to have been aware of its symbolic resonance. Given its position to the right of the open studio window, it could refer to Notre-Dame, which Matisse could see when he looked out his studio window and to the right. Or it could refer to the cross on St. Jerome's worktable in the Dürer engraving and to the calvary of making art. (Matisse is known to have read and identified with Thomas à Kempis's *Imitation of Christ,* which became in later years his favorite bedside reading.) But all of these interpretations seem contrived. Matisse, as we have noted, was something of a formalist; his meaning, he said, was in colors and forms, not couched in symbols: "A work of art must carry within itself its complete significance and impose that upon the beholder even before he recognizes the subject."

Artist and Goldfish is almost as forbidding a depiction of a window as *Open Window, Collioure* painted earlier that year. And it is nearly as ambiguous. It is not clear, for example, whether the vertical band of black falls in front of or behind the window grill. If the blue on either side of the black represents the outdoors, then what does the black band cutting into it stand for? And when this black band continues into the room's interior and crosses the white floor like a beam of light, why isn't it white? It is as if the visible world were turned inside out and seen in negative: there is darkness where there should be light, and light where there should be shadow. Equally strange (but a familiar device in Cubism), what is solid and opaque becomes transparent. You can see through the left edge of the table to the blue outside, and you can see through the palette to the artist's hand and arm. Paradoxically the transparent glass fishbowl is painted opaque white.

The prominence of black in Matisse's paintings from the war years recalls the gloom he felt about dark Paris winters—his fear of "falling into blackness." His friend the poet Max Jacob gave a good picture of wartime conditions: "Paris is dark at three in the afternoon. Each day is like Sunday; absinthe has been outlawed, there's only one kind of bread to eat, hardly any films to see, and no one dresses up or plays music." Matisse must have been longing for the South, but the war made travel increasingly difficult.

Enclosed in his studio, he tried to banish the war and to concentrate on painting an artificial world—fish not in a stream but in a bowl, foliage and an orange not in nature but placed in still life. Like the other studio interiors done at the quai Saint-Michel between 1914 and 1917, *Artist and Goldfish* conveys a mood of wintry isolation. Matisse himself seems to have felt as shut in as the two fish. Compared to earlier goldfish paintings like *Goldfish and Sculpture* (1912, see cover), the interior space in *Artist and Goldfish* is tight and closed. In the 1912 painting gold and green pour in through the open window to light up the studio. By contrast, in *Artist and Goldfish,* as in *Studio under the Eaves,* inside and outside are separate—if anything, the former's window view only ushers darkness into the room. Like the goldfish, Matisse looked out on the world from the confines of his studio and his self. But the bright red fish form a couple, whereas one senses that Matisse in his studio felt very much alone. Indeed, one friend observed that Matisse, always a bit separate from life, was something like a fish looking out from a glass bowl. Describing himself in 1947, Matisse said that he faced life with a "reserve" that protected him from "an uncontrolled surrender to it" and that he remained "an attentive spectator of life and of himself."

In 1916 Matisse became more productive, and he painted some of his largest and most ambitious works. One of them, *The Moroccans,* is based on his memories of Tangier. In February, he wrote to Camoin that he was working on a picture of the terrace of a little café in the Casbah with "languid idlers chatting toward the end of the day." The painting is divided into three sections. An architectural section at the top left contains a domed

THE MOROCCANS (Issy-les-Moulineaux, 1915–16). Oil on canvas, 71 ⅜″ × 9′ 2″.

temple and a vase with striped blue flowers. In the lower left, melons lie on a pavement or hang on a trellis; these melons have also been seen as Moroccans touching their foreheads to the ground in prayer, and though Matisse called them melons and gourds, it is unlikely that he missed their resemblance to praying Arabs. The right-hand section shows the café terrace with Moroccans seated on the floor. A man with a white turban— round as a melon, round as the dome or the flowers—sits with his back to us. The others are so abstract as to be mere hieroglyphs.

The Moroccans is composed somewhat like a Cubist collage. Over the past four years Matisse had watched and admired Picasso's development from Analytic to Synthetic Cubism. In Analytic Cubism an object is broken down into small, transparent planes that oscillate in a shallow space. In Synthetic Cubism, which developed out of collage, the object is built up by putting together abstract geometric shapes. Similarly, in *The Moroccans* Matisse seems to have built up his image out of abstract shapes,

and his space is conceptual, not perceptual: it is created by assembling separate abstract parts. This way of conceiving a painting is prophetic of his later habit of mapping out his paintings by moving around cut-paper shapes, a technique he began to use in the early 1930s and compared to moving pieces around a chessboard. For Matisse, who tended to see things in wholes, this creative procedure took enormous deliberation. He described the process as a battle: "I may not be in the trenches," he wrote to Camoin in January 1916, "but I am in one of my own making."

One of the things that had drawn Matisse to Morocco was its intense light, but in *The Moroccans* background space is black, an extraordinarily rich black that is made all the more vibrant by its interplay with white, green, and a cyclamen purple, and that is put under enormous spatial pressure by its mediation between surface and depth. In his paintings of this period Matisse began, he said, to "use pure black as a color of light and not as a color of darkness." In 1946 he asked a friend, "Doesn't my painting of the Moroccans use a grand black which is as luminous as the other colors in the painting?" With his paradoxical black he evoked the glare of Moroccan light, which creates an equally intense darkness in the shadows.

The Piano Lesson is another picture from 1916 that involves memory, this time a memory closer to home (plate 18). Though the boy at the piano is Pierre, Matisse transformed his sixteen-year-old son into a much younger boy. As the painting shows, Pierre was always reluctant to practice as he was expected to do for nine hours a day. Matisse wanted both his sons to be musicians. Jean took cello lessons and Pierre was removed from school at the age of fifteen so that he could devote himself to the violin. Pierre Matisse recalled, "When he [Matisse] wanted one to be a musician, he wouldn't hear the word 'no.' I was twelve already, and I couldn't hope to be any good, but he said that he had begun painting late, so why couldn't I begin the piano late. Luckily, World War One saved me from disgrace in that domain."

This large canvas, one of Matisse's most loved works, also reflects the artist's present life at Issy. The Pleyel piano is set before a window opening onto the garden, which is reduced to trapezoids of green and gray. The

painting's abstract harmony, with flat geometric planes measured according to the golden section, is as taut and alive as one of Piet Mondrian's geometric abstractions. The spirited curves of the music stand and the wrought-iron window grill (which does not spell NON or any other word) suggest music's rhythms moving through the room.

The Piano Lesson is both solemn and witty, serene and tense. Its structure is balanced and calm; the color, dominated by gray and pale blue, is subdued. But the near convergence of the sharp angles of the green and pink shapes at the place where black and gray angle in on each other is as explosive as the almost-touching hands in *Dance II*. And there is psychological tension as well. A triangular shadow cuts a wedge into the face of the sulky boy trapped behind the piano. The shadow echoes the shape of that tyrant of time, the metronome, which sits on the piano in front of him and has a presence as authoritative as an Egyptian pyramid. No doubt if the boy had his way he would be outside where the green grass lies, but interlocking verticals and horizontals create powerful compositional forces that keep him from moving. The flesh-colored vertical band above him even has a curved notch removed from the corner nearest his head: by echoing the roundness of the boy's head, the curve seems to clamp him in place.

Pierre is situated between two women; the white one above him is actually Matisse's grim, gray *Woman on a Stool* (1914). She seems to play the role of the music teacher—certainly she looks like a strict governess making sure the boy doesn't escape to the garden before his allotted practice time is done. Rigid and without sensuous substance, her body is mostly drawn, not painted, and the gray and blue splotches on her chest and knees reaffirm that she is pigment on canvas, not flesh and blood. Perhaps the woman on the stool stands for the boy's conscience. Since the boy has been seen by Flam as a "surrogate self-portrait"—a portrait in which Matisse projected his own conflicts and concerns onto the image of his son—the gray woman could stand for the rational side of Matisse and his art.

The other woman is her opposite. The warm brown nude tucked in the painting's lower left corner is likewise an artwork by Matisse. She

represents his 1908 bronze sculpture entitled *Decorative Figure*, and in *The Piano Lesson* she must stand for pleasure and the instinctual life. The boy is torn between duty (the straight-backed woman on the stool) and desire (the relaxed, curvaceous nude). In front of him on the piano, a brass candlestick and the gray metronome echo that antithesis. The metronome, which seems to balance and oppose the similarly shaped wedge of green grass, is still, solid, permanent; although it is not clear whether the candle is lit, a soft swirl of paint that could be flame or melted wax flows around the candlestick's top, suggesting warmth and movement. Both objects are measures of time. The metronome stands for discipline, obedience, and order; the candle for passion and imagination.

Matisse's color scheme reinforces the piano player's conflict: the warm fleshy ocher of his head is continued in the adjacent vertical band and, moving to the left and downward, in the candle and the nude. A series of cool pale blues pulls in the opposite direction. Two blue vertical bands that comprise the edge of the casement window frame and the wall block the boy's access to the garden and to the nude. Moving upward to the right, there is a blue brush stroke on the legs of the woman on the stool. The music book from which the boy is reading is blue as well. Blue seems to be the color of the spirit or the intellect, ocher the color of the senses.

In 1916 Matisse was faced with these conflicts in his life and in his art. He became fascinated with the sensuous Italian model Lorette, who appears in some fifty paintings between late 1916 and late 1917. Sometimes Lorette is luxuriantly sexual, as in various pictures in which she wears a chemise and lies on her back on the floor beside the small Moroccan style table upon which her coffee cup sits. With her fingers curled provocatively against her cheeks, she is the picture of contented abandonment. Other times, as in *The Studio, quai Saint-Michel* (1916–1917), she is represented merely as the artist's model—a motif, not a passion (plate 19). When she poses for Matisse in *The Painter in His Studio* (1916), she is featureless and anonymous. She wears a green robe, whereas, in an odd reversal of convention, the equally anonymous Matisse is nude. His youthful body suggests both a feeling of rejuvenation and a vulnerability—the sense of nakedness

LORETTE WITH COFFEE CUP
(Issy-les-Moulineaux, 1917).
Oil on canvas, 22½″ × 15¾″.

he might have felt in the act of painting a woman to whom he was attracted. His anonymity here and in other paintings where he is shown at work reminds the viewer of Matisse's insistence that when he painted, he lost himself through his emotional merging with his motif. It could also suggest Matisse's peculiar emotional aloofness—his way of masking personal feelings by projecting them into color, shape, texture, and line rather than into his recognizable subjects. This holding back is one of the things that give Matisse's seemingly open and direct paintings their enduring mystery.

There is a certain melancholy in many of Matisse's canvases from 1917. He was longing for the warmth and light of the South, and he felt

increasingly alienated in Paris and depressed by the war. His home in Issy did not offer much comfort. As Gertrude Stein observed, the Matisses were at this time "lonesome and troubled." Several family photographs show Amélie Matisse looking tired and sad, and she is often turned away from her husband. During the last few years she had been suffering from what is said to have been a psychosomatic illness. For the next two decades she was depressed, rarely went out, and, complaining of a bad back, spent most of her time lying down. Her fingers were swollen with rheumatism. Apparently she had some kind of vertebral disc problem that made her a

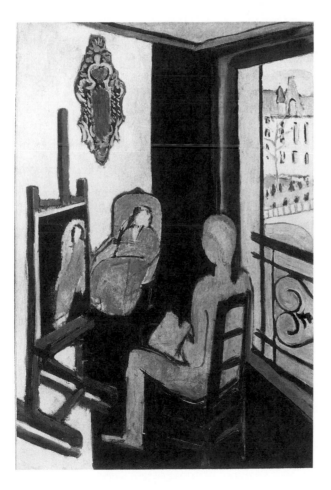

THE PAINTER IN HIS STUDIO
(Paris, 1916). Oil on canvas,
57⅝″ × 38 ¼″.

127

AMÉLIE MATISSE IN A
KIMONO (1914).
Etching, printed in
black, plate:
6 5⁄16″ × 2 ⅛″.

semi-invalid. It wasn't until 1939, when she and Matisse were formally separated, that her health was restored enough for her to lead an active life.

In 1917 Matisse no doubt felt helpless, guilty, and perhaps exasperated with his wife's condition. Anything that got in the way of his painting was an irritation to him. A 1914 etching he made of his forty-two-year-old wife in a kimono reveals his awareness of her depression. Compared to his earlier joyous depictions of her in a kimono in *The Terrace, Saint-Tropez* and *Woman in a Japanese Robe beside the Water* (1905), the etching makes her look old, stiff, bent with sorrow.

Matisse needed to escape, and in 1917 he began to spend his winters in Nice. Before he left Issy, he painted several canvases that express feelings of loss. One is *The Music Lesson* (1917), which is a second and more realistic version of *The Piano Lesson* from the previous year. It shows his family all together at Issy for the last time. Jean, who had just announced that he would report for military service in a few months, is seated, smoking and reading—as his posture shows, he is in a foul mood. Pierre plays the piano with Marguerite at his side. Madame Matisse is the small figure sitting outside in a bentwood rocking chair whose base, conflated with the circling pattern of the window's grillwork, suggests a wheelchair. On the piano Matisse's violin replaces the severe metronome. The portrait of the woman on the stool still hangs on the wall, but the woman has lost her controlling presence, for her head is cut off by the top of the canvas. The most extraordinary change is the enlargement of the bronze nude and its placement out-

THE MUSIC LESSON (Issy-les-Moulineaux, 1917).
Oil on canvas, 96 ⅜" × 79".

side in a lush garden setting. This Golden Age nude, luxuriating in her body, is opposed to the fully clothed Madame Matisse bent over her sewing on the opposite side of the pool.

For all the apparent relaxation of the family gathering—even the fluent, watercolor-like handling, which looks forward to Matisse's Nice style, is relaxed—the scene is full of tension and everybody seems alone. The reclining nude appears to be beckoning to Matisse, urging him to leave this well-ordered bourgeois home and to adventure into a more voluptuous life.

129

THE PINK MARBLE TABLE
(Issy-les-Moulineaux, 1917).
Oil on canvas, 57½″ × 38¼″.

Also in 1917, as though he were saying good-bye to familiar house-hold objects that he loved, Matisse painted several portraits of single objects. *The Pink Marble Table*, for example, evokes a feeling of incipient loss by showing a nearly empty table upon which an empty wire basket and three limes create an unabundant still life. Looming up in the Issy garden's crepuscular shadow, the table's pink marble surface looks as vulnerable as flesh as it absorbs all that is left of the dying light.

Matisse was fond of his palette of objects. He painted them again and again. Objects, like boulders in the stream of time, had been through what he called duration, the Bergsonian *durée.* It must have been hard for him to leave behind an object as sympathetic as the pink marble table, which he associated with the leisurely pastimes of bourgeois family life. The pleasure he took in it can be seen in his *Tea in the Garden,* painted in 1919 when he was home again for his regular summer sojourn with his family. This painting shows Marguerite and Matisse's model Antoinette Arnoux (whom he had brought to Issy from Nice) enjoying tea set on the marble

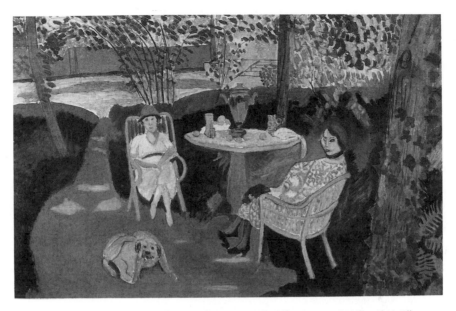

TEA IN THE GARDEN (Issy-les-Moulineaux, 1919). Oil on canvas, 55¼″ × 6′ 11¼″.

table. Even the Matisse family dog scratching his fleas suggests the familiar and unquestioned comforts of home. In 1951 Matisse spoke to a friend about his attachment to the pink marble table and to material things in general:

> Thus I have worked all my life before the same objects which continued to give me the force of reality by engaging my spirit towards everything that these objects had gone through for me and with me. The object is an actor: . . . an object can play a different role in ten different pictures. The object is not taken alone, it evokes an ensemble of elements. You reminded me of the [pink marble] table I painted isolated in a garden? . . . Well, it was representative of a whole open-air atmosphere in which I had lived.

Tree near Trivaux Pond, one of several Cézannesque landscapes done in a forest near Issy in the summer and early fall of 1917 (plate 20), has the same mood of gentle melancholy as *The Pink Marble Table*. Matisse has singled out a tree with several broken branches and surrounded it with

131

lesser trees half-obscured by grayish green mist. One can imagine the painter escaping to the forest to find peace and to ponder his forthcoming departure for Nice.

No doubt he escaped to the forest in his newly acquired 1911 Renault, for from these months in 1917 come a series of landscapes viewed from the window of a moving car, the first examples of this motif in the history of art. As his open-window paintings show, Matisse liked to be enclosed and alone, and at the same time to have before him a view of the world. Both his isolation and his pleasure in devouring the landscape while driving (and perhaps also his urge to move on in his own life) are expressed in *The Windowshield (Route de Villacoublay)*, painted before he drove south in 1917.

The complex of reasons for Matisse's move to the Riviera is not precisely known. We can conjecture that Matisse believed the move to Nice would be liberating for his painting, and that he was once again pursuing the perfect quality of light. No doubt he wanted to avoid the darkness and damp of the northern winters he found so depressing. Domestic tensions at home and his sense of confinement—perhaps even the longing for *luxe*,

MATISSE WITH FAMILY AND MONSIEUR PARAYRE, C. 1917.

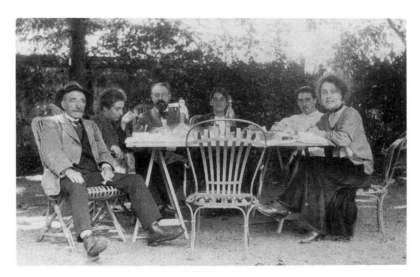

THE WINDOWSHIELD (ROUTE DE VILLACOUBLAY)
(Issy-les-Moulineaux, 1917). Oil on canvas, 15¼″ × 22″.

calme et volupté revealed in *The Music Lesson*—must have been motivating factors as well. "One can't live in a house too well kept, a house kept by country aunts," he once said (to explain his rejection of Divisionism). "One has to go off into the jungle to find simpler ways which won't stifle the spirit."

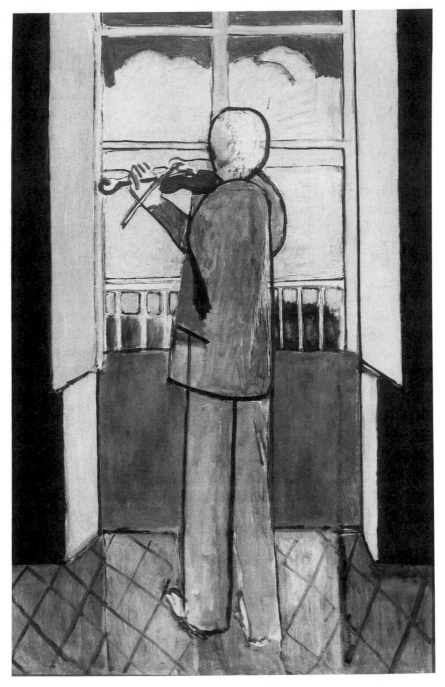

VIOLINIST AT THE WINDOW (Nice, 1918). Oil on canvas, 59″ × 38½″.

THIS IS ALL MINE

hen he arrived in Nice in mid-December of 1917, Matisse took a small room in the modest Hôtel Beau-Rivage at 107 quai des États-Unis. The hotel was near the Opéra, the flower and vegetable markets on cours Saleya, and the old part of the city. His room looked out over the Mediterranean on the other side of the promenade des Anglais (the section of the avenue now called quai des États-Unis). The broad, bustling avenue lined with palms and grand Victorian white-stucco holiday hotels; the boat-filled harbor; and the soft, clear, ever-changing silvery light were all just what he wanted: "When I first looked out of the window and said to myself 'This is all mine, for as long as I like to have it,'" Matisse later recalled, "I simply couldn't believe my good fortune." But, as in Morocco, his first weeks were plagued with rain: "Forced to work in a gloomy hotel room, I was reduced to painting my umbrella standing in a slop jar." In despair, he packed his suitcases, but then the mistral wind blew the clouds away, the sun came out, and he unpacked: "I decided not to leave Nice, and have stayed there practically the rest of my life." From now on,

his principal home would be the Côte d'Azur; he usually went north to Issy or Paris only during the hot summer months.

In *Interior at Nice* (1917–1918), one of several paintings of his room at the Beau-Rivage, Matisse cheered up his drearily furnished, long, narrow bedroom by painting its striped wallpaper a sunny yellow (plate 21). (A slightly later version shows the wallpaper as blue-green.) With its seemingly casual, feathery strokes, the interior looks so fresh that one can imagine the artist has just walked into his hotel room, set down his luggage, and stood back to survey his new home.

He transformed all the potentially offensive decorative frills (the flowered ceiling, the lace curtains, the patterned red rug, and the antimacassar on the ugly green chair) into something charming by rendering all surfaces as transmitters of light. His suitcase lies on the bed: Matisse was ever ready to pack up and leave, and during his first years in Nice he changed his domicile often.

But he didn't often change his routine, which was centered on work. He wrote to Camoin on April 10, 1918, "Here I work an enormous amount all day, and with ardor, I know that this is all there is, for certain." Matisse rose at seven and then played the violin for two hours in some remote bathroom so as not to disturb the other hotel guests. The violin limbered his fingers for painting, but Matisse's disciplined practice was also prompted by his fantasy that if he went blind he could support his family by playing the violin in the street. From nine to twelve he painted, either in his hotel room, in public gardens, or in the hills overlooking the city. Sometimes he began work even earlier. In May 1918, he wrote to Camoin that he was painting landscapes in the hills and that because of the heat he was changing his schedule:

> As of tomorrow I start at 6:30 or 7 in the morning. That should give me a good hour or two of work. The olive trees are so beautiful then. . . . A little while ago I took a nap under an olive tree, and the color harmonies I saw were touching. It's like a paradise you have no right to analyze, but you are a painter, for God's sake! Nice is so beautiful! A light so soft and tender, despite its brilliance. . . . Even though the

136

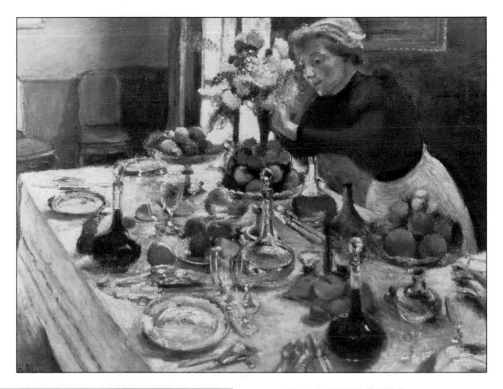

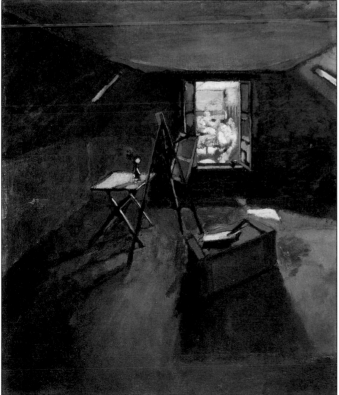

1. THE DINNER TABLE
(Paris, 1897). Oil on canvas,
39 ³/₈" x 51 ¹/₂".

———————————

2. STUDIO UNDER
THE EAVES
(Bohain-en-Vermandois, c. 1902).
Oil on canvas, 21 ¹/₂" x 17 ¹/₂".

3. LUXE, CALME ET VOLUPTÉ
(Paris, 1904–5). Oil on canvas,
38 ¹/₂" x 46 ¹/₂".

4. THE OPEN WINDOW
(Collioure, 1905). Oil on canvas,
21 ³/₄" x 18 ¹/₈".

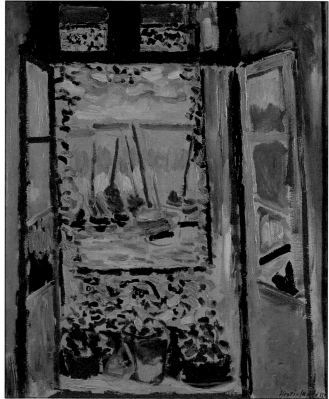

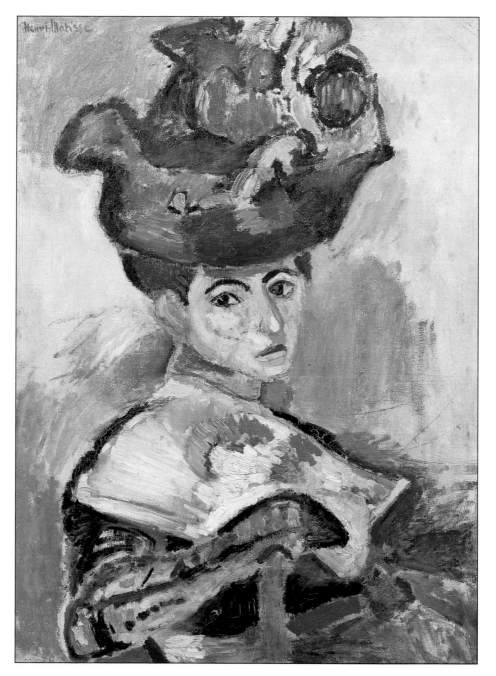

5 . THE WOMAN WITH THE HAT
(Paris, 1905). Oil on canvas, 31 3/4" x 23 1/2".

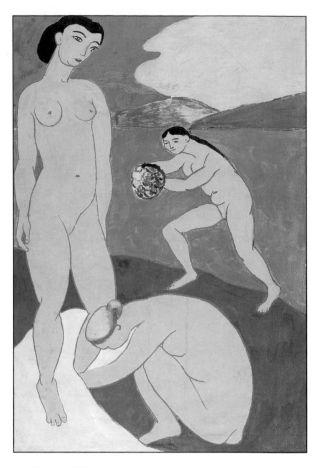

6 . LE LUXE II
(Collioure or Paris, 1907). Casein on canvas,
6' 10 1/2" x 54 3/8".

———————————

7 . BATHERS WITH A TURTLE
(Paris, 1908). Oil on canvas, 70 1/2" x 7' 3 3/4".

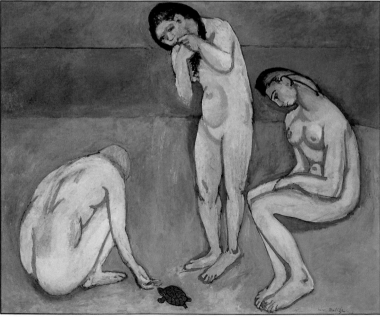

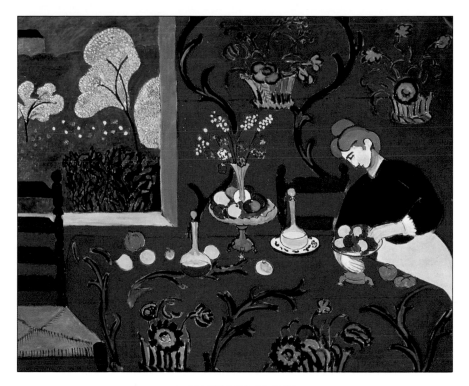

8. HARMONY IN RED
(Paris, 1908). Oil on canvas, 70 7/8" x 7' 2 5/8".

9. CONVERSATION
(Issy-les-Moulineaux, 1908–9/12). Oil on canvas, 69 5/8" x 7' 1 3/8".

10. DANCE II
(Issy-les-Moulineaux, 1909–10). Oil on canvas, 8' 5 5/8" x 12' 9 1/2".

11. THE RED STUDIO
(Issy-les-Moulineaux, 1911). Oil on canvas, 71 ¼" x 7' 2 ¼".

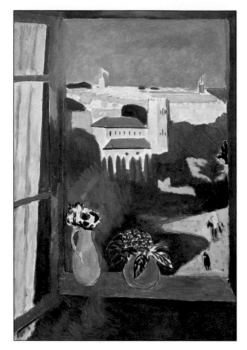

12. WINDOW AT TANGIER
(Tangier, 1912–13). Oil on canvas, 45 1/4" x 31 1/2".

———————

13. ZORAH ON THE TERRACE
(Tangier, 1912–13). Oil on canvas, 45 1/4" x 39 3/8".

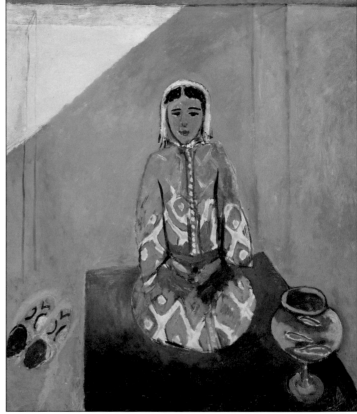

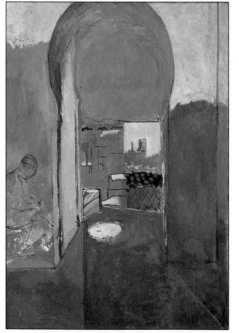

14. THE CASBAH GATE
(Tangier, 1912–13). Oil on canvas, 45 5/8" x 31 1/2".

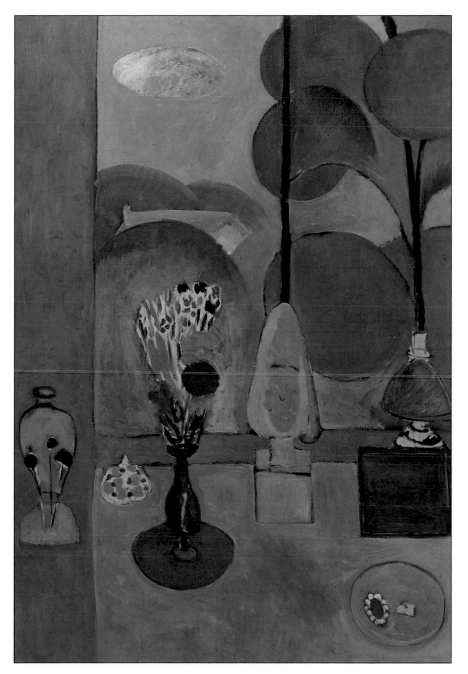

15. THE BLUE WINDOW
(Issy-les-Moulineaux, 1913). Oil on canvas, 51 1/2" x 35 5/8".

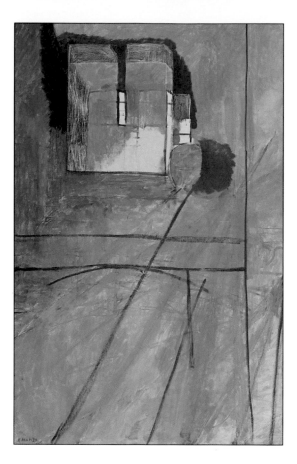

16. VIEW OF NOTRE-DAME
(Paris, 1914). Oil on canvas, 58" x 37 ¹/₈".

17. OPEN WINDOW, COLLIOURE
(Collioure, 1914). Oil on canvas, 45 ⁷/₈" x 35".

18 . THE PIANO LESSON
(Issy-les-Moulineaux, 1916). Oil on canvas, 8' 1/2" x 6' 11 3/4".

19. THE STUDIO,
QUAI SAINT-MICHEL
(Paris, 1916–17). Oil on canvas,
57 ¹/₂" x 45 ³/₄".

20. TREE NEAR TRIVAUX POND
(Issy-les-Moulineaux, 1917). Oil on canvas,
36 ¹/₂" x 29 ¹/₄".

21. INTERIOR AT NICE
(Nice, 1917–18). Oil on canvas,
29" x 23 7/8".

———————————

22. INTERIOR WITH A VIOLIN
(Nice, 1917–18). Oil on canvas,
45 3/4" x 35".

23. ODALISQUE WITH MAGNOLIAS
(Nice, 1923 or 1924). Oil on canvas, 25 5/8" x 31 7/8".

———————

24. DECORATIVE FIGURE ON AN
ORNAMENTAL BACKGROUND
(Nice, 1925). Oil on canvas, 51 1/8" x 38 5/8".

———————

25. THE PINK NUDE
(Nice, 1935). Oil on canvas, 26" x 36 1/2".

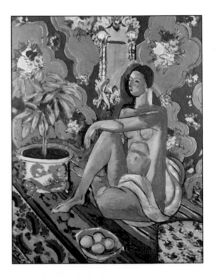

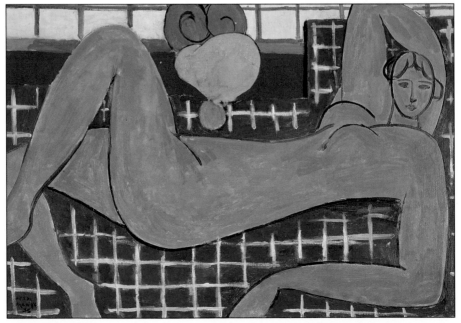

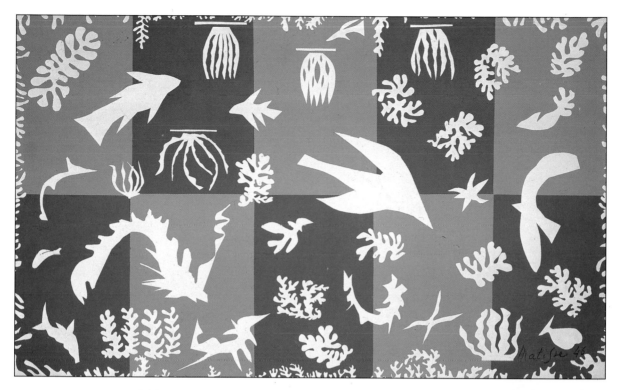

26. POLYNESIA, THE SEA
(1946). Tapestry maquette, gouache on paper
cutout, 77 3/16" x 123 5/8".

27. INTERIOR WITH AN
EGYPTIAN CURTAIN
(Vence, 1948). Oil on canvas,
45 3/4" x 35 1/8".

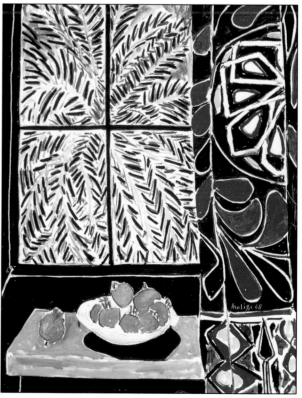

28. MEMORY OF OCEANIA

(Nice-Cimiez, 1952–53). Gouache on paper, cut and pasted, and charcoal on white paper, 9' 4" x 9' 4 $\frac{7}{8}$".

objects it touches have rich colors—the greens, for example, I often break my back trying to paint them. Having written that, I let my eyes wander the room where some of my old daubings are hanging, and it occurs to me that I may have hit the mark once in a while after all, though I can't be sure.

Matisse would drive to his motif in his old Renault. He preferred to drive slowly and in the middle of the road. Asked what he would do if another car approached, he said, "Well, in that case, I should bring my machine to a halt, get down, and sit by the side of the road until the other machine had passed." Another time he advised, "In a car, one shouldn't go faster than five kilometers an hour. Otherwise you no longer have a sense of the trees."

After lunch he would rest or stroll to a nearby café. At four he was back at his easel, and in the evening he ate in a café and sometimes drew in his room. Or, since he was never satisfied and always in pursuit of knowledge, he would draw and model from casts at the École des Arts Décoratifs, whose director had been a fellow student under Moreau. He was fascinated by the casts of Michelangelo's Medici tomb figures, especially the allegorical figure of night lying at Lorenzo de Medici's feet, which informed many of his painted and sculpted nudes. To Camoin he wrote on April 10, 1918, "I'm drawing *Night* and modeling it too: I'm studying Michelangelo's Lorenzo de Medici, I hope to instill in myself the clear yet complex conception behind Michelangelo's construction."

In Nice, Matisse became avid about exercise. Like violin practice, or like the walking and horseback riding he had done at Issy, it was a way to relieve tension; for Matisse, engaging in strenuous effort was the only way to relax enough to sleep. As he wrote in the same letter to Camoin on April 10, "One has to toil all day every day to accept the irresponsibility that puts one's consciousness at rest." Now he took up a new sport, rowing at the Club Nautique, a boating club a few doors from the Beau-Rivage. He kept two small boats here, and during his first year he rowed 134 times and won the club's *prix d'émulation*. The following year he went on 154 outings, and the third year he won the club's gold medal "for

MATISSE IN A SINGLE SCULL, NICE, EARLY 1920s.

assiduity," as he put it. He later said, "[It was] the only medal I was ever awarded." His passion for boating continued as long as his health allowed. In 1929 he told his Greek friend Emmanuel Tériade, later the publisher of *Verve* (a review of art and literature published in France between 1937 and 1960), that during his stay in Paris he would rather visit the boat show (he did so almost every day) than art galleries. "I adore boating," he said. "I go out every afternoon, and I only paint in the morning when the light is good. Look at the calluses on my hands." Pierre Schneider has observed that many of Matisse's works—including his 1925 sculpture *Large Seated Nude*, in which the figure leans backward in a precarious cantilevered position—are based on Matisse's understanding of the strains and balances involved in rowing. "Assume the pose of the model yourself," Matisse used to tell his students, and he took his own advice, gaining a kinesthetic knowledge of the way a rower's equilibrium is maintained through movement and constant muscular effort.

Matisse's existence was fairly solitary, but his children came to visit, and so, occasionally, did Madame Matisse. In 1928 she would come south to live with him for a while in an apartment he would take in 1921 at no. 1

place Charles-Félix. Matisse also had a few friends living within driving distance, and he would develop friendships with painters Pierre Bonnard, who lived at Antibes, and Pierre-Auguste Renoir, whose villa was in nearby Cagnes-sur-Mer.

On December 31, 1917, Matisse's forty-eighth birthday, he went with his friend the critic and collector Georges Besson to Cagnes to meet Renoir, who was so old and arthritic he had to be carried to his studio to paint. Full of admiration for Renoir's indomitable spirit, Matisse later said, "As his body dwindled, the soul in him seemed to grow stronger continually and to express itself with more radiant ease." Matisse was impressed as well by the fact that the art of this man in his late seventies still showed such relish for women's bodies. The delight with which Renoir remembered the women to whom he had made love struck Matisse as remarkable. (In 1941, noting the paradox that an old artist like himself could express love's ardor better than ever, Matisse recalled that Renoir shortly before his death had said, "If you knew, my dear, how I loved my wife . . . and not like a *vieux cochon*," which, loosely translated, means that Renoir's love for his wife was a tender passion, not the gross appetite of an "old hog.") After this visit to Cagnes, Renoir joined Cézanne in Matisse's pantheon.

Some weeks later Matisse returned to Cagnes to show Renoir some of his recent paintings. Renoir was disapproving: "In all truthfulness, I don't like what you do." But the older man was amazed with the way Matisse used black as a color without its poking holes in the canvas. Almost certainly referring to *Interior at Nice*, Renoir said, "How you have managed to express the atmosphere of a hotel room in Nice!" But, he asked, how had Matisse kept the blue of the sea from coming forward, and the black valance from either advancing or receding into depth? "If I put a black like that in a picture," Renoir said, "it would jump forward, it wouldn't stay in place." Finally he declared, "Everything is very accurate. It was difficult. . . . It makes me mad." And Renoir had to acknowlege, "I think that you are most surely a painter."

The day after his first encounter with Renoir, perhaps to take stock of himself as a painter, Matisse began another self-portrait. With his middle-

aged belly, brown tweed suit, dark tie, and spectacles, Matisse looks emi-nently respectable, but his huge thumb sticking through the hole in his palette and the paint brush that projects upward across his lap suggest that the artist has not lost his vigor. Perhaps his encounter with Renoir re-charged his virile energy. But, for all the phallic suggestiveness of the thumb and brush, it was really Matisse's creative energies that were excited by Renoir. In this self-portrait he looks not at the viewer but at his canvas, the tacked edge of which can be seen propped on his suitcase in the lower right corner of this picture. His expression is one of total concentration, and his upright posture suggests the rigor and probity of his attention to work. The room in which he paints is as dour as a monk's cell; the proces-sion of pretty models that would inhabit his interiors in the coming years has not yet arrived. For now, the room's dark, confining walls and the umbrella in the slop pail remind us that the weather during his first month at the Beau-Rivage was terrible: the suitcase placed between his knees looks packed and ready to go.

Several of Matisse's first Nice paintings express a loneliness similar to that in certain 1916 studio interiors and to paintings like *The Pink Marble Table*. Yet Matisse clearly needed to be alone. Solitude and boredom, he once said, were what drove him to paint. In spite of his models, painting, for Matisse, was a solitary pursuit. "An artist is an explorer," he told an interviewer in 1945. "He should begin by seeking himself." In that same interview he advised painters, "Watch out for the influence of wives. The priest and the doctor should never marry, so as not to risk letting temporal considerations come before their profes-sions; the same goes for the artist." By the time he said this, of course, Matisse did not have many domestic responsibilities to worry about, and in any case, during his conjugal years, his wife had tried to create an atmosphere conducive to his work and to help him survive as a painter.

When asked about the role of love in his life, Matisse, the world's most discreet man, said only that love is "not compatible with hard work" and that "one can't express oneself fully in all ways." In his last years, however,

SELF-PORTRAIT (Nice, 1918). Oil on canvas, 25 ½″ × 21 ¼″.

he spoke of a spiritual love as the basis of his artistic intuition of the relatedness of all things. Without love, he said, "there is no longer any work of art." Quoting Thomas à Kempis in 1947, he went further: "Nothing is more gentle than love, nothing stronger, nothing higher, nothing larger, nothing more pleasant, nothing more complete, nothing better—in heaven or on earth." These hardly seem the sentiments of a man who entirely eschewed the love of women.

The hotel room is still dark in *Interior with a Violin*, done in late 1917 and early 1918, but it is clear from the view of a palm tree and the sea outside the window that the rain has stopped (plate 22). This is one of the last of Matisse's interiors to be dominated by black. From now on light, diaphanous textures like the white curtain seen in the upper left corner will predominate. Although there are no figures in this room, one feels the artist's own dynamic presence in the open case of his violin, the instrument that was his chief companion and whose warm brown curves are almost as inviting as those of the models he was to paint in the coming years. The violin case's blue lining, set off by the white antimacassar, glows like the blue sea beyond the shutters and makes the empty room's dark silence resound.

In *Violinist at the Window* (page 134), a self-portrait begun in the spring of 1918, probably after he left a portrait of Pierre playing the violin unfinished, Matisse makes his image as schematic and anonymous as it was in *The Painter in His Studio*. Even so, he looks mournfully alone; indeed, he seems to revel in his loneliness. His back to us, he plays a tiny red violin as he looks out of the closed window of his dark hotel room at a red sky above heavy clouds and brown trees that close off space and hide the sea. As Jack Flam has pointed out, if a window (even a closed one) is a metaphor for a painting, then the violinist/painter can be seen to be standing before his canvas. As in *Artist and Goldfish* the window becomes both the easel and the canvas, and the bow and violin become his brush and palette. *Violinist at the Window*'s few sharp, but not bright, colors are as piercing as the sound of a violin.

The following winter, when he painted *Interior with a Violin Case* (1918–1919), the gloom has turned to light, and Matisse's Nice style is in full swing. The room he moved into in the fall of 1918 after spending the summer at Issy was on a low floor of the luxurious Hôtel de la Mediterranée at 25 promenades des Anglais. It looked out over the baie des Anges, and its French doors surmounted by a glass lunette opened onto a balcony with a substantial balustrade in front of which Matisse could pose his models. In *Interior with a Violin Case* the morning light pouring through the balustrade creates a triangle that literally wedges its way across the tiled

INTERIOR WITH A VIOLIN CASE (Nice, 1918–19). Oil on canvas, 28¾″ × 23⅝″.

floor and into the room. Matisse called this painting a "study of light," noting "the sentimental association" between interior and exterior light.

Here and in many views of this room at the Hôtel de la Mediterranée, with or without models, an oval mirror set on a dressing table dominates the composition. Sometimes the mirror's surface is solid black, sometimes

it is cross-hatched, and other times it reflects the room's interior, framing it rather as Matisse's open windows frame the outside view and, like an open window, wittily mediating between surface and depth. In several paintings a vase of flowers is placed in front of the mirror and painted in such a way that the viewer becomes confused as to which are the real flowers and which are the reflections.

In *Interior with a Violin Case* Matisse played with the dichotomy between nature and illusion by contrasting the black surface of the oval mirror with a rectangular black object (either a drawing portfolio or a blotter) set on the dressing table's white surface directly under it. Matisse seems to be comparing two different kinds of black surface, one that we know to be flat and the other that reflects a deep but invisible space. Both black surfaces are contrasted with the white tabletop: indeed, a number of the interiors featuring the oval mirror are studies in black and white.

As his *The Painter and His Model* (painted around 1919 at the Hôtel de la Mediterranée) shows, now that the war was over Matisse's art began to rejoice in the comforts of life that the French cultivate with such care. Although Matisse was disciplined and obsessed with his work, he did have his pleasures—flowers, textiles, objects, women. Every inch of space in *The Painter and His Model* is covered with decorative pattern. The cozy, busy brightness of this hotel room is at the farthest remove from the isolated, empty pink marble table painted two years before. Of the Hôtel de la Mediterranée, where he lived from 1918 to 1921, he said, "I stayed there four years for the pleasure of painting nudes and figures in an old rococo salon." He reminisced to a friend, "Do you remember the way the light came through the shutters? It came from below like footlights. Everything was fake, absurd, terrific, delicious."

Matisse appears in *The Painter and His Model* wearing striped pajamas, sitting at his easel, and painting a luscious nude who lolls on an upholstered chair in front of the window. The woman's veil suggests she represents one of the many oriental harem women, or odalisques, that he painted in Nice and that were anticipated by his paintings of Lorette wearing turbans and caftans. When asked about his series of odalisques, Matisse

was disingenuous: "I had seen them in Morocco," he said, "so was able to put them in my pictures back in France without playing make-believe." But he was playing make-believe. He was inventing a mundane version of *luxe, calme et volupté.* He dressed his models in harem pants, transparent skirts, and ankle bracelets, and he placed them in exotic settings with props such as Persian carpets, Turkish divans, textiles stretched on demountable frames, and even a carved and inlaid harem screen. Even so, the Niçoise girls almost always betray their nonexotic origin: their 1920s-style plucked eyebrows, short hair, and plump pink faces give them away.

THE PAINTER AND HIS MODEL (Nice, c. 1919). Oil on canvas, 23 ⅝″ × 28 ¾″.

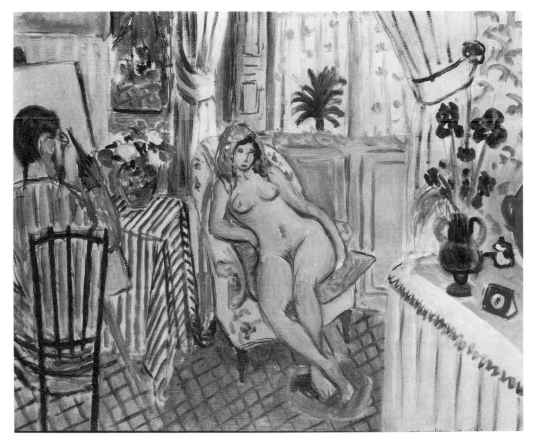

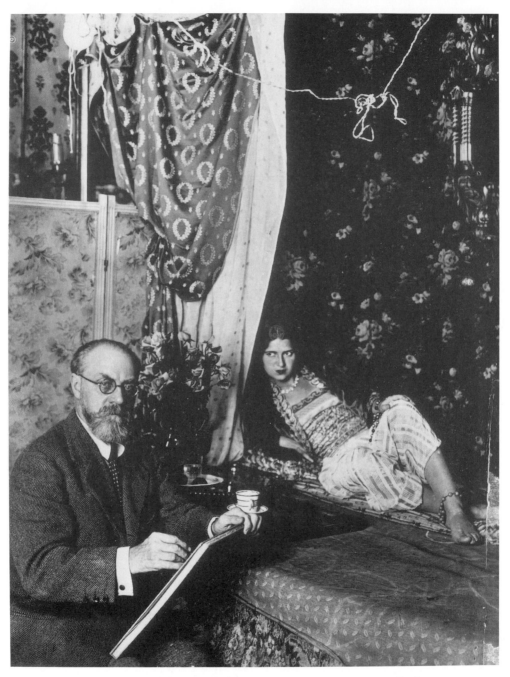

MATISSE DRAWING A MODEL (PROBABLY HENRIETTE DARRICARRÈRE)
AT NO. 1, PLACE CHARLES-FÉLIX, NICE, C. 1927–28.

Perhaps the languorous odalisques appealed to him especially because they were the opposite of his hard-working, nervous, Northern, bourgeois self. For Matisse they were the perfect motif—pliant creatures content to be objects, to play slave to his pasha without agitating him or interfering in his life. As he put it, "The odalisques were the bounty of a happy nostalgia, a lovely, vivid dream, and the almost ecstatic, enchanted days and nights of the Moroccan climate. I felt an irrepressible need to express that ecstasy, that divine unconcern, in corresponding colored rhythms, rhythms of sunny and lavish figures and colors." The increasingly exotic odalisques were also the bounty of having more space in which to create a kind of studio/theater set, after he moved to larger quarters at no. 1 place Charles-Félix in 1921.

Just as the sea and sky seem totally available in Matisse's Nice paintings, so do his models—almost all of them female. Partly because he was nearsighted, Matisse sat close to his model. According to Louis Aragon, he sometimes sat with his knee pressed against the model's knee. One photograph shows him resting one hand on a model's knee while he drew with the other. "When I paint or draw," he said, "I feel the need for close communication with the object that inspires me." Some models found this proximity unnerving. Matisse enjoyed it: "A cake seen through a store window does not make you salivate as much as when, having entered the store, you have your nose on top of it," he used to say. When it came to models for his sculptures, some of which are based on mildly pornographic magazine photographs of nude women, Matisse sometimes felt the need for direct tactile knowledge and empathy. He said of one model, "She was a pretty girl, a perfect model. I touched her body, my hands enveloped her forms, and I transmitted into clay the equivalent of my sensation."

The Nice paintings of the early 1920s are suffused with eroticism, but it is not necessarily to be found in the figures. Instead, Matisse projected his sexuality onto the surfaces of flowers, curtains, and clothes—all of which are encompassed by the Riviera's caressing light. "My models, human figures, are never just 'extras' in an interior," he said. "They are the principal theme in my work. I depend entirely on my model, whom I

observe at liberty, and then I decide on the pose which best suits *her nature.* . . . The emotional interest aroused in me by them does not appear particularly in the representation of their bodies, but often rather in the lines or the special values distributed over the whole canvas or paper, which form its complete orchestration, its architecture. . . . It is perhaps sublimated sensual pleasure, which may not yet be perceived by everyone."

He insisted that his response to a voluptuous model was the same as his reaction to a plant or a vase, but he was not averse to describing their physical attractions, as in his letter to Camoin written on May 2, 1918, while he was waiting for a model who was late: "She is a big sixteen-year-old girl, a colossal woman, she has tits like two liter Chianti bottles!" His insistence that his reaction to a model's shape was purely formal is belied by the sumptuous eroticism of paintings like *Odalisque with Magnolias* (plate 23). This 1923 or 1924 painting's sexual excitement is made all the more piquant by the visual rhyming of breasts with peaches and of the folds of the woman's white-and-green pantaloons with the opening petals of the magnolia blossom. Unlike the vacant, bored expressions of so many of Matisse's models, this woman's half-closed eyes and dreamy half smile suggest that she enjoys displaying her luxuriance. Matisse could have had this painting in mind when he described his odalisques: "the sensuality of heavy, drowsy bodies, the blissful torpor in the eyes lying in wait for pleasure, all this splendid display of a siesta elevated to the maximum intensity of arabesque and color . . ." Yet he also saw that in the Nice odalisques "there is a great tension brewing, a tension of a specifically pictorial order."

Some models—such as the young Antoinette Arnoux, whom he painted and drew in 1919, and Henriette Darricarrère, who appeared in his work from 1920 to 1927, when she married and left Matisse's employ—intrigued Matisse so much that he explored their features again and again. When his interest in a model was exhausted, he dismissed her and looked for someone new. Starting in the 1920s and continuing for thirty years, he had models supplied by a nearby movie-extra agency, the Studios de la Victorine. It was here that he discovered Henriette Darricarrère performing as a ballerina before the camera. "The ones I don't use, I pay off with

ten francs. I have them pose in shifts, three hours in the morning, three hours in the afternoon." When models complained about working on holidays, he would cajole them or pay them extra. If they were restless, he would let them pose by the window or on the balcony so they could watch the world go by. Often while painting he chatted with his model on superficial matters, but if, when he was really concentrating, a model asked the time, he found the interruption devastating.

Henriette was a great and resourceful model for Matisse. She enjoyed role-playing in his imaginary harem, and her dramatic flair encouraged him to make his art into an exotic spectacle. He employed her for seven years, during which time he painted her not only as an odalisque (probably she posed for *Odalisque with Magnolias*) but also with her brothers as part of a kind of substitute family. According to her family, Matisse encouraged Henriette to continue studying piano, violin, and ballet, and he painted her engaged in various contemplative activities such as reading, painting, practicing music, or simply ruminating as she watches goldfish.

Although Matisse said he wanted to capture the model's nature, he was not interested in her psychology; apart from serving as a stimulus to his imagination, the model had for him no separate reality. "As in love," he said, "all depends on what the artist unconsciously projects on everything he sees. It is the quality of the projection rather than the presence of a living person that gives an artist's vision its life."

His motif was woman, but the central preoccupation of the Nice paintings of the early 1920s was light. When he was asked by Louis Aragon in 1943 about his choice to live in Nice, Matisse said, "Nice, why Nice? In my work I have tried to create a translucent setting for the mind. . . . If I had painted in the North, as I did thirty years ago, my painting would have been different. There would have been browns, grays, shadings of color through perspective." What he needed, he said, was "the silver clarity of light in Nice." He needed a light he could count on. "In order to paint my pictures I need to remain for several days in the same state of mind, and I do not find this in any atmosphere but that of the Côte d'Azur." Matisse suffused the Nice canvases with light by painting them with delicate

strokes of transparent color over a white ground. He kept the paint thin and avoided building it up with layers of reworking. The colors are soft, often muted, and truer to nature than at any time since his pre-Fauvist years.

After World War I, the energy that had driven artists to invent revolutionary new forms such as Fauvism and Cubism was exhausted. In all aspects of culture there was a call to order, a reaffirmation of traditional humanistic and classical values. Along with many European artists after the war, Matisse based his art more closely on the observation of the world around him. His handling of space became easier to decipher, and figures and objects in the Nice period are drawn in a clearer, more detailed, more realistic manner. His compositions are no longer rigorously geometric. They are seemingly casual, looser, more fluent. The Nice paintings look effortless; they have the "radiant ease" that he admired in Renoir's work. But Matisse struggled to achieve that ease. In 1948 he spoke of his "apparent facility" in a letter to Henry Clifford, who was organizing a Matisse retrospective at the Philadelphia Museum of Art: "I have always tried to hide my own efforts and wanted my work to have the lightness and joyousness of a springtime which never lets anyone suspect the labors it has cost."

In general the public loved Matisse's more pleasant and accessible Nice paintings. Prices rose quickly, and the work sold well. A medium-sized canvas that cost five thousand francs in 1917 (the year when Matisse's renewed contract with the Bernheim-Jeune gallery more than doubled his prices) was worth thirty to fifty thousand francs in 1928. Some paintings, like a 1921 version of a favorite motif, *Fête des Fleurs*, sold for as much as 121,000 francs in 1928, making Matisse the highest priced living artist at that time. For all Matisse's popularity (and maybe because of it), some critics felt he had become too relaxed, too superficial, even retrogressive. As the poet Jean Cocteau wrote in 1919, "The sun-drenched wild beast of Fauvism has turned into one of Bonnard's kittens." Matisse's statement in 1908 that painting should be soothing—"something like a good armchair"—seemed to be exemplified in the Nice paintings, and the values they expressed were from some points of view unforgivably bourgeois. Years later, recalling his change from the austere, semiabstract style of the war

years to the plush Nice paintings, Matisse spoke of "emerging from long, tiring years of experimentation" and "internal conflict." He went on: "Yes I needed to have a respite, to let myself go and relax, to forget all worries far from Paris." But at the time he saw the change differently. He said in 1919,

> You see, when you've gotten what you wanted in a particular do-
> main, when you've exploited the possibilities inherent in a certain direc-
> tion, eventually you have to turn around and seek something new. . . .
> It's simply a matter of health. If I'd continued on the other path, the one
> I knew so well, I'd have ended by becoming a mannerist. One must
> always keep one's freshness of vision and of emotion; one must follow
> one's instincts. Besides, I'm seeking a new synthesis.

In 1925 he found that "new synthesis" in *Decorative Figure on an Ornamental Background* (plate 24). Here he invented a simpler, more monumental, yet opulent and decorative style inspired in part by the Byzantine mosaics he saw during his 1925 trip to southern Italy with his wife, daughter, and son-in-law, Georges Duthuit, a Byzantine scholar whom Marguerite had married in December 1923. The more linear and classical mode with which the firmly volumetric nude is drawn could also have been stimulated by his abiding admiration for the frescoes of Giotto, seen eighteen years before.

Decorative Figure on an Ornamental Background began as a nude slouched against a wall. As the painting progressed, Matisse squared the woman's shoulders, straightened her back, and made her buttocks turn into her thigh at a right angle. She is no longer lusciously pliant but as rigid as a pyramid, as hieratic as a figure in a Byzantine mosaic. With her solidly modeled flesh fortified by a triangular outline, the nude can hold her own against the wildly exuberant wallpaper pattern. She is so monolithic that it took just one shadow to the left of her head and shoulders to make her stand out. By contrast, it is amusing to see how the ornate mirror just to the left of her head is camouflaged by the wallpaper. The painting's multiple patterns combine into a rich, flat tapestry, but the nude refuses to be swal-lowed up in the weave; she remains implacably sculptural, bringing to

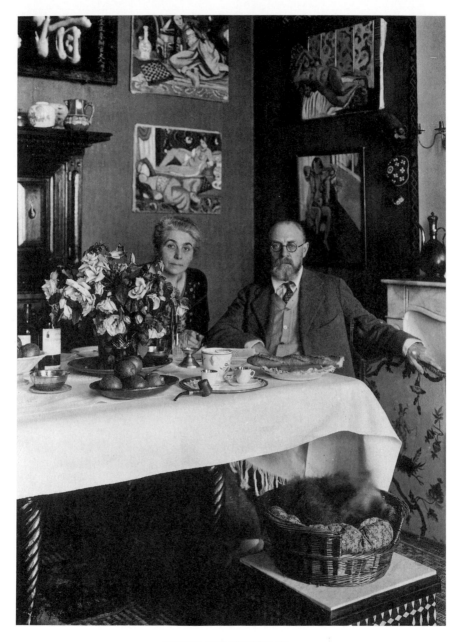

MATISSE AND HIS WIFE IN
THE DINING ROOM,
NO. 1 PLACE CHARLES-FÉLIX,
4TH FLOOR, C. 1929.

mind the fact that Matisse not only drew and modeled from the cast of Michelangelo's *The Night* but also had a photograph of the original hanging on his wall.

The sculptural quality of the nude in *Decorative Figure on an Ornamental Background* forces the viewer to go back and forth between seeing the painting as surface and reading it in terms of deep space. This alternation between two- and three-dimensional readings in the nudes Matisse painted in Nice keeps things chaste: you may be attracted to the pastry but get closer and you bump your nose against the store window. The nudes say come hither, but they do not deliver. Or, as novelist Janet Hobhouse observed, Matisse seems simultaneously to play the roles of procurer and bouncer. In any case, soon after Madame Matisse joined her husband in the place Charles-Félix apartment in the spring of 1928, the odalisques were banished from the stage set of Matisse's art; but stripped of the harem paraphernalia, their lines and volumes continued to excite his formal invention.

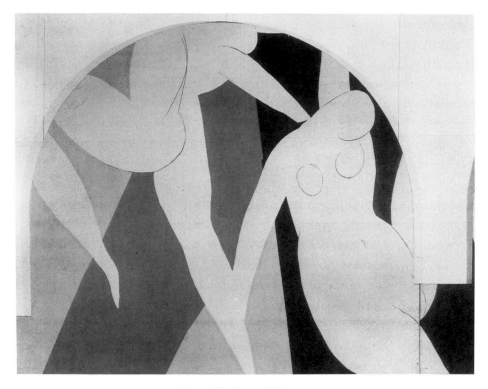

Detail of DANCE (Nice, 1931–32 and 1933). Version installed in the
Musée d'Art Moderne de la Ville de Paris. Oil on canvas,
three panels, 11′ 2″ × 12′ 8⅜″; 11′ 8½″ × 16′ 4″; 10′ 11″ × 12′ 10″.

PUT YOUR WORK
BACK ON THE ANVIL

n the late 1920s Matisse became restless and dissatisfied with the progress of his work. By 1929 he was hardly painting at all, and until 1933, with some important exceptions, he concentrated on drawing, printmaking, and sculpting. No doubt Madame Matisse's illness continued to worry him. Early in 1930 her condition worsened, and she was confined to her bed. In that same year he decided to fulfill a long-held wish to see the South Seas and to experience the quality of tropical light:

> When you have worked for a long time in the same milieu, it is useful at a given moment to stop the usual mental routine and take a voyage which will let parts of the mind rest while other parts have free rein—especially those parts repressed by the will. . . . Having worked forty years in European light and space, I always dreamed of other proportions which might be found in the other hemisphere. I was always conscious of another space in which the objects of my reveries evolved. I was seeking something other than real space.

155

On February 27, 1930, he left for Tahiti, sailing first to New York from Le Havre on the *Île-de-France*. While in New York, he saw his son Pierre, who had given up art studies and gone to live in Manhattan in 1924. After organizing exhibitions at the Dudensing galleries, Pierre Matisse opened his own gallery and became a highly respected dealer, showing mostly European modernists and helping to promote his father's work. Matisse was overwhelmed by New York City's grandeur: "The first time that I saw America, I mean New York, at 7 o'clock in the evening, this gold and black block in the night, reflected in the water, I was in complete ecstasy. . . . New York seemed to me like a gold nugget."

After a few days of being dazzled by Manhattan's skyscrapers and by the city's "very pure, non-material light," Matisse traveled by train to Chicago, Los Angles, and San Francisco, where he boarded the *Tahiti* on March 21 and sailed to Papeete. Though he made only one small painting

MATISSE IN NEW YORK CITY, 1930 OR 1933.

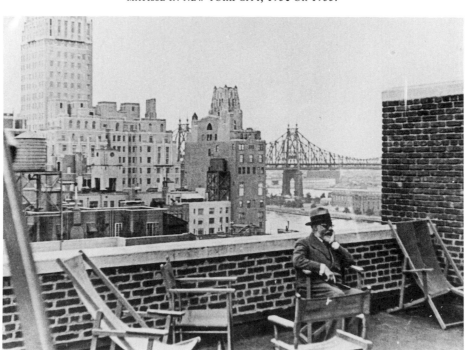

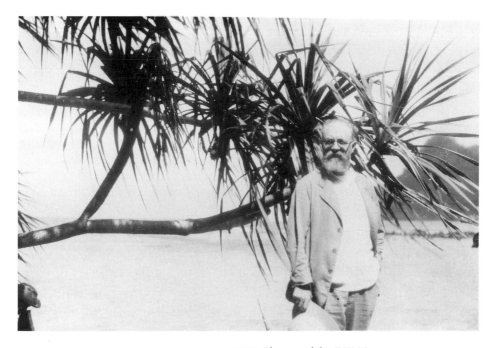

MATISSE IN TAHITI, SPRING 1930. Photograph by F. W. Murnau.

during his stay and claimed to have been disappointed with the island, he found the light he was looking for, and it would reappear in the work of his last years. "I stayed there three months absorbed by my surroundings without a thought in my head in front of the novelty of everything I saw, dumbfounded, yet unconsciously storing up a great deal." Later he described the light as something like looking into a "deep goblet of gold." His vision of Tahitian light and space was conditioned by his experience of being in and near water: "I used to bathe in the lagoon. I swam around the brilliant corals. . . . I would plunge my head into the water, transparent above the absinthe bottom of the lagoon, my eyes wide open . . . and then suddenly I would lift my head above the water and gaze at the luminous whole." Another time he described the effect of the South Seas this way: "I was mentally aware that above me, above my motif, above the studio, even

157

above the house, there was a cosmic space in which I was as unconscious of any walls as a fish in the sea." Over a decade later, when his work came to rely on memory, he would draw upon his experience of Tahiti's limitless, "cosmic" space and of being dazzled by light after swimming underwater, when he made his great cutout paper gouaches, such as *Polynesia, the Sea* from 1946 (plate 26) or that marvelous conflation of water, light, and moving bodies, *The Swimming Pool* from 1952 (page 183).

Although Tahiti seduced him, Matisse was disappointed by its undramatic scale. The trees, he said, were like potted plants. "You don't have an immediate reaction which makes you need to unwind by working. . . . I had no pictorial reaction whatsoever." To him Tahiti was an "isle of thoughtless indolence and pleasure." Matisse, who was made nervous by having to relax, often quipped, "It has never amused me to amuse myself." Years later he recalled that Tahiti had been "both superb and boring. There are no worries in that land, and from our tenderest years we have our worries; they probably keep us alive. There the weather is beautiful at sunrise and it does not change until night. Such immutable happiness is tiring."

For all that, Tahiti lingered in his mind. Years later, during his insomniac nights of World War II, he would note down his memories of "the elegant coconut palms with their upswept hair, accompanying the murmur of the free sea over the reef against the quiet, unruffled water of the lagoon." He wrote of the lagoons' "jade green" waters with their "branched corals and their variety of soft pastel tints, around which pass shoals of small fish, blue, yellow and striped with brown, looking as if they were enameled." And, though he rejected Gauguin's romantic picture of Tahitians (whose amorality, he said, was finally "demoralizing"), he was clearly fascinated by the women's "voluptuous roundness," which he said could make a man imagine "that the sky is clearer." In his notebook he wrote: "Tahitian girl, with her satin skin, with her flowing, curling hair, the copper glow of her coloring combining sumptuously with the somber greenery of the island."

After visiting several islands and atolls, Matisse sailed to France on the *Ville de Verdun* on June 15, stopping at Panama, Martinique, and

Guadeloupe, and arriving in Marseille on July 31. In mid-September 1930, he set out for the United States for the second time. He had been invited to serve on the jury of the Carnegie International Exhibition, whose prestigious prize he had won three years before. After serving as a juror in Pittsburgh (where the jury awarded the prize to Picasso), he went to see the two great American collections of his paintings, the Cone Collection in Baltimore and the Barnes Collection in Merion, outside of Philadelphia.

Dr. Albert C. Barnes, a patent-medicine millionaire (he helped develop and then market the antiseptic Argyrol), had begun to acquire Matisse's work around 1914, replacing Matisse's Russian patrons, who had stopped buying when World War I and the Russian Revolution isolated them from Western Europe. When Matisse visited the Barnes Foundation Museum in late September, Dr. Barnes announced that he wanted Matisse to paint a mural for the three adjoining arched spaces over the large French windows of the museum's large central gallery. A few days later, full of enthusiasm for the Barnes Foundation collection, Matisse sailed back to France. By mid-November he had accepted Dr. Barnes's commission. He began making small studies, and in December he made a third trip to America to examine the mural site. After returning to Nice in January, he rented a vacant warehouse at 8 rue Désiré-Niel, which was large enough to fit the approximately 12½- by 47½-foot mural.

Among the paintings Barnes had already purchased for his museum was Matisse's *Le bonheur de vivre*. To compose the mural, Matisse returned to the theme of a ring of dancers that had appeared in *Le bonheur* and reappeared in Shchukin's *Dance*. Using for the first time a technique that was to become his chief medium in his last years, he cut shapes out of sheets of paper covered with gouache and moved them around the canvas. His first full-scale canvas version of the Barnes mural, which was left unfinished and became the study for the next version, is covered with pinholes that reveal the endless decisions and revisions that were part of Matisse's tormented effort to find the ideal solution to the largest painting he ever produced. Compared to the limpid linearity of the two completed murals, the first version is expressive and painterly. The figures are heavy and muscular, recalling the heroic bodies

in art-deco reliefs. Some figures are left sketchy; others appear to have been painted over several times, as if Matisse could not quite control their energy and make them stay put on the canvas surface. Perhaps that is why Matisse abandoned them, for he came to realize that he wanted the dancers to be highly distilled, flat, and not obtrusive so that they would become part of the wall. This first unfinished version of the Barnes mural was rolled up, wrapped in paper, and stored in a warehouse near Nice for some sixty years. It was thought to have been a carpet until it was rediscovered in 1992.

A 1931 photograph, showing Matisse working on the first completed version of *Dance* illustrates the artist's statement that his mural was "the result of a physical encounter" between himself and his immense canvas. Matisse did not simply square up and enlarge one of his studies in order to

MATISSE IN 1931 IN HIS TEMPORARY STUDIO AT NO. 8 RUE DÉSIRÉ-NIEL, NICE, WORKING ON THE FIRST VERSION OF THE BARNES FOUNDATION *Dance,* WHICH WAS LATER ACQUIRED BY THE MUSÉE D'ART MODERNE DE LA VILLE DE PARIS.

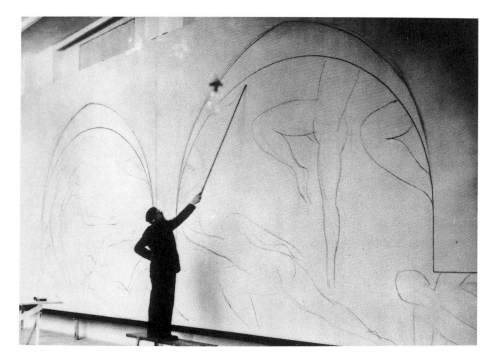

transfer it to the canvas. As he explained, "A man with a searchlight who follows an airplane in the immensity of the sky does not traverse space in the same way as an aviator." In order to "take possession" of the mural at its actual scale, he drew directly on the canvas with a piece of charcoal fastened to a long bamboo pole. His first confrontation with the huge blank canvas almost paralyzed him. Matisse later recalled that he walked back and forth in front of it until suddenly he noticed the shadow cast by a cord hanging in front of a fan light. Then he made his first mark—a long curving line. After this, Matisse said, the whole composition emerged. "One day, armed with a charcoal stick at the end of a bamboo pole, I set about drawing the whole thing in one stroke." Another time he described the fluency with which the composition finally came to him by saying, "It was inside me, like a rhythm that carried me along."

Nonetheless, to achieve simplicity and synthesis was, as usual, a strain: "To arrive at something that was alive and singing I had to grope my way, modifying all the time." After boldly outlining his composition in charcoal, he still needed to compose with color, and, as he recalled, "I had to change all the prearranged forms." The changes went on for months. Often he became desperate and would call for help. Once he cabled his friend Simon Bussy, who lived nearby in La Souco, Roquebrune: "Decoration in terrible state composition completely out of hand am in despair light suitable this afternoon for God's sake come at once matisse."

In the spring of 1932, Matisse discovered that his first completed mural was too small for the space it was intended to occupy; he had been

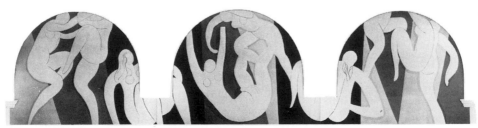

DANCE (Nice, 1932–33). Version installed in the Barnes Foundation.
Oil on canvas, three panels: 12′ 7½″ × 15′ 7″; 13′ 1½″ × 16′ 5″; 12′ 3½″ × 15′ 5″.

given incorrect dimensions for the lunettes and the pendentives between them. Instead of simply adjusting the existing work to fit, he painted a new mural, using the opportunity to refine the relationship between figures and architecture. In the second finished version, installed at the Barnes Foundation in the spring of 1933, he added two more nymphs and made the figures less heroic, more graceful, and slightly smaller, so that they appear to be pushed back a little from the plane of the wall. The arrangement no longer suggests the ring of dancers which had been his first idea; rather, the figures are spread out laterally like a frieze.

The linear clarity and monumentality that emerged in the 1925 *Decorative Figure on an Ornamental Background* culminates in the eight giant nude dancers in the Barnes Foundation's *Dance*. The silhouettes are as lucid and distilled as those on a Greek vase. Color is reduced to gray for the dancers and blue, pink, and black for the space around them. The dancers retain the flat cutout quality of the papers used to position them. Their extreme flatness and the uninflected, almost mechanical contours worried Matisse. Even though he felt that in architectural painting, "the human element has to be tempered if not excluded," the nudes seemed too inhuman; so he took a brush and drew a few spare, obviously freehand lines over the flat nudes and added narrow bands of shading along the figures' contours to hint at shadow and depth.

Some critics feel that the mural's color is dull, but Matisse wanted it to be matt like a fresco, and he also wanted a counterpoise to the bright light and the view of green grass coming in the large windows. In addition, he did not want color to distract from the masterpieces hanging below. "One will *feel* my picture rather than see it," he said. His statement has some literal truth, for the windows' dazzling light makes the dancers seem to shimmer and hover.

Matisse claimed that, as with his dance panels of 1908, he had whistled the farandole while painting the Barnes mural. The dancers do indeed seem propelled by a rousing tune. They leap and tumble with such fierce energy that they burst beyond the lateral confines of the lunette's arched spaces. Yet their contours also follow the lines of the arches; and, with the perfect

balance of figure and ground, the figures become part of the architecture—in Matisse's words, "the equivalent of stone or cement." The dancers not only conform to the architecture, they marry it, for Matisse coupled each of the pendentives that divide the lunettes with a supine nymph who receives the pendentive in her ample lap like Danaë receiving Zeus's shower of gold. The dancers also transform architectural space by seeming to extend beyond and behind the arches. Matisse thus succeeded in his aim "to give the idea of immensity within a very limited space."

After overseeing his mural's installation in Merion in May, Matisse pronounced his pleasure at the way his lunettes fit in with their setting. From New York he wrote to Bussy, "It is a splendid thing, which one can have no idea of without having seen it—since the whole arched ceiling

MATISSE AT THE LOUVRE, 1932.

163

MATISSE, 1933.

radiates out—and this effect even extends down to the ground. . . . Having seen the picture in place—I now feel disconnected from it. I feel it has become part of the building. . . . Seeing the picture again was a real *birth* relieving me of the labor and pain that led up to it."

For all his pleasure in seeing his mural in place, Matisse wanted Barnes to remove the low-relief frieze of African motifs that ran between the windows. He also asked Barnes to remove the two paintings that hung under his mural—his own *The Seated Riffian,* painted in Morocco, and Picasso's *The Blind Flower Seller* (1906). These elements, he said, were incongruent. Though Matisse was insistent, Barnes was equally stubborn and the two quarrelled. In the end, the only thing Matisse succeeded in moving was a podium during a lecture he gave to a group of art students. The sculptor Sidney Simon, who was studying art at Philadelphia's

Pennsylvania Academy, remembers seeing the door of the great hall open and Dr. Barnes leading a man with a white beard into the room. "It's Matisse!" someone murmured. Matisse went up to the lectern, which stood in front of Picasso's *The Blind Flower Seller*. Before addressing the audience, he moved the lectern to a spot not dominated by his rival's canvas. Then he pointed up to his eight monumental dancers and said, "Do not follow these. These are not your beginnings, they are my endings."

Soon after, Matisse realized, to his chagrin, that the mural—which he felt by its nature should be public art—would be seen by few people. Back in Nice, he decided to continue working on the version of the mural that had not fit the great hall's dimensions. But exhausted from the strain of working on the Barnes mural, he went in June to Saint-Jean-Cap-Ferrat to rest. From there he wrote to Simon Bussy that he was "tired at heart." He said that he was "incapable of doing any work right now," and that doctors had warned him not to take on another big project like the mural. But he added, "Anyway, when I'm on the point of sinking into a depression I pull myself together by reminding myself of the complete success of that famous panel." Instead of improving, his health grew worse. He came down with acute nephritis, and from late August until mid-September he was in Vittel taking the cure. As always, he found it hard to relax: in his impatience he skipped the first and second springs and went on to take the water in the third, and this made him sicker still.

Before leaving Nice for Vittel, he had gone to his warehouse/studio to take a photograph, and, as he wrote to Bussy, "I couldn't resist the impulse and reworked my first panel from top to bottom for an hour—fortunately in chalk, so nothing is irreversible. Don't worry, if I go back to it, it'll be only for a day or two each week—between working on the paintings I want to do when I get back. I'm still boiling, an old stallion who has sniffed a mare." After returning from his cure, Matisse continued work on the version that had not fit. On October 15 he wrote again to Bussy: "The right [and] center panels have been stood up with the cartoon in place, and I'm now going to do a tracing. For the third panel, I have to wait for a couple of weeks until I get the canvas from Guichardaz." It sounds as though he

MATISSE IN THE BOIS DE BOULOGNE, C. 1931,
SKETCHING A SWAN FOR *Poésies de Stéphane Mallarmé.*

reinvented the mural again, almost from scratch. Thus, what has always been called the first completed version is in fact the last. Although he finished this reworked version of *Dance* by the end of 1933, it is signed and dated "Nice, 1932," perhaps because Matisse did not want Barnes to know that the Barnes Foundation version was not the final one. In 1936 it was donated to Paris's Petit Palais and now belongs to the Musée d'Art Moderne de la Ville de Paris.

In 1931 and 1932 Matisse was so absorbed with the Barnes mural that he did not begin any new paintings, but while he struggled with the mural during the winter months in Nice, during his Paris summers he was challenged by a commission on a much smaller scale. In 1930 the Swiss publisher Albert Skira invited him to illustrate a book by the nineteenth-century poet Stéphane Mallarmé. It was the first of Matisse's many illustrated books. The etchings he made for it have the same terse, clean line as the Barnes mural. "To draw," he said, "is to make an idea precise. Drawing is the precision of thought." That exactitude, he was quick to point out, demanded numerous studies in a less precise medium such as charcoal. And the unerring simplicity has another source as well: Matisse sometimes

Ses purs ongles très haut dédiant leur onyx,
L'Angoisse, ce minuit, soutient, lampadophore,
Maint rêve vespéral brûlé par le Phénix
Que ne recueille pas de cinéraire amphore

Sur les crédences, au salon vide : nul ptyx,
Aboli bibelot d'inanité sonore
(Car le Maître est allé puiser des pleurs au Styx
Avec ce seul objet dont le Néant s'honore).

Mais proche la croisée au nord vacante, un or
Agonise selon peut-être le décor
Des licornes ruant du feu contre une nixe,

Elle, défunte nue en le miroir, encor
Que, dans l'oubli fermé par le cadre, se fixe
De scintillations sitôt le septuor.

128

LA CHEVELURE, from *Poésies de Stéphane Mallarmé* (1932).
Etching, printed in black, 13⅛″ × 9⅞″.

felt that when he was drawing, some higher power took over. "I am guided," he said. "I do not lead." Although the Mallarmé etchings look extraordinarily distilled and pure, Matisse made sure they kept the specificity and excitement of real life by drawing from nature, for example making pencil sketches for *Le cygne (The Swan)* from an actual swan he observed in the Bois de Boulogne.

What he wanted to achieve in the Mallarmé book was a balance between the pages with text and the pages with illustrations. It was, he said, like juggling. His marks spread out over the whole page rather than being massed toward the center. This kept the surface light, and the page does not lose interest at its periphery. In *La Chevelure (Hair)* the white of the paper is as alive as the line. "My line drawing," said Matisse, "is the purest and most direct translation of my emotion. . . . They [the drawings] generate

light; seen on a dull day or in indirect light they contain, in addition to the quality and sensitivity of line, light and value differences which quite clearly correspond to color."

Whether speaking of drawing or of painting, Matisse repeatedly insisted on the value of hard work: "Put your work back on the anvil twenty times and then begin over again until you are satisfied." And that is what he did when he painted *The Pink Nude* (plate 25), as can be seen from the long series of photographs taken of the painting in progress. Although he surely must have fretted, he enjoyed the struggle: contradicting his earlier statement to Gertrude Stein that painting was "so sweet when it comes of its own accord," he told a friend that he preferred doing the paintings that gave him problems to those that seemed to paint themselves. Matisse began *The Pink Nude* in May 1935. After much scraping, repainting, and moving and changing the colored cutout papers that he pinned to the canvas to help him find his way, he finished *The Pink Nude* half a year later, on October 30. As he worked, the nude became flatter and more abstract. "At each state, I reach a balance, a conclusion," Matisse said of painting in general. "The next time I return to the work, if I find a weakness in the whole,

MATISSE IN THE
JARDIN DES PLANTES, 1932.

(A) (B)

(C) (D)

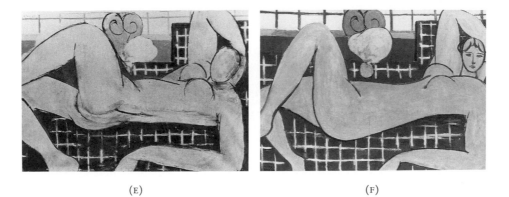

(E) (F)

THE PINK NUDE in progress, April–October, 1935.
(A) May 3, the first documented state. (B) May 20. (C) May 29. (D) September 6.
(E) October 16. (F) October 30, the completed work.

SELF-PORTRAIT (Nice or Paris, 1937).
Charcoal and estompe on paper, 18⅜″ × 15⅜″.

I find my way back into the picture by means of the weakness—I return through the breach—and I can conceive the whole afresh."

As the figure in *The Pink Nude* grew larger, her limbs touched the canvas edge and positioned themselves according to those horizontal and vertical axes, thus locking her to the canvas surface and preventing her from rolling out into the viewer's space. As in the Barnes mural, the figure is abstracted into an emblem, what Matisse called a sign.

The model for *The Pink Nude* was Lydia Delectorskaya, a beautiful young Russian woman who had served as Matisse's assistant for the Barnes mural and who had come to work as companion and nurse to Madame Matisse in 1934. According to Jane Simone Bussy, it took Matisse two years to realize that Delectorskaya was "passionately in love with him." In February 1935, she became Matisse's model, and soon she filled the roles of secretary, studio assistant, household manager, hostess, and, until the end of his life, beloved companion. Bussy recalls that Delectorskaya not only "nursed Madame Matisse in her mysterious disease apparently with the devotion of a daughter," she also was the "perfect secretary: she had all the

NYMPH AND FAUN WITH PIPES (Nice, 1940–43).
Charcoal on canvas, 60 ¼″ × 65 ⅛″.

master's works down to the last lithograph at her little fingertips; her quiet, steely manner was even more efficient with dealers than his own genial 'Good pictures are never [too] dear,' with which he would add on an extra ten francs. . . ."

And she continued to play the role of studio helper. At the close of each day's painting session, after photographing the canvas, Delectorskaya would take a turpentine-saturated rag and wipe out the parts of the painting Matisse wished to repaint. It was her job also to protect Matisse from

171

disturbances. As one visitor in the mid-1940s put it, "with deep respect and obedience to the master, she satisfied his least desire with quiet efficiency." In the 1940s Picasso and Françoise Gilot once witnessed a different side of her relationship to Matisse when they saw Matisse, who had not heard their arrival in his house, jump out from behind the door where he had hidden in a game of hide-and-seek with Madame Lydia. From 1935 until around 1937, Delectorskaya appeared in many of his paintings. Perhaps more than any other model, except his daughter Marguerite, Delectorskaya elicited from Matisse a reaction that is tender and personal. In portraits like *Blue Eyes* (1935), she is not just an attractive motif to trigger formal invention; she is an individual human presence.

Delectorskaya seems to have released a new wave of sexual energy in Matisse; from the mid-1930s come numerous rather erotic drawings of nudes, and in 1935 he began *Nymph in the Forest*, a much larger version of the nymph and satyr subject that is thought to have originally been prompted by his love affair with another blond Russian woman, Olga Merson. The searching, turbulent quality of the drawing in *Nymph in the Forest* works to greater advantage in *Nymph and Faun with Pipes*, a large charcoal drawing on canvas, a version of which was begun in the mid-1930s and reworked in the early 1940s. Here the urgency of the lines perfectly suits the dramatic moment in which the faun moves in upon the sleeping nymph and arouses her with his music. The figures are drawn with several alternate lines so that they seem to move and their positions are ambiguous. All the light is focused on the faun's enormous hands. They must be the hands of a creator, for the only other hands in Matisse's work that are quite as large and luminous are his own in *Self-Portrait as an Etcher* (1903). Just as the bow in *Violinist at the Window* might have been a substitute for the painter's brush, so in this fervent drawing the faun's pipes might stand for the artist's stick of charcoal or his pencil. And the recumbent nude is his creation. The faun holds the pipes in both hands; as art historian Leo Steinberg has pointed out, the pipes also resemble a compass. The faun's gesture is one of opening; he is taking the nude's measure. In his creative thrust, the faun not only invents the nymph through drawing but also

seduces and opens her. This connection between drawing, painting, and lovemaking was noted by Matisse when he said to Louis Aragon that he needed the model's presence to fire the alchemy of invention—"to keep my emotions going, in a kind of flirtation, which ends in rape." *Nymph and Faun with Pipes* is a ravishment of the canvas by line.

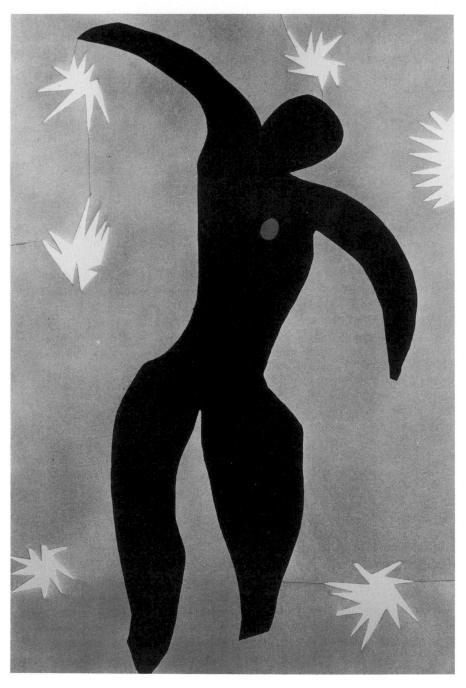

ICARUS (1943). Plate VIII from *Jazz* (published in 1947).

THE COLOR OF IDEAS,
THE LIGHT OF THE MIND

lthough Lydia Delectorskaya now presided over Matisse's home as well as his imagination, Madame Matisse spent periods of time with her husband in Nice as well. Jane Simone Bussy recalled her and her father's once or twice yearly luncheons at the Matisses' place Charles-Félix apartment: while Madame Matisse spent most of her day on the sofa because of her back problems, Matisse was, despite his monologues about art, "extremely amusing and even charming. He is far more cultured than most painters, particularly in music, and is curiously well read. He is one of the best mimics I know, taking people off with an extreme economy of means— a look or an intonation is enough to conjure up a person. One of his star turns was imitating Bouguereau. . . ." These visits, Bussy went on, were "rather formal. Madame Matisse I found pleasant but quite uninteresting. We would be given a very good meal and afterwards led into the studio, which was just a big L-angle room and shown the work in progress. I used always on these occasions to be struck by the elaborate character of the ritual for so apparently spontaneous an artist. He would for instance have the

175

picture he was working on photographed every time he made an alteration. Sometimes there were a dozen or so of these photographs placed by the side of his easel. He would, he explained, lie awake all night wondering which was the best and thinking out new combinations of forms which would sometimes turn into some quite new composition and sometimes lead him back to the first. Sometimes, however many photographs he took he would never find out what was wrong. Art was hard."

Matisse moved to a grand apartment in the Hôtel Régina in the suburb of Cimiez high on a hill behind Nice in November 1938. The building was a huge Victorian wedding-cake-style edifice constructed as a hotel at the turn of the century in the expectation that Queen Victoria would vacation there. Its large rooms, which overlooked a public garden and offered views of the Mediterranean, provided ample space and light for Matisse to live and work. When Matisse moved in, Madame Matisse may have been with him. In any case, she joined him at some point that fall or winter and left in March 1939. According to Bussy, who saw Matisse every afternoon when he came to her parents' house for tea and to pour out his miseries, the parting was a protracted battle. Furious over her husband's liaison with Lydia Delectorskaya, Madame Matisse left her sickbed and rushed around screaming at Matisse that he had to choose between her and Lydia. Matisse did not want to choose. He wanted to keep them both. At one point Lydia was fired and forced to leave the house, but she and Matisse met secretly. As Bussy recalled in her flamboyantly colorful and no doubt exaggerated account, Delectorskaya "committed suicide once or twice by firing an empty revolver at the wall. . . ." and Madame Matisse's hysteria gave her a "demonic energy" which apparently cured her spine. "She tore the clothes off her back, she threw tables and chairs across the room, she purloined Matisse's illegal store of gold ingots and hid it under her pillow." At some point Amélie Matisse shrieked, "You may be a great artist, but you're a filthy bastard!" Matisse was dismayed by his usually demure wife's outburst. "Yes, but would you believe it, she said that to ME!" he said to the Bussys. Finally Lydia won and Madame Matisse "departed in a cloud of smoke." After she left, the bitter process of legal separation began. It

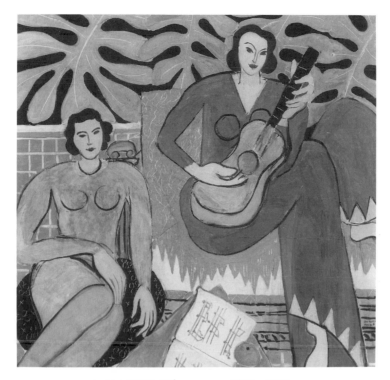

MUSIC (1939). Oil on canvas, 45⅜″ × 45⅜″.

dragged on until April 1940. Because of financial complexities, however, Amélie and Henri Matisse never divorced. After they recovered from the conflicts involved in arranging a settlement, their relationship once again became cordial.

The legal battle depressed Matisse, as did the beginning of World War II in the autumn of 1939, when he was almost seventy. His paintings during the war years—for the most part boldly colored, highly synthesized still lifes and interiors with female figures—do not refer to the war, unless the increased use of black in paintings such as *Music* (1939) is, like the predominance of black in his World War I paintings, an expression of his gloom. Matisse was not politically engaged; he said discussions about politics and the war bored and tired him. He wrote to Tériade in December 1942: "I seem to be living above everything, troubled only by the ups and

downs of my liver ailments, but I am also affected by the same things that affect the community." The war made him anxious, and he sometimes had trouble concentrating on art. "For myself," he wrote to another friend, "I have kept on working despite the fact that this is fairly difficult, for the artist is only in full possession of his mind before his easel." Painting was always what mattered most. In 1943 he wrote to Louis Aragon, "I am an elephant, feeling, in my present frame of mind, that I am the master of my fate and capable of thinking that nothing matters for me except the conclusion of all of these years of work, for which I feel myself so well equipped."

After France and Britain declared war on Germany on September 3, Matisse and Lydia Delectorskaya left Paris to spend a month in a country inn near Rambouillet. Matisse wrote to Bussy that he was working and that on his frequent visits to Paris he found the city empty and sinister. "Those who are still around scuttle about like black rats, with their gas mask boxes at their sides." That winter he and Lydia went south to Nice as usual, but when German troops entered France and began their advance toward Paris in May 1940, the couple was back in Paris, and Matisse, nervous as ever, went to the movies at night to distract himself. In the mornings, around seven or eight, he would go to Tériade's office at *Verve* magazine, apparently because his Greek friend's optimism calmed him. There he would pass the time making cutouts from colored papers in printer's ink sample albums. Often he refused to go into the air raid shelters because they were too cold: "When the air raid warnings forced me to take refuge in the cold, damp shelters, I was worried I might catch pneumonia and decided to leave Paris." On May 14 he and Lydia, along with numerous other refugees, headed south. Their circuitous journey took them first to Bordeaux, where Matisse observed, "The overcrowding was such that hundreds of people were sleeping in their cars in the street." Many trains were too packed to board, and they were at one point stranded in Saint-Gaudens. It was often impossible to find hotel rooms: Matisse spent one night in what turned out to be a brothel. After passing through Ciboure, Saint-Gaudens, Carcarsonne, and Marseilles, on August 27 he and Lydia were back in Nice, installed in the apartment in the Hôtel Régina.

Matisse had considered going abroad to escape the war. He had even acquired a Brazilian visa and a ticket to Rio de Janeiro for June 8. Part of what had made him change his mind was a chance meeting with Picasso in a Paris street. Both painters blamed the war and France's humiliating collapse on French conservatism: "It's the École des Beaux-Arts!" Picasso quipped. In Matisse's opinion, if people had minded their own business and worked at their jobs as he and Picasso had, none of this would have happened. Picasso was digging in his heels, not leaving Paris. To Matisse, this began to seem the honorable thing to do. Then, during the exodus to the South, Matisse was moved by the crowds of refugees at the Spanish frontier: "When I was at that border and saw the unending line of people leaving I hadn't the slightest thought of leaving in mind. . . . When I saw what a mess everything was in, I asked for my money back on the ticket. I would have felt I was running away. If everyone of any value leaves France, what will remain of France?"

In June, Paris fell to the Germans. Safe in the unoccupied South, Matisse focused on painting. On September 1 he wrote to his son Pierre, "I am trying hard to settle down to my work. Before arriving here I had intended to paint flowers and fruits—I have set up several arrangements in my studio—but this kind of uncertainty in which we are living here makes it impossible; consequently I am afraid to start working face-to-face with objects which I have to animate myself with my own feelings—therefore I have arranged with some motion picture agents to send me their prettiest girls—if I don't keep them I give them ten francs." On October 11, he wrote Pierre again: "My life is between the walls of my studio," and in the same month he wrote to a friend: "I don't think I'm any longer capable of envisaging anything that is not part of my usual obsession, which is to think myself completely secure only when I'm hard at work." But his ability to work was increasingly hindered by intestinal problems, which Matisse said were due to a congenital intestinal malformation that had been bothering him for months.

His daughter took him to a hospital in Lyon where he was operated on for duodenal cancer in January 1941. Two pulmonary embolisms and

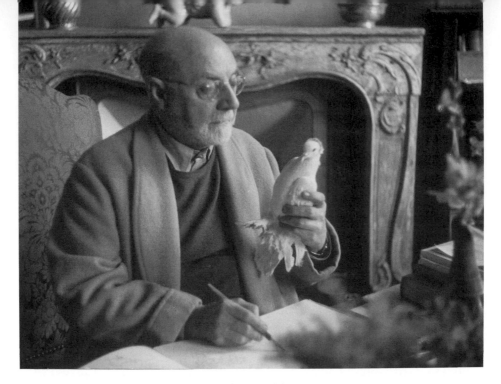

MATISSE IN VENCE, 1944. Photograph by Henri Cartier-Bresson.

another operation followed. Astonished at his survival, the Dominican nuns who nursed him nicknamed Matisse the "Risen One." Matisse was delighted with the name. After going home to the Régina in May, he worked in bed, drawing and doing book illustrations. Lydia Delectorskaya took care of him. One year after the operation, he wrote to Albert Marquet that the operation "made me young again and philosophical. . . . I had prepared for my departure from this life so well that it's as if I'm in another second life."

However, the operation had left him an invalid. The muscular abdominal wall was weakened and prolapsed. He had to wear a supporting belt, and could not stand for long. Matisse summoned his Picardian stubbornness and kept on working. "Whether you can or not, you hold on: that's the essential," he said in 1941. "When you're out of willpower you call on stubbornness, that's the trick. For big things as well as small, that suffices, almost always." He had great ambitions for this second life. In March 1942, he told Louis Aragon, "It's just as if I were someone who is preparing to tackle large-scale composition." It was, he said, "as if I had all my life ahead of me, or rather a whole other life."

His mobility restricted, he assembled around him everything that gave him pleasure, creating a Golden Age world of *luxe* and *volupté* in his Régina apartment, filling it with oriental carpets, Indian shawls, panther skins, African and Oceanic masks, gourds, an archaic Apollo, a plaster cast of Michelangelo's *Dying Slave*, and all his other favorite objects—vases, crocks, shells, Chinese porcelain, ornate mirrors, and a marvelous assortment of chairs upon which to pose his models. Of his rococo armchair with a seat and back shaped like an open scallop shell, he wrote to Aragon: "I have at last found the object for which I've been longing for a whole year. . . . When I found it in an antique shop, a few weeks ago, I was quite bowled over. It's splendid. I'm obsessed with it. I am going to bounce on it gently."

Matisse also had an aviary full of many different species of tropical birds and numerous white pigeons, which were allowed to fly about the apartment. He said, "Sometimes when I bought one of these birds I found it really expensive . . . but when I thought I was done for, I said . . . You must always do what gives you pleasure." Because the birds were too expensive to feed during the war, he gave some of them to Picasso, for whom they served as models for his famous peace dove. Matisse talked about his birds as though he were an expert—and he could hold forth on a subject for hours. Sometimes, one friend noted, his ideas "went a bit beyond the realm of science, as when he said that European birds are brighter and more intelligent than those of exotic countries." (Critics who analyze the relationship of Matisse's art, especially the odalisques, to French colonialism could make something out of this.) Each day he tended the exotic plants in his conservatory, which he called "my farm." Caring for plants, he explained, helped him in his drawing of them. "Everything is new, everything is fresh, as if the world had just been born," he said in 1943. "A flower, a leaf, a pebble, they all shine, they all glisten, lustrous, varnished, you can't imagine how beautiful it is! I sometimes think we desecrate life; from seeing things so much, we don't look at them any more." This freshness of eye and affection for nature are clearly visible in the art that came out of this explosion of creative energy toward the end of his life.

In 1942 France's so-called Free Zone was annexed by the Germans, and late in that year Nice was occupied by the Italians. Cimiez was bombed by the Allies in March 1943. Danger of further air raids as part of the preparation for the Allied landing prompted Matisse to move in July to the ancient hill town of Vence, five miles inland from Nice. For six years he rented a villa called Le Rêve (The Dream), a simple, colonial-style pink house built by a British admiral on the outskirts of town. In a letter to Louis Aragon written on August 22, 1943, Matisse described Le Rêve as full of light. He loved its balustraded terrace covered with ivy and geraniums, as well as the villa's view of palm fronds. "I can put all my memories of Tahiti into this setting," he told his poet friend.

In June 1943, shortly before leaving Nice for Vence, Matisse produced two versions of *Icarus*, one of his most succinct and moving images (page 174). When the war was over, he used one version as the frontispiece for a 1945 issue of *Verve* that was devoted to his work of the war years, and later he included the other version in his book *Jazz*, which Tériade published in 1947.

Painters from Pieter Brueghel to José Clemente Orozco have been moved by the myth of Icarus, perhaps seeing the boy's urge to fly toward the sun, and his fall when the sun melted the wax that attached his wings, as a parable of the artistic life. A black silhouette lit by a passionate red heart, Matisse's Icarus falls through the night's blue abyss, evoking both human vulnerability and the imagination of the artist as it soars and then plummets back to earth. The stars exploding around Icarus represent, Matisse said, bursts of antiaircraft shells. *Icarus* also expresses Matisse's feelings about the tragedy of war and the fall of France.

The reproduction of *Icarus* in *Verve* marked the public debut of Matisse's paper cutouts. This technique, which in 1938 he began to use as an end in itself rather than as an aid to composition, became during the last decade of his life his chief preoccupation. In 1950 he made his last sculpture, and in 1951 his last painting.

Although there is a relationship between Matisse's cutouts and Cubist collage, the Cubists used found fragments of paper to build an image, whereas Matisse most often cut paper with the shape of his image in mind.

THE SWIMMING POOL (Nice-Cimiez, 1952).
Nine-panel mural in two parts: gouache on paper, cut and pasted on white paper,
mounted on burlap. A–F: 7′ 6⅜″ × 27′ 9½″; F–I: 7′ 6⅜″ × 26′ 1½″.

From a distance his cutout figures look as if he cut the whole figure in one
go out of a single sheet of paper, even though they are sometimes made up
of numerous small patches of paper that bear little relationship to the
image's overall shape. Unlike the geometric papers that build a Cubist col-
lage, they are the equivalent of brush strokes.

Matisse's first major cutout project was *Jazz*, begun in 1943. Too frail
and too upset about the war to paint, he accepted Tériade's suggestion to do
a book illustrated in color. He based the book's twenty color plates on
maquettes made of cut and pasted paper. Later he produced a handwritten
text, which he said (not quite accurately) was a "purely visual" accompani-
ment to the images in color.

Working with cutout paper was convenient for a bedridden man. His
subject matter, memory, suited his confinement, too. In the text for *Jazz* he
said, "These images . . . have resulted from crystallizations of memories of
the circus, popular tales, or travel." After his operation, memory became
increasingly important. "I'm growing old, I delight in the past!" he wrote
to Marquet in 1941. He no longer relied on the model. "It's as though my

memory had suddenly taken the place of the outside world," he confided to his friend the photographer Brassai in 1946.

With the cutouts he resolved what he called the "endless conflict of line and color": the two became identical. "The paper cutout," he said in 1951, "allows me to draw in color. It is for me a matter of simplification. Instead of drawing the contour and filling in the color—one modifying the other— I draw directly into the color, which is all the more controlled in that it is not transposed."

The method's flexibility allowed for a great deal of improvisation. Matisse would have sheets of white paper painted by an assistant with opaque watercolor (gouache). Then he would cut out the shapes and tell the assistant (in the case of *Jazz*, the assistant was Lydia Delectorskaya) where to pin them on the support. Extra pinholes in the paper show that as with the Barnes mural, he changed his mind often. In some cutouts partially rubbed-out charcoal lines indicate another method of searching for the right configuration. When he had made his final compositional decisions, the assistant would glue the cut papers in place. Like much of Matisse's work, the cutouts look simple. Nothing seems to come between the painter and his image, or between the image and the viewer. Everything seems inevitable, easy. "I have worked for years," Matisse said, "in order that people might say, 'It seems so simple to do.'" The joy of that simplicity is Matisse's great gift.

The cutouts combined aspects of painting, drawing, and sculpture. In his text for *Jazz* Matisse said, "Cutting directly into color reminds me of a sculptor's carving into stone." Although the cutout colored shapes are flat, Matisse's powerful understanding of three-dimensional form gives the shapes a feeling of volume.

The freedom of the cutout technique is felt in the way shapes seem to float in space and are not tied to a location by perspective or by rigid compositional lines. Space is expansive—what Matisse called "cosmic." It is not something built; it is something that flows. It is identical with light, and it suggests the unlimited space of memory and imagination. Forms move in space as weightlessly as Matisse's goldfish in their bowls. This open space

recalls, too, Matisse's memory of opening his eyes underwater in the lagoons of Tahiti, feeling free of gravity and exploring the endless and seamless underwater space from the viewpoint of a fish. The cutouts also recall the dazzlement of coming to the water's surface and seeing "the luminous whole." In addition, Matisse saw that air travel had changed and expanded the perception of space. His own concept of spatial freedom is captured by his description of watching his pet doves: "Their spheres, their curves, glide within one as in a large interior space. When I am doing the cutouts, you cannot imagine to what degree the sensation of flight which comes to me helps me better to adjust my hand as it guides the path of my scissors. It's hard to explain. I would say that it is a kind of linear equivalence of the sensation of flight."

The cutouts' new openness and freedom also came from the change in Matisse after his operation. His brush with death gave him a measure of spiritual peace:

> Everything that I did before this illness, before this operation, gives the feeling of too much effort; before this, I always lived with my belt buckled. Only what I created after the illness constitutes my real self: free, liberated. . . . There is only one thing that counts in the long run: you have to abandon yourself to your work. . . . Only then does your work contain you totally.

In the cutouts, each paper shape has a single, flat, almost unmodulated color, and the organization of these colored shapes is what makes the composition resound. Matisse felt strongly that different colors have different personalities. A simple blue "acts upon the feelings like a sharp blow on a gong," he said. In 1952 he told an interviewer, "Color works you over more and more. A certain blue enters your soul. A certain red has an effect on your blood-pressure. A certain color tones you up. It's the concentration of timbres." Both color and light in the cutouts seem to sail free of earthly substance: they are liberated from the demands of quotidian reality. They are what Matisse once called "the color of ideas" and "the light of the mind."

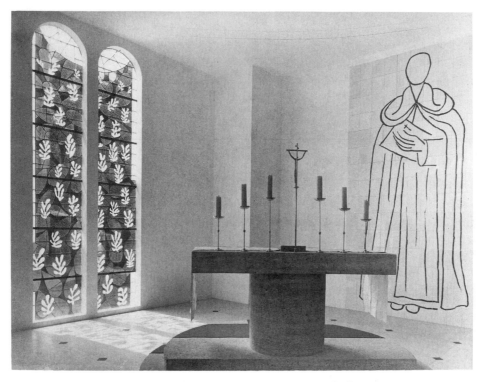

THE CHAPEL OF THE ROSARY AT VENCE WITH THE *Tree of Life* APSE WINDOW,
THE ALTAR, AND THE CERAMIC TILE MURAL OF SAINT DOMINIC.
Photograph by Hélène Adant.

FORM FILTERED TO ESSENTIALS

n 1944 Marguerite, now fifty, and Amélie Matisse, seventy-three, were captured by the Gestapo and punished for their involvement in the French Resistance. Matisse was worried too about his son Jean, who had become a sculptor and who was also active in the Resistance: he used his cellar to teach recruits how to use firearms, and he hid dynamite inside his sculptures. Matisse wrote to Camoin on May 5, 1944:

> I have just had the worst shock of my life, and I suppose I shall bear it by working.
>
> My wife and daughter have been arrested separately, in different places. I heard it two days later, with no further details and since, no more news. . . . I have someone who is trying to help. He wrote me about it, but nothing since. I don't know how they are, if they are lacking everything, and I can do nothing from here. . . . Life is hard!

Friends urged him to go to Paris to try to help, but Matisse was too frail to travel. A few weeks later he wrote to Camoin again:

> I am too worried to be able to work seriously. . . . About Madame Matisse and Marguerite, you can imagine how I have suffered, especially without news. I force myself to think the situation has improved, without giving way to my imagination. I have worked a lot so as to keep calm. I refuse to think of it, so my life can be bearable.

By July 23 he had news that his wife had been condemned to prison for six months for having typed some clandestine news-sheets, but he knew nothing about Marguerite, not even where she was. He was exhausted.

> For the last three months, in order to bear my anxiety, I have worked as much as possible. I have worn myself out. . . . I have been in bed for nearly a week, the liver out of order, fearing a complicated return of the gall-bladder trouble, which, a year ago, brought me within a hair's breath of an operation I certainly would not have survived.
> And in that state, my dear old friend, or in spite of it, one must draw and paint with serenity.

Matisse could only work for two hours a day, and he was, as he put it in 1943, "plagued by the feeling that I will not be able to finish my life's work for lack of time. This is what ties me down to the course I'm pursuing and nothing can really turn me away from it."

While Madame Matisse had been imprisoned, Marguerite fared worse. As part of her work for a partisan group called the FTP (Franc-tireurs Partisons) she was sent to Brittany to help with preparations for the Allied landing. People serving the Germans denounced her. She was tortured by the Gestapo and put on a prison train bound for the Ravensbruck concentration camp in Germany. Thanks to an Allied air raid, the train was stopped. Marguerite escaped, and after hiding in a forest for a few weeks in November, she made her way to Paris, which had been liberated by the Allies on August 25, 1944. Matisse was not told what had happened to her

until after she was safe. When she came to see him for two weeks in Vence in January 1945, he saw her thinness and her sallow complexion, and drew her portrait in charcoal as he listened to her story. In a note about Marguerite's visit written to Lydia, who was in the Basses-Pyrénées recovering from an illness, he said, "I lived through her prison experiences, all that she suffered and the horrors that surrounded her—what a subject for a Dostoyevsky!" Too upset to speak, he had held his daughter's hand for a long time and then said, "Let's not speak about any of these events; let's just resume our relationship."

After the armistice in May 1945, Matisse continued to live in Vence for another four years, also spending some months in his Paris apartment at 132 boulevard Montparnasse. In the capital he enjoyed the renewal of art life and the fact that France now honored him as a great master. In 1945 the Salon d'Automne had a retrospective in Matisse's honor. In the following years he had various one-man shows in France and abroad. He was made commander of the Legion of Honor in 1947. To make up for its earlier neglect, the French government began to acquire his work for Paris's Museum of Modern Art.

Although he had not participated in the war, his example, like that of Picasso, had been sustaining for the French. His perseverance in his expression of civilized values and his insistence on artistic freedom provided moral encouragement. As Louis Aragon put it, Matisse "carries on that great French interpretation of the world which remains our indefensible right." Matisse's paintings, along with those of other modernists, were reviled by the Nazis as degenerate. "Into the ashcan with Matisse" was the cry, and on May 23, 1943, German authorities burned numerous examples of modern art in the garden of the Jeu de Paume. In the dark days of France's humiliation and defeat, Matisse, simply by continuing to make brilliant images that extolled a specifically French pleasure in life, helped to restore that all-important mainstay of well-being, the French notion of *gloire*.

After the war the simplification of form and color seen in Matisse's cutouts moved his easel painting toward a more abstract and decorative

mode, in which highly saturated, flat color areas and bold patterning take us further than ever from the textures and tactility of immediate, observed life. A series of interiors done in Vence between 1946 and 1948 seem to be done in a kind of sign language—an oval for the head, for example, or a few loops, curls, and X's for a table or a chair. Still-life objects are defined by vigorous brush drawing overlaid on, and separate from, color. Color is so intense it is almost invasive, and black is brilliant, too: as in *The Moroccans*, black appears to be the very condition, the tabula rasa of light.

Quoting Pissarro in 1947, Matisse said that Manet had "made light with black," and this is what Matisse did in paintings like his 1948 *Interior with an Egyptian Curtain* (plate 27). The glare of black often has a tinge of melancholy, as if all the pyrotechnics of color had a perilous instantaneity. Although he loved light, Matisse in these years was apt to pull curtains against sunshine, perhaps because of eye problems. When Françoise Gilot visited Le Rêve, she was surprised by the darkness inside. This darkness pervades both *Interior with an Egyptian Curtain* and *The Silence Living in Houses* (1947). The latter's title captures the Vence interiors' mood of gentle sadness and suggests something of the isolation of Matisse's life, when more and more he was confined to his bed. Perhaps the ghostly blue figures reading in the blackened room of *The Silence Living in Houses* express the sadness that comes to older people when their contemporaries are dying and thoughts of mortality become more real. Specifically, the painting's somber atmosphere could reflect Matisse's sorrow over the loss of his old friend Marquet, who died the year it was painted.

In both of these Vence interiors, black shadowed walls frame closed windows whose mullions make it clear that the glow of light on the trees outside will not enter the house. In *Interior with an Egyptian Curtain* the palm fronds' radiant burst of strokes lights up the sky behind a black cross formed by the mullions. This almost apocalyptic light suggests the old man's ecstatic reverence for life heightened by his knowledge that life, like the partly drawn Egyptian curtain, was coming to a close. In conversation with a friend in 1947, the seventy-seven-year-old Matisse said, "It's strange

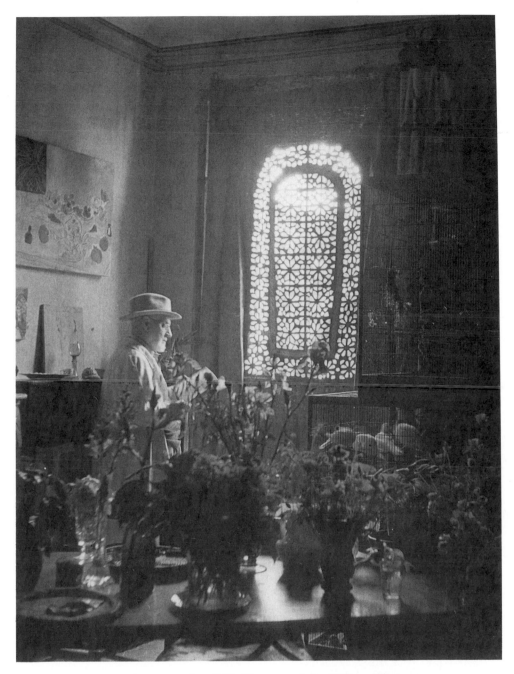

MATISSE AT LE RÊVE, 1946. Photograph by Hélène Adant.

how short life is: now I can see what I have to do, I would like to start over again, but a painter's life is never long enough, you leave your work in the middle."

In the late 1940s Matisse began work on the Chapel of the Rosary at Vence, a four-year project that fulfilled his ambition to work on a large scale (page 186). Because it united light, color, drawing, sculpture, and architecture in one artistic statement, he saw the project as the culmination of his life's work. Ever since his recovery from the operation in 1941, Matisse had wanted to find some way to express his gratitude to the Dominican nuns who had cared for him. By coincidence, one of his favorite nurses had since taken the veil and had come to work in a Dominican convalescent home situated across the road from Villa Le Rêve. On one of her visits Sister Jacques, as she was now called, showed Matisse her design for a stained-glass window for a chapel that the Dominicans hoped to build. Before long it was decided that Matisse would design not only the stained-glass windows but the whole chapel—the building, the altar, furnishings, and even the chasubles. In 1949 he moved back to the Hôtel Régina in Cimiez, where the large rooms allowed him to make studies on the same scale as the chapel.

The interior of the Vence chapel is stunningly modest, at first almost disconcertingly so. "In the chapel," Matisse said in 1951, "my chief aim was to balance a surface of light and color against a solid wall with black drawing on a white background." White-tiled walls with spare black line drawings face and reflect yellow, blue, and green stained-glass windows. The interconnection between tiled and glass surfaces is subtle. Matisse was able to bring color, line, and light together in an extraordinary—and delicately spiritual unity—spiritual because what animates the work is light that literally comes from on high. When the sun shines, the glazed white ceramic tiles, with their simple black images, reflect the ever-changing colored light that pours through the stained-glass windows. As in Matisse's open-window paintings, inside and outside join in a single vital flux. The effect is both gentle and consoling.

The chapel's windows and the vestments, designed with paper cutout maquettes, exemplify what Matisse called "form filtered to its essentials." To draw the figures of Saint Dominic, the Virgin and Child, and the stations of the cross he used a bamboo pole with charcoal attached. He deliberately contrasted the firm, smooth drawing of the serene figures of the Virgin and Saint Dominic with agitated drawing in the scenes of the passion. As mentioned earlier, Matisse read and reread the *Imitation of Christ*, and he admitted that he felt a powerful empathy for Christ's tragedy; the lines that evoke the story of the Crucifixion are jagged, intentionally halting, and washed out rather than opaque. It is as if he himself felt the exhaustion and pain of bearing a cross.

The chapel's cornerstone was laid in December 1949. The Chapel of the Rosary was consecrated with much art-world and media fanfare on June 25, 1951. Matisse's doctors forbade him to attend, but he sent his son Pierre along with a message to the bishop that said he considered the chapel to be his masterpiece. He called the chapel "my revelation."

With his faith in art's capacity to uplift and to heal, Matisse said he wanted visitors to the chapel "to feel purified and relieved of their burdens." He wanted them to experience in "peaceful contemplation" that "balance . . . purity, and serenity" he had described in "Notes of a Painter" forty-three years before.

At the end of his life, Matisse's art shed the dross of reality and reached for a more spiritual idea. "Retain only what cannot be seen," he advised students in 1946. Matisse was not a formally religious man, yet the Vence chapel and many of his writings convey a religious feeling. In a 1929 or 1930 conversation with Tériade, he said, "The artist or the poet possesses an interior light which tranforms objects to make a new world of them—sensitive, organized, a living world which is in itself an infallible sign of the Divinity, a reflection of Divinity." And in his text for *Jazz* he answered the question "Do I believe in God?" with "Yes, when I work. When I am submissive and modest, I sense myself helped immensely by someone who makes me do things by which I surpass myself."

After the chapel was completed, some believers seized the opportunity to say that Matisse had embraced religion, while leftists like Picasso and Aragon were disgruntled by their friend's making art for the Catholic church. "You're crazy," Picasso said, "to make a chapel for those people. Do you believe in that stuff or not?" Matisse replied, "I don't know whether I believe in God or not. I think, really, I'm some kind of Buddhist. But the essential thing is to put oneself in a frame of mind which is close to that of prayer." Around that time Matisse further clarified his relationship to religion: "The only religion I have is my love of the work that I have to do, my love of creation, and my love of absolute sincerity. I made the chapel to express myself completely, and for no other reasons."

Matisse's cutouts of the 1950s, like the windows of his Vence chapel, move away from earthbound concreteness, and specificity and toward a dematerialized, spiritual realm. He was, he said, drawing "closer to the absolute, with greater abstraction. I pursue the essential wherever it leads." Some cutouts—*Memory of Oceania* (1952–1953), for example (plate 28)—are almost entirely abstract, yet they are always based on natural forms (in *Memory of Oceania* they suggest a figure or figures enjoying sea, sky, and sand), and Matisse did not see them as a radical departure:

> All this time I have looked for the same things, which I have perhaps realized by different means. . . . There is no separation between my old pictures and my cutouts, except that with greater completeness and abstraction I have attained a form filtered to its essentials and of the object which I used to present in the complexity of space, I have preserved the sign.

Matisse covered the walls of his home with huge cutout designs, many of them based on plants, animals, and memories of the South Seas. When in the 1950s he could no longer manage to get to his conservatory, he took pleasure in the invented paradise on his walls: "Now that I don't get up I've made myself a little garden to go for walks in," he said. "Everything is there—fruit and flowers and leaves, a bird or two." On the ceiling over his bed, using charcoal attached to a fishing rod, he drew several large heads of

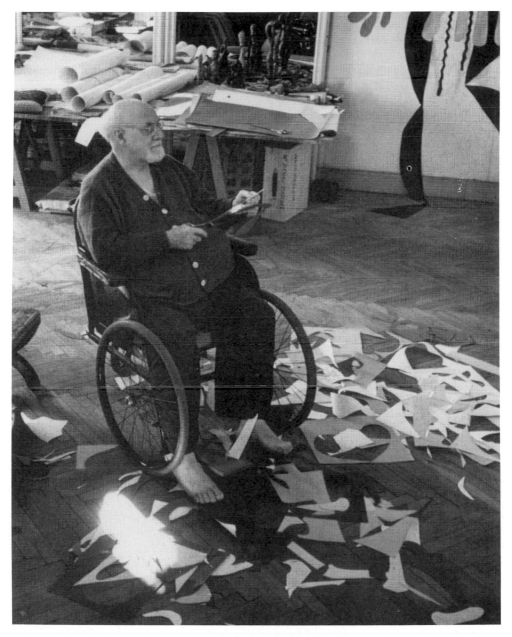

MATISSE CUTTING PAINTED PAPER IN HIS STUDIO
AT THE HÔTEL RÉGINA, NICE-CIMIEZ, 1952.
Photograph by Hélène Adant.

women and of his grandchildren: "They keep me company too," he said.

With the cutouts, Matisse was once again an inventor of a new pictorial mode. Once again he was at the forefront of the avant-garde. "A new era is opening up," he said in 1952. When the public, which had grown used to thinking of Matisse as an established old master, saw the cutouts, they were astonished at their youthful inventiveness. Younger artists in Europe and in the United States took off from his ideas to create abstractions of pure color and form.

After the war, Matisse was revered, along with Picasso, as a genius who had changed the course of art history. He had invented a new kind of space, one that was freer and more open, created by color, and inhabited by light. In his own life he had taken hold of happiness and nurtured it with a long and painful struggle, and, with great generosity, expressed it in his art. "If people knew," he said in 1952, "what Matisse, supposedly the painter of happiness, had gone through, the anguish and tragedy he had to overcome to manage to capture that light which has never left him, if people knew all that, they would also realize that this happiness, this light, this dispassionate wisdom which seems to be mine, are sometimes well-deserved, given the severity of my trials."

Matisse's popularity continued to grow in the 1950s. In 1950 he received first prize for painting at the Venice Biennale, and in 1951 he was honored with a major retrospective at New York's Museum of Modern Art. Although his behavior grew increasingly seigneurial, all of this success did not make him complacent in relation to his work. The multiple pinholes and searching lines in several cutouts from the 1950s show his ongoing struggles. He was desperate to keep on working, to keep his work alive by looking at life as though he saw it for the first time. "Work cures everything," he said the year before he died.

Matisse's continuing self-doubt is revealed in the story of his encounter with a group of schoolgirls in a Nice gallery where some of his paintings were on display. Years later one of the schoolgirls remembered, "At one moment we all stopped dead in front of a picture we couldn't

understand. . . . To our eyes, conditioned to perfect classical art, that work appeared as just 'bad.'" Matisse happened to be walking incognito among the students and heard their negative comments. When a girl asked him if he were Matisse, he did not identify himself, but when the group was about to leave he took their teacher aside and apologized for his lie. He said he had been afraid of the children's criticism: "I believe they are the only ones who see rightly, and for the moment I hate that picture in my heart for having shocked the eyes of a child, even if the critics should call it a masterpiece." In his last years Matisse often praised the freshness of a child's vision: "One must be a child all one's life even while a man."

As an old man, Matisse continued to feel that he had much to learn, and he never lost his childlike empathy with nature. In 1949 he said, "It is by entering the object that one enters one's own skin. I had to do this parakeet with colored paper. Very well: I became a parakeet. And I rediscovered myself in the work." He took pleasure in drawing over and over again the acacias and palms he could see from his window. He wanted to learn to "express a tree," he said. "I have to take in patiently how the mass of the tree is made, then the tree itself, the trunk, the branches, the leaves. . . . After identifying myself with it, I must create an object which resembles the tree. The sign of the tree." He quoted an old Chinese proverb: "When you draw a tree, you must gradually feel yourself growing with it."

Matisse's advice to young artists was to be alive to the world and true to themselves. If, he said, the young painter "knows how to keep his sincerity toward his deepest feeling, without cheating or self-complacence, his curiosity will not leave him; neither, until the last, will his ardor for hard work and the need to learn. What could be more wonderful!"

To the end, he kept learning and working, even when plagued by attacks of asthma and angina. And he did not lose his stubbornness or his passion for life. In his last year, the nuns at Vence urged him to take the Easter sacrament and to confess. He refused, saying, "I have done what I had to do as best I could, and nothing else matters much." On the day he died, November 3, 1954, he noticed a group of doctors conferring about his

health and said, "Please go and tell those gentlemen that, considering they're discussing a patient who isn't, as it happens, ill, they are spending an awful lot of time over it." Three hours later, at dusk, Matisse died of a heart attack in Marguerite's arms.

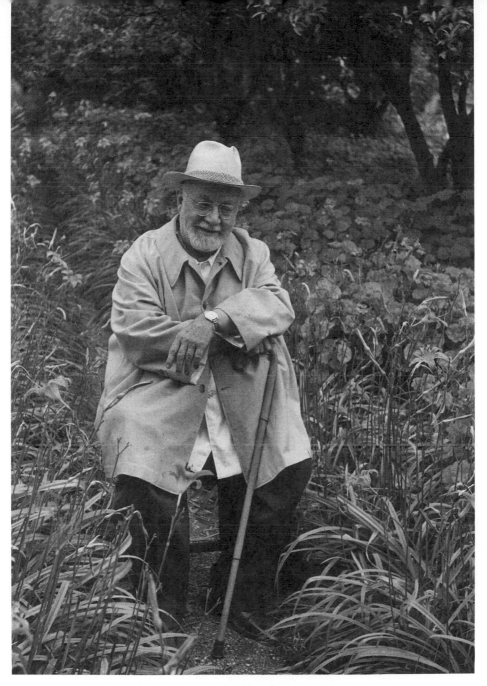

MATISSE IN TÉRIADE'S GARDEN, 1953.
Photograph by Henri Cartier-Bresson who wrote on the back:
"Last picture I took of Matisse, two days ago in Tériade's garden. His conversation is full
of life, gaiety and pep, just like a young student of the École des Beaux-Arts,
yet everything he says is full of meaning. He is a grand old man."

LIST OF ILLUSTRATIONS

All works of Henri Matisse: © 1993 Succession H. Matisse, Paris/Artists Rights Society (ARS), New York.

167 *La chevelure*, pages 128–129 from *Poésies de Stéphane Mallarmé*, published in Lausanne, Albert Skira & Cie, October 1932. The Museum of Modern Art, New York. The Louis E. Stern Collection.

168 Matisse in the Jardin des Plantes, 1932. Courtesy of the Pierre Matisse Foundation, New York.

169 *The Pink Nude* in progress, April–October, 1935. Courtesy of the Cone Archives and The Baltimore Museum of Art, the Cone Collection, formed by Dr. Claribel Cone and Miss Etta Cone of Baltimore, Maryland.

170 *Self-Portrait* (1937). The Baltimore Museum of Art, the Cone Collection, formed by Dr. Claribel Cone and Miss Etta Cone of Baltimore, Maryland.

171 *Nymph and Faun with Pipes* (1940–43). Musée National d'Art Moderne, Centre Georges Pompidou, Paris. Photograph by Philippe Migeat.

174 *Icarus* (1943). Plate VIII from *Jazz* (published in 1947). Courtesy of Giraudon/Art Resource, New York.

177 *Music* (1939). Albright Knox Art Gallery, Buffalo, New York. Room of Contemporary Art Fund.

180 Matisse in Vence, 1944. Photograph by Henri Cartier-Bresson. Courtesy of Magnum Photos, Inc.

183 *The Swimming Pool* (1952). The Museum of Modern Art, New York. Mrs. Bernard F. Gimbel Fund.

186 The Chapel of the Rosary at Vence with *The Tree of Life* apse window, the altar, and the ceramic tile mural of Saint Dominic. Photograph by Hélène Adant. Used by permission of the Musée National d'Art Moderne, Centre Georges Pompidou, Paris.

BIBLIOGRAPHIC NOTE

o write *Matisse: A Portrait* I relied on the writings of a number of Matisse scholars and critics. Jack Flam's work on Matisse was indispensable. His *Matisse on Art* (New York: Phaidon, 1973) gathers and annotates the painter's most important writings and statements. His *Matisse: A Retrospective* (New York: Hugh Lauter Levin, 1988) compiles excerpts from critical texts about Matisse and writings by Matisse about his art. Most important, Flam's lucid, perceptive, and well-researched critical biography, *Matisse: The Man and His Art, 1869–1918* (Ithaca and New York: Cornell University Press, 1986), provides extensive and reliable biographical information as well as astute analyses of Matisse's art.

Dominique Fourcade's *Henri Matisse: Écrits et propos sur l'art* (Paris: Hermann, 1972) brings together and annotates Matisse's writings using a thematic organization. "Correspondance Henri Matisse—Charles Camoin," *Revue de l'art* 12 (1971) edited by Daniele Giraudy, covers four decades ending in the mid-1940s, and is full of Matisse's comments on art. Taking a thematic approach, Pierre Schneider's brilliant but discursive *Matisse* (New

York: Rizzoli, 1984) relates Matisse to a wide cultural context and is rich in quotations from, anecdotes about, and insights into Matisse. Raymond Escholier's *Matisse: From the Life* (London: Faber & Faber, 1960) is a useful if somewhat erratic biographical study containing numerous quotations from Matisse. Alfred H. Barr, Jr.'s ground-breaking *Matisse: His Art and His Public* (New York: The Museum of Modern Art, 1951) offers a great deal of factual information as well as sober formal analysis.

Among other books that provide insight into Matisse's art and life are Lawrence Gowing's wonderfully written and highly perceptive *Matisse* (New York and Toronto: Oxford University Press, 1979); John Russell's lively *The World of Matisse, 1869–1954* (New York: Time-Life, 1969); and Nicholas Watkins's *Matisse* (New York, Oxford University Press, 1985). John Elderfield's *Henri Matisse in the Collection of The Museum of Modern Art* (New York: The Museum of Modern Art, 1978) illuminates Matisse's creative process in a discussion of some of his most important works. Elderfield's chronology (compiled with Beatrice Kernan) and introductory essay in *Henri Matisse: A Retrospective* (New York: The Museum of Modern Art, 1992) are full of new interpretations and information. Louis Aragon's *Henri Matisse: A Novel* (New York: Harcourt Brace Jovanovich, 1972) is a highly subjective, indeed somewhat self-indulgent, account of Matisse by a friend and poet. Jack Cowart's essay "The Place of Silvered Light: An Expanded Illustrated Chronology of Matisse in the South of France, 1916–1932" in *Matisse: The Early Years in Nice* (Washington D.C.: The National Gallery of Art, 1986) is intelligent and informative. Lydia Delectorskaya's *L'Apparente Facilité . . . : Henri Matisse—Peintures de 1935–1939* (Paris: Adrien Maeght, 1986) gives a vivid picture of Matisse at work. Jane Simone Bussy's article "A Great Man," published in *The Burlington Magazine* (1986: volume 128, no. 995) is a witty personal memoir written to be read to the Bloomsbury "Memoir Club," probably in the autumn of 1947. Jane was the daughter of Matisse's old friend and fellow Moreau student Simon Bussy; the family saw Matisse often in the 1920s and 1930s.

Useful studies of Matisse's work in media besides painting include Albert E. Elsen's *The Sculpture of Henri Matisse* (New York: Abrams, 1972); The St. Louis Art Museum's *Henri Matisse: Paper Cut-Outs* (The St. Louis Art Museum, 1977), an exhibition catalogue with essays by Jack Cowart, Jack Flam, Dominique Fourcade, and John Hallmark Neff; and John Elderfield's *The Drawings of Henri Matisse* (London: Arts Council of Great Britain and Thames & Hudson, 1984).

ACKNOWLEDGMENTS

am indebted to the generosity of many people and institutions for their support in the preparation of this book. First I would like to thank my editor, Alane Mason, whose enthusiasm and discernment made working with her a pleasure. The good will and diligence of her assistant, Celia Wren, were invaluable as well. For their splendid work in gathering photographs of Matisse's works I am most grateful to Laurie Winfrey and Robin Sand of Carousel Research, Inc. To the staff of Art Resource and Artists Rights Society goes my deep appreciation of their assistance: I especially thank Ted Feder and Elizabeth Weisberg for their kind cooperation. My gratitude goes also to Claude Duthuit and to the Archives Henri Matisse in Paris for all their help in making this book possible. In New York I am indebted to Andrea Farrington of the Pierre Matisse Archive for letting me look through photographs of Matisse.

For the privilege of reproducing works of art in their possession, I am grateful to the owners, private and public, of the paintings, drawings, sculptures, cutouts, photographs, and prints illustrated here. Many people

and departments in The Museum of Modern Art, New York, have extended their help to me. Most especially I thank John Trause and Eumie Imm in The Museum of Modern Art's library, Tom Grischkowsky in the Department of Rights and Reproductions, and Sharon Dec and Carolyn Maxwell in the Drawings Department. A number of museums, dealers, and private collectors have provided me with photographs of works by Matisse. Among them special thanks go to the Musée National d'Art Moderne, Centre Georges Pompidou, Paris, and to Madame Charton for her generous help.

Among other museums to whom I owe a debt of gratitude are The Hermitage Museum, Saint Petersburg; The Pushkin Museum of Fine Arts, Moscow; Statens Museum for Kunst, Copenhagen; Moderna Museet, Stockholm; Kunstsammlung Nordheim-Westfalen, Düsseldorf; Fitzwilliam Museum, Cambridge; Musée d'Orsay, Paris; Tate Gallery, London; Chapel of the Rosary, Vence; The Baltimore Museum of Art; The Barnes Foundation, Merion, Pennsylvania; Isabella Stewart Gardner Museum, Boston; The St. Louis Art Museum; Philadelphia Museum of Art; Albright-Knox Art Gallery, Buffalo; San Francisco Museum of Modern Art; The Minneapolis Institute of Arts; The Phillips Collection, Washington, D.C.; The Cleveland Museum of Art; and Los Angeles County Museum of Art.

Finally, I wish to express my gratitude to Jacqueline Monnier, Paul Matisse, and Jack Flam for giving their time to share with me their knowledge of Matisse.

INDEX

Works cited are by Matisse unless otherwise indicated.
Italicized page numbers refer to reproduced art.